50 SCULPTURES
YOU SHOULD KNOW

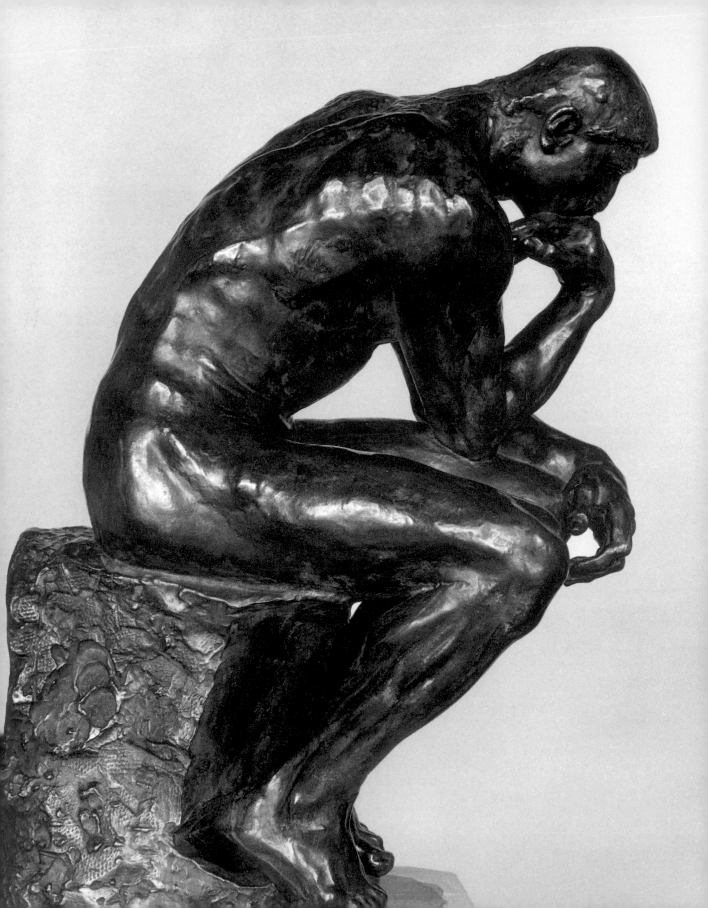

50 SCULPTURES
YOU SHOULD KNOW

Isabel Kuhl
Klaus Reichold
Kristina Lowis
Christiane Weidemann

Prestel

Munich · Berlin · London · New York

Front cover from top to bottom:
Michelangelo, detail from *David*, see page 80
Claes Oldenburg, *Giant Toothpaste Tube*, see page 132
Frédéric Auguste Bartholdi, detail from *The Statue of Liberty*, see page 110
Detail of *The Korai of Erectheion*, see page 14
Frontispiece: Auguste Rodin, *The Thinker*, see page 104
Pages 10/11: Antony Gormley, *Angel of the North*, see page 146

Prestel Verlag
Königinstrasse 9
80539 Munich
Tel. +49 (0)89 24 29 08-300
Fax +49 (0)89 24 29 08-335

Prestel Publishing Ltd.
4 Bloomsbury Place
London WC1A 2QA
Tel. +44 (0)20 7323-5004
Fax +44 (0)20 7636-8004

Prestel Publishing
900 Broadway, Suite 603
New York, N.Y. 10003
Tel. +1 (212) 995-2720
Fax +1 (212) 995-2733

www.prestel.com

Prestel books are available worldwide. Please contact your nearest bookseller or one of the above addresses
for information concerning your local distributor.

The Library of Congress Control Number: 2009932156

British Library Cataloguing-in-Publication Data: a catalogue record for this book is available from the British Library.
The Deutsche Bibliothek holds a record of this publication in the Deutsche Nationalbibliografie;
detailed bibliographical data can be found under: http://dnb.ddb.de

FSC
Mixed Sources
Product group from well-managed
forests and other controlled sources
Cert no. GFA-COC-001526
www.fsc.org
© 1996 Forest Stewardship Council

Verlagsgruppe Random House FSC-DEU-0100
The FSC-certified *Opuspraximatt* paper in this book
is produced by Condat and delivered by Deutsche Papier.

Editorial direction by Claudia Stäuble
Translated from German by Paul Aston, Rome
Copyediting by Chris Murray, Crewe and Reegan Köster
Cover and design by LIQUID, Agentur für Gestaltung, Augsburg
Layout and production by zwischenschritt, Rainald Schwarz, Munich
Picture research and timeline by Katharina Reiter
Origination by Reproline Mediateam
Printed and bound by Druckerei Uhl GmbH & Co. KG, Radolfzell

Printed in Germany

ISBN 978-3-7913-4338-9

CONTENTS

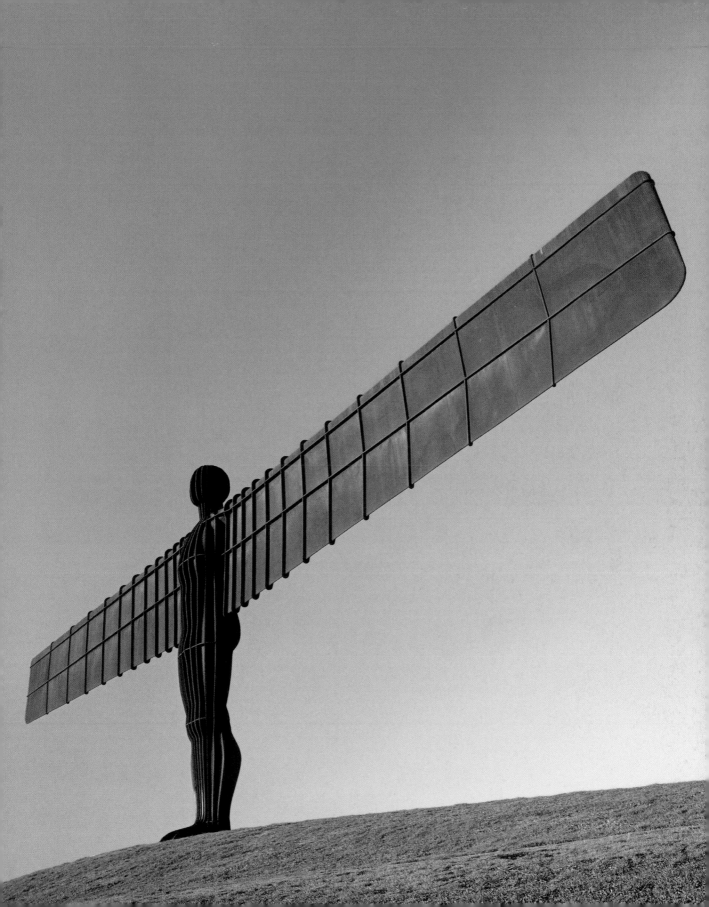

C. 480 BC Beginning of classical period in Greek art

490 BC Miltiades defeats the Persians in Marathon. The distance race is later inspired by the legend of the runner who brought the news to Athens.

460 BC Democritus is born, best known for his atomic theory

447–432 BC The Parthenon constructed

431 BC Start of the Peloponnesian War

515 510 505 500 495 490 485 480 475 470 465 460 455 450 445 440 435 430

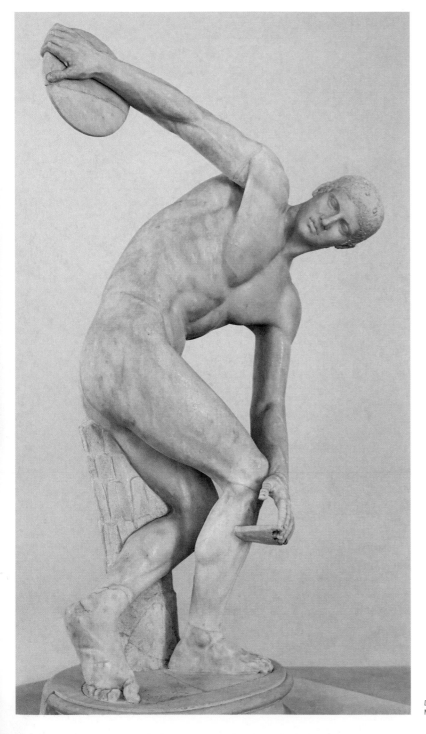

Discus Thrower, Roman marble copy of a bronze original by Myron from c. 433–401 BC, h. 155 cm, Museo Nazionale, Rome

HIPPOCRATES OF COS,
MOST RENOWNED DOCTOR OF ANTIQUITY

C. 420–410 BC *The Korai of Erectheion*

387 BC Plato founds his academy
in Athens

| 425 | 420 | 415 | 410 | 405 | 400 | 395 | 390 | 385 | 380 | 375 | 370 | 365 | 360 | 355 | 350 | 345 | 340 BC |

DISCUS THROWER

If a photographer were to take a picture of a modern discus thrower, we would get a very different image of the athlete. Nonetheless—or perhaps because of that—the lost 5th-century BC sculpture by Greek sculptor Myron must have been so impressive that it has remained the image of an ideal sportsman to our day.

The *Discus Thrower* (also known by the Greek name *Discoboulous*) is one of the best-known classical images. Although the original hasn't survived, the great number of later copies—in some cases known only as fragments—testifies to the popularity of the figure. Even in Roman times, there were so many replicas that it was later possible to piece together new discus thrower statues from the fragments.

Variant Poses

All these variants show a nude male athlete whose body is turned to the right, his knees bent, his left foot set behind his right leg. His left hand hangs over his right knee and his right hand grips the discus, which is held vertically. He's psyching up for the throw. Roman author Pliny praised Myron principally for his lifelike style. And yet this sculpture does not actually show a precise moment in the preparation for throwing the discus; it's more of a synthesis of visibly tense parts of the body that creates a convincing and powerful whole. Without the surviving original, we don't know exactly how the head was originally aligned. A discus thrower found in fragments at the end of the 18th century in Hadrian's Villa in Tivoli (now in the British Museum) was bought immediately after its discovery by the British collector Charles Townley. However, the head was incorrectly put on prior to the purchase so that the athlete looks downwards, almost as if in meditation, instead of looking at the discus. This variant underlined, so it was said at the time, the massive concentration of the pose.

In the version preserved in the Museo Nazionale in Rome, the athlete is looking at his discus. This corresponds with the description by Lucian in the 2nd century BC: "You don't mean the one with the discus leaning forward ready to throw—he has turned his head back to look at the hand throwing the discus, and the other knee slightly bent, and he

looks as if he will finish up erect after throwing?—No, not that one, that's the *Discus Thrower* you're talking of—the one Myron did."

Ideal Image of an Athlete

Apart from the discus, the pentathlon includes the long jump, running, wrestling, and javelin throwing. The event was represented not only at the Olympic Games but also at other ancient sports festivals as well. The bodies of trained pentathletes have evenly developed muscles, and are accordingly more attractive than athletes trained for one sport. In the case of this sculpture, therefore, we have not a particular person but the ideal image of an athlete. No doubt the fame and great influence of the sculpture is due to its capturing the essence of physical expression in sport. Sculptors such as Auguste Rodin (see pages 104–107) were successors in using the approach developed by Myron. The athletic ideal was also much admired by the Nazis. In the prologue to her film *Festival of the Nations* in 1937, Leni Riefenstahl superimposed the body of decathlonist Erwin Huber on the *Discus Thrower*. In 1938, Hitler acquired the Roman version (known as the *Lancelotti* in Italian), but ten years later it was returned to Italy. Even today, the *Dicus Thrower* is a symbol of the sporting ideal. *kl*

MYRON OF ELEUTHERAI
Attic sculptor active c. 480–440 BC. He was one of the most notable creators of early classical Greek bronzes.
His surviving works are the *Discus Thrower* and *Athene and Marsyas*, both only in copies dating from Imperial Rome.
He was famous for his images of athletes: the *Discus Thrower* survives in over 20 copies.
His son Lykios was his most distinguished pupil.

Discus Thrower, Roman marble copy of a bronze original by Myron from c. 433–401 BC, h. 167.6 cm, British Museum, London

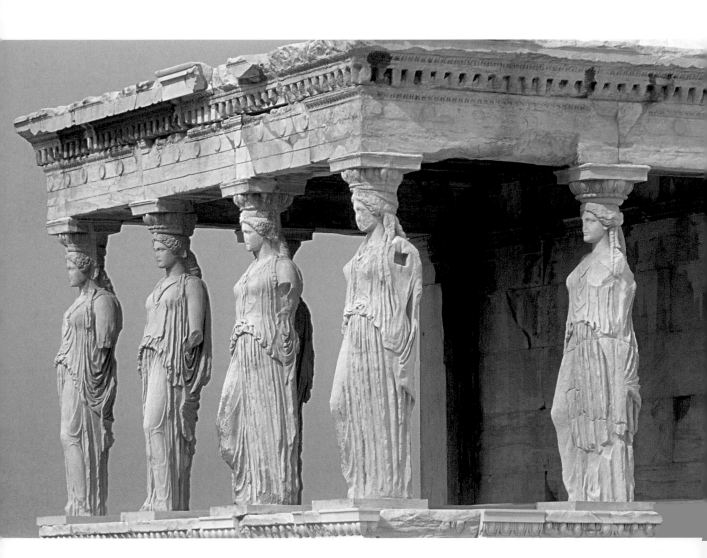

PHIDIAS (PARTHENON)

THE ACROPOLIS
CONSTRUCTED

469 BC Socrates born

C. 480 BC Beginning of classical period
in Greek art

477 BC The Confederacy of
Delos founded

447–438 BC The Parthenon constructed

431 BC Start of the
Peloponnesian War

C. 400 BC Heyday of
Greek comedy,
with Aristo-
phanes and
Menander

| 480 | 475 | 470 | 465 | 460 | 455 | 450 | 445 | 440 | 435 | 430 | 425 | 420 | 415 | 410 | 405 | 400 | 395 |

The Korai of the Erectheion, late
5th century BC, marble, h. 231 cm,
Acropolis Museum, Athens

367 BC Aristotle enters Plato's
academy in Athens

323 BC Alexander the Great dies

C. 320 BC Beginning of the Helle-
nistic period in Greek art

390 385 380 375 370 365 360 355 350 345 340 335 330 325 320 315 310 305 BC

THE KORAI OF THE ERECTHEION

Six dignified young women have been supporting the entablature of an Ionic porch on their heads for over 2,400 years, and have become famous for the graceful way they do it. Their prominent location, the Erectheion temple on the Acropolis in Athens, Greece's most famous symbol, may of course have something to do with that.

Except for a few details, the six statues are identically dressed, and are distinct from each other mainly through the symmetrical arrangement of their weight-bearing and relaxed legs. They wear long, thin tunics (the *chiton*) which are gathered and tucked up under a belt. Their hair is braided rounded their heads and falls in thick braids over the nape and down their backs, which indicates that these are young women. The arms no longer survive, but from what we know of later Roman copies, we may assume that they hung down each side of the body. The hands were raised, one to hold the tunic, the other to present a bowl. A serpent-bangle decorated the wrist. Their pose manifests a particular lightness and also pride—they are supporting a stone crown, after all.

Slaves or Devotees?

We know from historic evidence that the *korai* (young women) were already in place on the porch in 409 BC. Construction had begun on the Erectheion 15 years earlier and was completed around three years later.

Of all kinds of architectural sculpture, the so-called caryatids are perhaps the ones most closely tied up with the building they serve, even though they are freestanding elements. Roman architectural writer Vitruvius recognized this unusual circumstance, and sought an explanation for the origin of these female support figures. His conclusion was that they represented women slaves from the city of Karyas, which was allied with the hostile Persians—after their defeat by the Athenians, their tribute was symbolically translated into monumental form. This theory is possible but unlikely, and there is, as of yet, no way of proving or disproving it. They are more likely to be young Athenian women who proudly served the funeral cult of the first Attic king, Kekrops—the chamber beneath them is dedicated to his memory. He is, moreover, considered the founder of the cult of ceremonial burial. The bowls

they once held suggest the gifts of sacrificial liquids (e.g. milk, wine, or honey). Their eternal service to the mythical founder symbolizes loyalty to Athens and its history.

A Symbol of Greek Culture

Roman clients who later commissioned sculptors to produce copies of the female statues—for example in the Forum of Augustus in Rome and in the garden of Hadrian's Villa near Tivoli—must have been aware that the caryatids were symbols of Attic tradition. By using these figures, they underlined their political and historical attitude. In the 18th century, statues inspired by the *Korai of the Erectheion* enjoyed great popularity, and even today the *korai* are used as emblems of Greek culture and historical symbols.

In 1803, classical enthusiast Lord Elgin went to Greece and took numerous sculptures from the Acropolis back to England with him. Among them was one *kore*, which he casually replaced with bricks. This *kore* can now be seen in the British Museum. Admittedly, since it has been long spared the pollution damage that her contemporaries have suffered, she is now the best preserved. The other five were replaced on the building by copies at the end of the 20th century, and can be admired in the New Acropolis Museum in Athens. *kl*

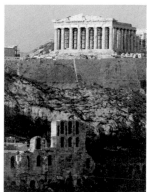

ACROPOLIS
Traces of settlements on the Athenian Acropolis go back to the Neolithic period. The Acropolis was dedicated to the city's patron divinity, Athena, and was the seat of the Athenian royal palaces.
MID-5TH CENTURY The Acropolis is redesigned during Pericles's time by architects Iktinos, Mnesikles, and Kallikrates, supervised by sculptor Phidias.
447–432 BC The Parthenon, which was a treasury and the location of a statue of Athene, is built.
424 BC Work starts on the Erectheion.
5TH CENTURY AD The Parthenon is converted into a Christian church.
EARLY 19TH CENTURY Lord Elgin visits Greece and removes some of the sculptures from the Acropolis buildings, including a caryatid and the Elgin Marbles.

Parthenon, 447–438 BC, Acropolis, Athens

477 BC The Delian League is founded

431 BC Start of the Peloponnesian War

469 BC Socrates born

480 475 470 465 460 455 450 445 440 435 430 425 420 415 410 405 400 395

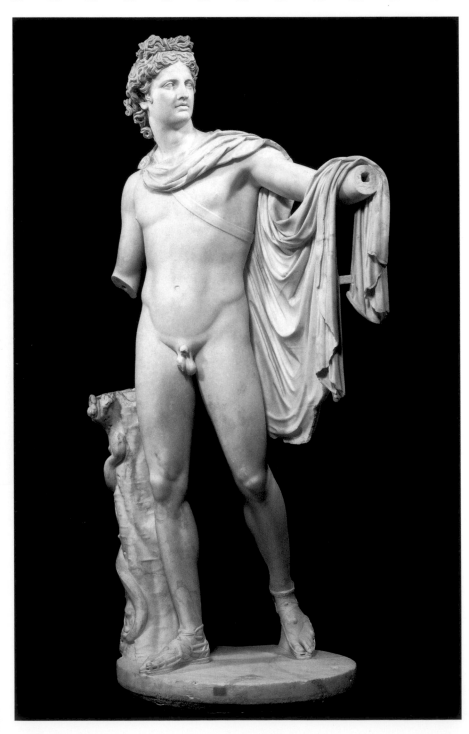

Apollo Belvedere, AD 2, marble copy of a bronze
original by Leochares from c. 330/320 BC, h. 224 cm,
Museo Pio Clementino, Vatican

C. 390 BC Lysippus born, Greek sculptor

367 BC Aristotle enters Plato's academy in Athens

328–325 BC Silanion creative period

390	385	380	375	370	365	360	355	350	345	340	335	330	325	320	315	310	305 BC

APOLLO BELVEDERE

The marble archer turned up in Rome in the late 15th century. It was then owned by Cardinal della Rovere, who prudently kept it out of sight in his garden until 1503, when he became Pope Julius II. Only then did he move it to the Belvedere, where it became famous.

Its origins are not wholly clear, but the Apollo is presumed to be a Roman copy of a bronze statue by the Greek sculptor Leochares from the 4th century BC. In other words, it is an example of the admiration that Rome had for Greek art. Praised as the quintessence of perfect beauty, as the ultimate ideal of the male body, for centuries the Apollo Belvedere was considered the finest surviving single figure of antiquity. Certainly the sculpture of the god of the arts and light is one of the most famous of classical sculptures.

Generations of Admirers

Thanks to plaster casts, the figure was analyzed and copied everywhere, down to the last detail. Studying it closely was part of their training for generations of artists. Its effect on sculptors, painters, and even poets was immense—for many, the statue represented the zenith of Greek art. In the 18th century, German archeologist J. J. Winckelmann further boosted the fame of the work by saying that for him the Belvedere Apollo was "the highest ideal of art, of all works of antiquity."

Weightless Elegance

Seven feet four inches (2.24 m) tall, the marble statue is clearly meant to be seen from the front. Viewed from the side, however, its slight pacing stance is clear. The right leg is locked straight and facing forwards, whereas the left is slightly bent and splayed outwards so that the foot touches the ground only at the tip of the sandal. From the front, this shift of weight is almost imperceptible, the dropped shoulder on the weight-bearing side being the only indication. At hip level, it is invisible. But the effect of the statue is indisputable—the god appears weightless, almost removed from the earthly sphere. Originally a tree trunk on Apollo's right provided support. Today the right arm that rested on it is missing, as is the left hand, which once held a bow. Apollo's gaze is aligned along the out-stretched left arm into the distance. On his back he carries a quiver and arrows, his short robe—a *chlamys*—falling over his shoulders and lower left arm in soft swathes. *ik*

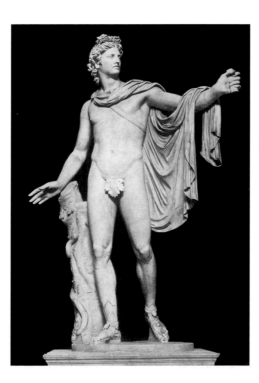

Apollo Belvedere, AD 2, marble copy of a bronze original by Leochares from c. 330/320 BC, h. 224 cm, Museo Pio Clementino, Vatican

LEOCHARES

C. 370–320 BC The active career of the sculptor Leochares. Nothing is known about his life and artistic training, and most of his works have not survived. The fame of the Ganymede statue is documented. Ganymede was a youth who was kidnapped by Zeus, who had assumed the shape of an eagle. (Roman copy in the Vatican.)

C. 350 BC Creates sculptural decoration of the Mausoleum of Halicarnassus, together with Skopas, Timotheos, and Bryaxis.

2ND HALF OF 4TH CENTURY BC *Artemis of Versailles*, Roman marble copy (now in Louvre), is often attributed to Leochares.

C. 320 BC His last datable work created, the *Lion Hunt of Alexander the Great*, done jointly with Lysippus.

C. 250 BC Heyday of Hellenism

218 BC Hannibal defeats the
Romans at Trebia

200–197 BC Second Mace-
donian War

275 270 265 260 255 250 245 240 235 230 225 220 215 210 205 200 195 190

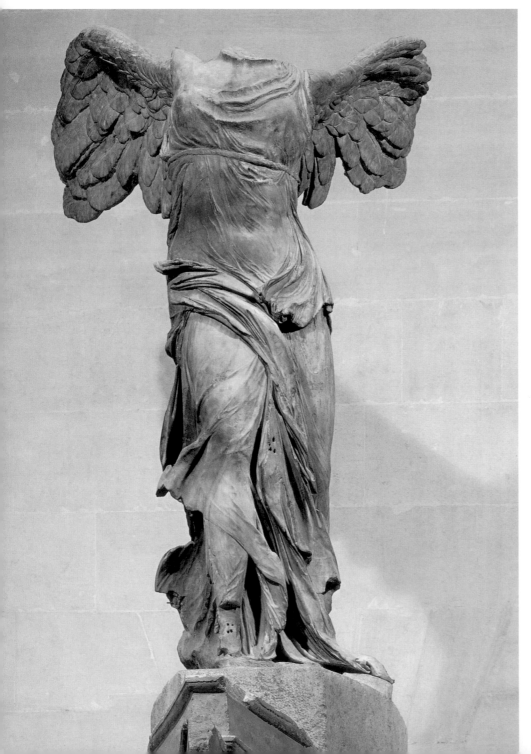

Victory of Samothrace, c. 190 BC, marble,
h. 245 cm, Musée du Louvre, Paris

190 BC Sculptor Nikeratos active

0 BC Rhodes defeats Antiochus III of Syria at sea

C. 180 BC Pergamon Altar

150–100 BC *Alexander Mosaic*, Pompeii

148 BC Greece annexed by Rome

C. 150 BC *Venus de Milo*

123–88 BC King Mithridates II revives
the Parthian Empire

185	180	175	170	165	160	155	150	145	140	135	130	125	120	115	110	105	100 BC

VICTORY OF SAMOTHRACE

When French archeologists found the statue on the small northern Greek island of Samothrace 150 years ago, it was broken into more than 100 parts. Once they had put them together again, the fragments formed one of the most dynamic monumental statues of antiquity. The winged goddess of victory was quickly sent to Paris.

Since then, the marble figure has occupied a commanding position on the stairwell of the Louvre, where she makes an impressive sight—not surprisingly, since this Victory is the largest preserved sculpture of its day. And not only that: she is also one of the best-known sculptures of antiquity. The fact that the sculpture still lacks parts does not diminish its effect. In 1950, researchers found more fragments of the once-shattered statue, and there are further bits in Vienna. The principal parts still missing include her head, both arms and parts of her feet. But even without these the figure still reaches a height of over 8 feet (2.4 m).

Divine Balancing Act

Originating from Hellenistic Greece, the figure radiates a great energy. The winged goddess has only just touched the ground. She has hastened there to proclaim victory (the statue is sometimes known as the *Nike of Samothrace*, after the Greek word for victory). She alights on her lofty pedestal with wings still outstretched, her whole body exuding movement and dynamism. She strides forward with her right leg, and balances with the left. The wind catches the ample folds of her gown, which is tied under the breast, the thin fabric clinging to her body at the breasts, belly, and thighs. The cloak that is wound round her hips forms a contrast, shrouding the right leg of the sculpture in a dense mass of folds.

A Dramatic Position

Dating from around 190 BC, the Victory of Samothrace originally stood on a pedestal modeled on the prow of a ship. This pedestal was in turn placed in a pool at the highest point of a shrine in Samothrace. The marble goddess once looked out over her surroundings like a figurehead on a galleon. The main view was from the left side, as is evident from the fact that the left side being more finished than the right.

Presumably the statue commemorates a naval victory. Scholars are confident that it was paid for by Rhodes, which was allied with the Romans, after they had defeated the fleet of Syrian ruler Antiochus III. But for all the vigor that the monumental figure exudes, the clients probably realized that no victory lasts forever. The marble Victory comes ashore, but that does not mean she cannot set sail again. *ik*

SAMOTHRACE

C. 700 BC Samothrace is colonized by Aiolians from Lesbos, and a city state (polis) is founded on the island.

480 BC After the Battle of Salamis (3rd Persian War), Samothrace becomes a tribute-paying ally of the victorious Athenians.

336–30 BC Under Hellenism, Samothrace is an important shrine for the Dioscuri, and also an important trading center.

1457 Ottomans capture the island.

1912 Following the Balkan War, the island becomes part of Greece.

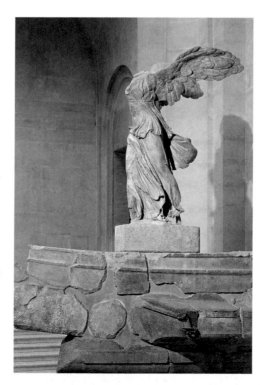

Victory of Samothrace, side view

255 250 245 240 235 230 225 220 215 210 205 200 195 190 185 180 175 170

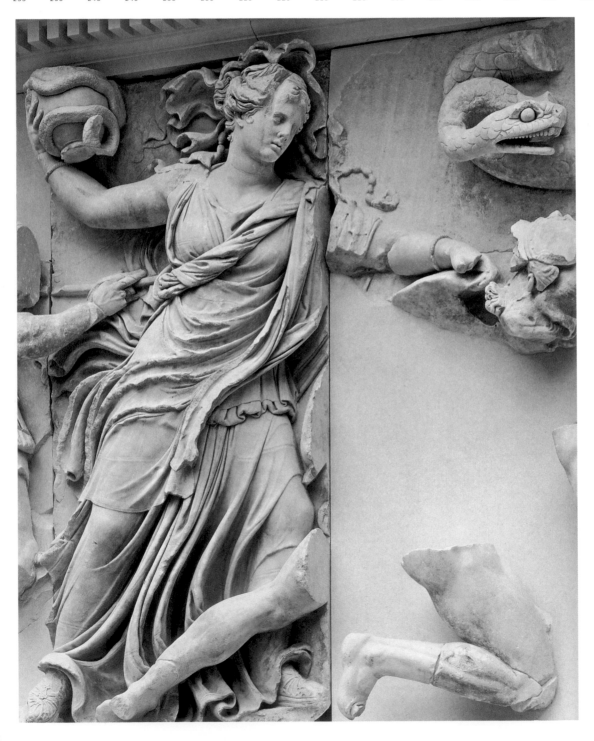

PUNIC WARS END WITH THE DESTRUCTION
OF CARTHAGE BY THE ROMANS

ALEXANDER MOSAIC, POMPEII

148 BC Greece annexed by Rome 131 BC Kingdom of Pergamon
 annexed by Rome
71–168 BC Rome subjugates Macedonia C. 150 BC Venus de Milo

160 BC Adelphoe (The Brothers) 123–88 BC King Mithridates II revives
 by Roman dramatist right the Parthian Empire
 Terence first performed

165 160 155 150 145 140 135 130 125 120 115 110 105 100 95 90 85 80 BC

PERGAMON ALTAR

Scholars began excavating in the ancient Greek city of Pergamon in 1878. They soon struck archeological treasure, bringing to light a singularly impressive and important work of Hellenistic art that is 623 feet (190 m) long—the frieze of the Zeus Altar.

Alexander the Great began to extend his empire towards Persia, Central Asia, and Egypt in the 4th century BC. His successes introduced an era of Hellenism, spreading Greek culture eastwards and creating numerous new Greek-ruled cities such as Alexandria in Egypt. As these cities expanded, there were many major commissions for temples, libraries, theaters, palaces, and private houses. Located on the west coast of Anatolia (present-day Turkey), Pergamon (Pergamum) steadily grew in importance over the 3rd century BC. Its rulers expanded the power of the city until finally it became one of the most important in the Greek world. Around 180 BC, a huge temple was built in Pergamon, following the model of the Parthenon on the acropolis in Athens. It was dedicated to Zeus and likewise on the highest part of the city, the acropolis.

Scenes of Fighting Gods …?

A broad flight of steps led up to a colonnaded portico and then into the interior of the temple. The base of the colonnade was adorned by a frieze which, made up of over 100 individual marble panels, extended over 623 feet (190 m). The frieze shows the gods battling giants in an impressive demonstration of Hellenistic sculpture. On the northern frieze, for example, a goddess lashes out with her left hand to snatch her opponent's shield. In her right hand she holds a container with a snake wound around it. All the figures are almost in the round, a fact that conveys a feeling of movement even where the complete scene has not survived. The frieze is 7 feet 6 inches (2.30 cm) high, so the figures are larger than life, and because they are deeply cut they seem to occupy a space outside the relief. As they fight, some of the warriors support themselves on the steps, becoming part of the architecture.

… Or History in Stone?

Another interpretation of the monumental pictorial program is that it has more to do with contemporary events. In the 3rd century BC, the Galatians, an alliance of Celtic tribes, invaded Asia Minor.

PERGAMON
In the period after the rule of Alexander the Great, the city of Pergamon (Pergamum) in Asia Minor becomes the seat of an influential dynasty.
281–133 BC The Attalids rule Pergamon, and the city becomes an important cultural center of Greek art and science.
C. 200 BC The ruling Attalids establish a library on the acropolis in Pergamon. After the one in Alexandria, it is the second largest library in ancient Greece (with 200,000 parchment rolls).
C. 180 BC Construction of the Zeus Altar, the largest sculptural ensemble ever made in antiquity.
133 BC With no heir, Attalus III bequeaths the city to the Romans.

MUSEUM TIP
German engineer Carl Humann excavated the Pergamon Altar in two major campaigns in 1879 and 1904, the relief panels being sent to Berlin. Nowadays, anyone interested can enjoy the reconstruction of the altar in the Pergamon Museum on Monument Island in Berlin.

Hellenism

The beginning of Hellenism dates back to the year Alexander the Great came to the throne, 336 BC. His conquests took the Greek language and Greek culture over large parts of Asia, where they fused with various regional traditions of Asia Minor to become a distinctive Hellenistic culture. Hellenistic rulers founded a host of cities, including Alexandria in Egypt and Pergamon in northwest Asia Minor, offering much work for artists and architects. Under Hellenism, sculpture, and in particular portraiture, flourished.

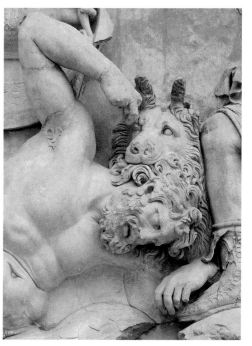

left page:
Pergamon Altar, detail from the north frieze

left:
Pergamon Altar, detail: fallen giant

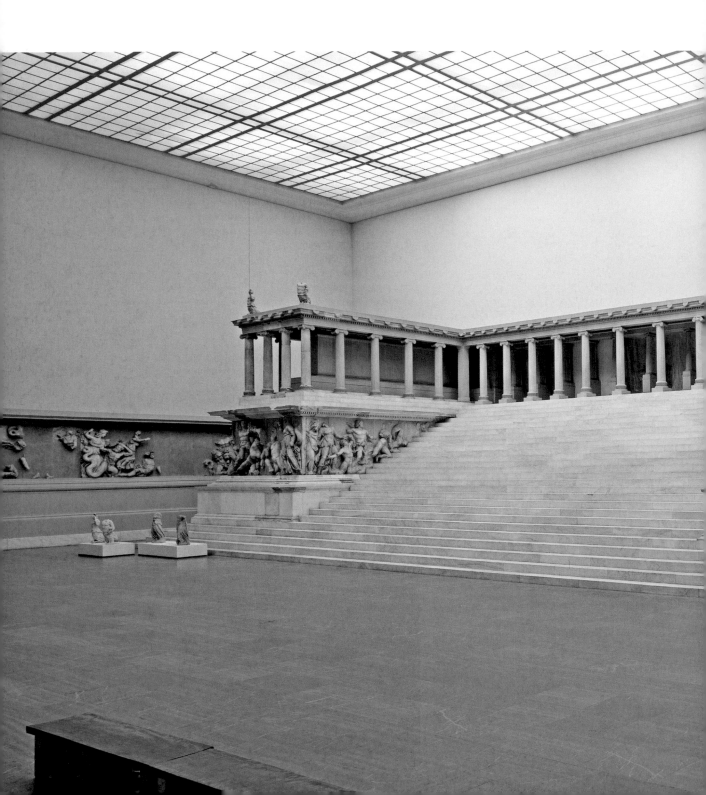

The ruler of Pergamon was the one who finally stopped their advance. As the Pergamonians saw it, civilization had achieved an important victory over the barbarians, and they interpreted the reliefs in the Zeus temple as representing not just mythology but also Pergamon's fight against the Galatians. The importance of this victory can scarcely be over-estimated, since after this military victory the kingdom of Pergamon gained even more influence. *ik*

Pergamon Altar, c. 180 BC, marble, Pergamon Museum, Staatliche Museen, Berlin

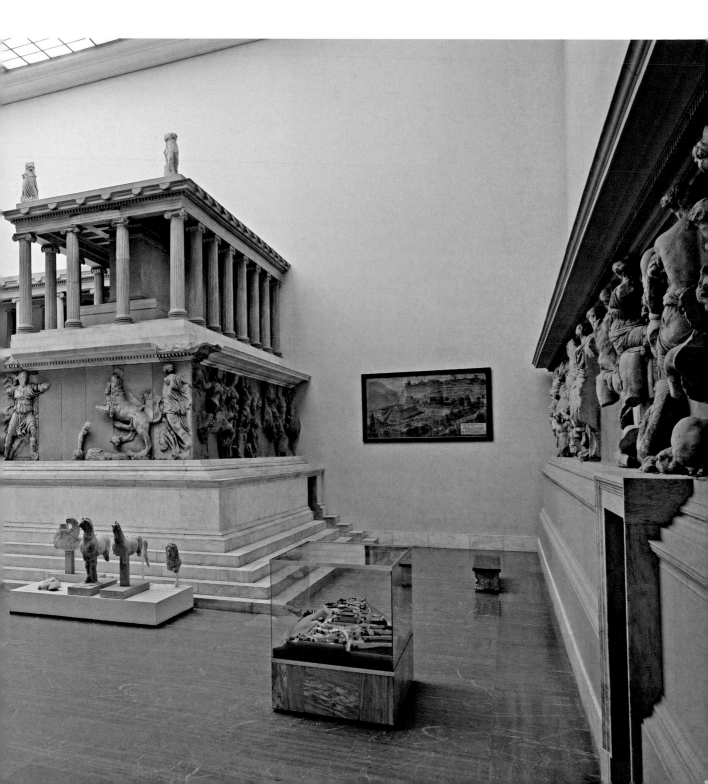

221 BC Shi Huángdì becomes first emperor
of China. Work begins on Great Wall

218 BC Hannibal defeats the Romans at Trebia

C. 190 BC Sculptor Nikeratos active
C. 190 BC *Victory of Samothrace*

C. 180 BC *Pergamon Altar*

148 BC Greece annexed
by Rome

160 BC *Adelphoe* (The Brothers) by Roman
dramatist right Terence first performed

225 220 215 210 205 200 195 190 185 180 175 170 165 160 155 150 145 140

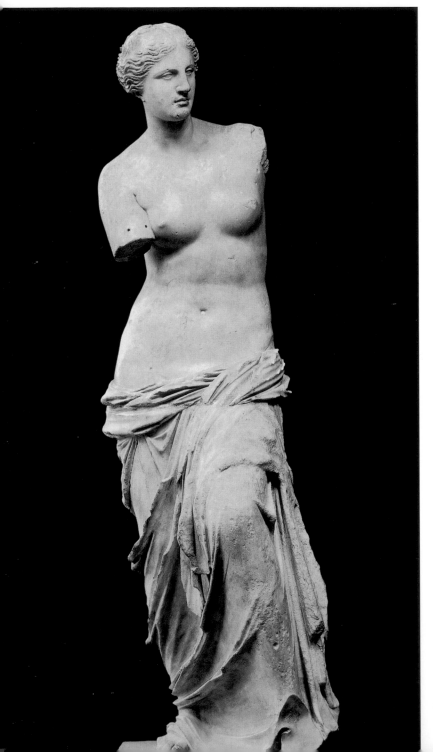

Venus de Milo, c. 150 BC, marble, h. 204 cm, Musée du Louvre, Paris

KING MITHRIDATES II REVIVES
THE PARTHIAN EMPIRE

131 BC Kingdom of Pergamon
 annexed by Rome

52 BC Gallic revolt

C. 50 BC Villa of Mysteries,
 Pompeii

135 130 125 120 115 110 105 100 95 90 85 80 75 70 65 60 55 50 BC

VENUS DE MILO

The Venus de Milo (or Aphrodite of Milos), which is among the last great divine images of Greek antiquity, has fascinated art lovers throughout the world since it was discovered nearly 190 years ago. A depiction of Aphrodite, goddess of love and female beauty, it is a famous example of late Hellenistic craftsmanship.

The *Venus de Milo* was found in 1820 on the Greek island of Melos (Milos in Modern Greek), one of the southwestern Cyclades islands. A peasant discovered the marble statue in the vicinity of an ancient theater near Tripiti, in a wall niche of a *gymnasion*. A sailor from the French fleet helped him dig it out, meanwhile notifying French Consul Marquis de Riviere in Constantinople of the find. The same year, the Marquis had the statue shipped to France, and presented it to King Louis XVIII as a gift. He in turn gave it to the Louvre in 1821, where it has been on display ever since. There is a copy in the Archeological Museum in Plaka, the principal town on Milos.

Graceful Diety from the Late Hellenistic Period

The find contained a fragment of a plinth with an inscription referring to "[Hage?]sandros" from Antiochia on the Meander—a small town in western Anatolia—as the sculptor. However, it is uncertain whether this plinth actually belongs to the statue, and to enhance the statue's value, the plinth was removed so that the sculpture could be attributed to the great sculptor Praxiteles, and was subsequently lost.

The graceful deity is now considered to date from the late Hellenistic period. It is based on classical antecedents, and makes use of stylistic innovations from the 3rd–1st century BC, known as Hellenism. Typical, for example, is the formulaic contrast between the nakedness of Aphrodite's upper body and the busy folds of the mantle covering her lower body. The movement of the figure, involving a slight turn from the hips up to the right shoulder, combined with a body shape with a projecting pelvis and comparatively small torso, were typical of the stylistic features and ideals of that period.

Sensual Ideal of Female Beauty

Above all, it is the sensuality of the half-naked young goddess with her feminine curves that has brought the statue its enduring fame. At first glance natural-looking, her memorable pose is in fact studied. The left leg is slightly turned inwards, with the foot forward and resting on a (no longer surviving) prominence. Combined with the outward thrust of the right hip, the result is a captivating S-shaped pose. It terminates artistically in the regal attitude of the head, with the goddess looking into the distance, absorbed in her thoughts.

Both arms of the figure have been lost, one at and one below the shoulder, which makes it impossible to reconstruct them with any assurance. A fragment of the right arm with a hand that once held a round object was found nearby, but it is a matter of controversy whether it belongs to the statue. In the view of most scholars, the statue represents Aphrodite after a bath, preparing for the Judgment of Paris. Accordingly, it would have been an apple she was holding, alluding to her victory in this ancient beauty contest. Despite the missing parts of the body, the mystery-shrouded *Venus de Milo* symbolizes the ideal of female beauty, which for many is its special charm. *cw*

MELOS

Melos has been occupied by man since the 5th millennium BC.

6TH CENTURY BC Dorians from Lakonia settle on the island.

5TH CENTURY BC During the Peloponnesian War, the inhabitants resist the powerful Athenians and following their defeat are enslaved.

1204–1537 Melos belongs to the Venetian duchy of Naxos.

1820 The *Venus de Milo* is discovered.

Venus de Milo, detail

VESPASIAN

27 BC After defeating his rival Mark Antony, Octavian becomes Emperor Augustus

54 Nero becomes emperor

45 The Apostle Paul embarks on his evangelical travels, which eventually take him to Rome

70–82 The Colosseum in Rome constructed

79 Pompeii destroyed by Mt. Vesuvius

0 5 10 15 20 25 30 35 40 45 50 55 60 65 70 75 80 85

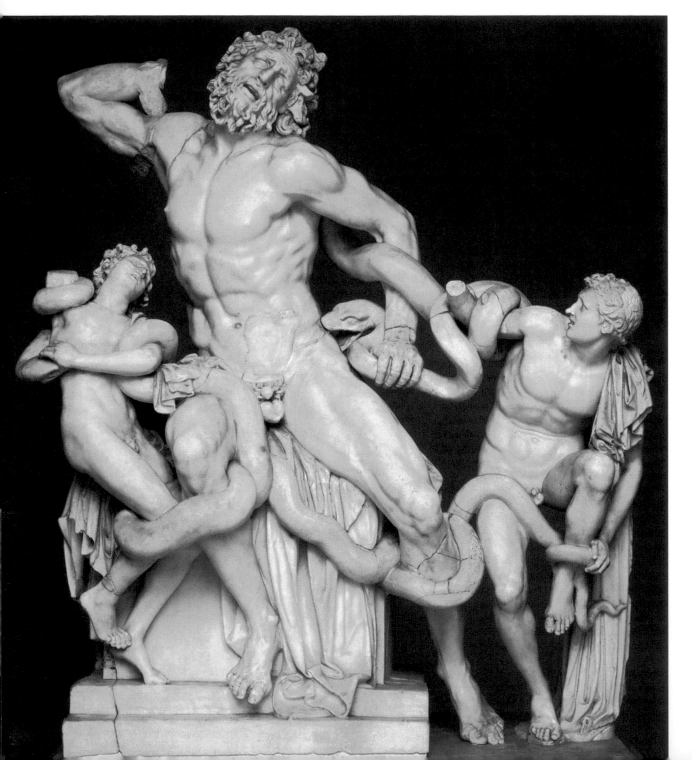

c. 125 Hadrian's Wall in Britain
constructed

98–117 Aqueduct of Segovia, Spain,
constructed

c. 150 First Germanic tribal migrations

130 Dome is placed on Pantheon in Rome

174 Marcus Aurelius
starts writing his
Meditations

| 90 | 95 | 100 | 105 | 110 | 115 | 120 | 125 | 130 | 135 | 140 | 145 | 150 | 155 | 160 | 165 | 170 | 175 |

LAOCOÖN AND HIS SONS

It was a sensational find that Felice de' Freddi made when he discovered a large marble sculpture buried in the ground of his Roman vineyard. News of the find spread rapidly, and one of the first people to hurry to the excavated site in January 1506 was the sculptor Michelangelo.

Michelangelo was astonished. What had been buried beneath the soil awaiting discovery was a group of three figures that was 8 feet (2.42 m) high. Those present recognized it immediately, for the Roman writer Pliny the Elder had described the work in one of his histories, saying that it was "superior to all works in painting and bronze."

What a Find!
Pope Julius II himself soon proved no less enthusiastic, particularly since the classical sculpture was well preserved despite a few losses. He ordered the work to be brought immediately to the Vatican. And that's where the *Laocoön*, the basis of the papal collection of classical antiquities, can still be seen. Its impact can scarcely be overestimated. It influenced not only contemporaries but also artists of later centuries. Whether drawn or painted, hewn in stone or cast in a reduced bronze copy, the *Laocoön* inspired generations. Despite scholars failing to agree on the precise origin and date of the marble sculpture, it remains a dramatic scene whose fascination never wanes.

A Struggle with a Tragic End
The sculpture depicts the Trojan priest Laocoön with his two sons. Their violent end is described by Virgil in his epic poem the *Aeneid*. Laocoön had warned the Trojans not to let the wooden horse, the gift of the Greeks, into Troy. They ignored his warnings and the horse, with Greek soldiers hidden inside it, was allowed in. For the gods, of course, the destruction of Troy was already decided, and Laocoön's warning threatened to upset their divine plans. So they intervened, and sent sea serpents to strangle the priest and his sons. The statue captures a moment in this ghastly struggle between man and beast: the force of the snakes seems to be preventing Laocoön from rising—he is half sitting, half standing, with every muscle betraying the huge strain of his exertions. The priest is trying with all his might to crush a snake that is about to bite him on the hip. His head tilts to one side, his wild mane of hair framing a face distorted with agony. On the right of the father, leaning against the altar block, the younger son seems to have already lost the battle. His head is thrown back, and snakes have a firm hold of his arms and legs. The elder son is on Laocoön's left, looking desperately across to his father and trying to free his left leg. The end of the unequal struggle is not far off. *ik*

29–19 BC Virgil writes the *Aeneid*.
AD 23–79 Pliny the Elder (who describes the sculpture).
1506 4 January: the *Laocoön* is unearthed in Rome.
1506 March: it is handed over to Pope Julius II.
1766 The German playwright G. E. Lessing writes a celebrated essay about *Laocoön* and the limitations of painting and literature.
1798 The German poet Goethe writes an essay about *Laocoön*.
1905 The right arm of *Laocoön* is found.

Laocoön and His Sons, 1st century AD, marble, h. 242 cm, Museo Pio Clementino, Vatican

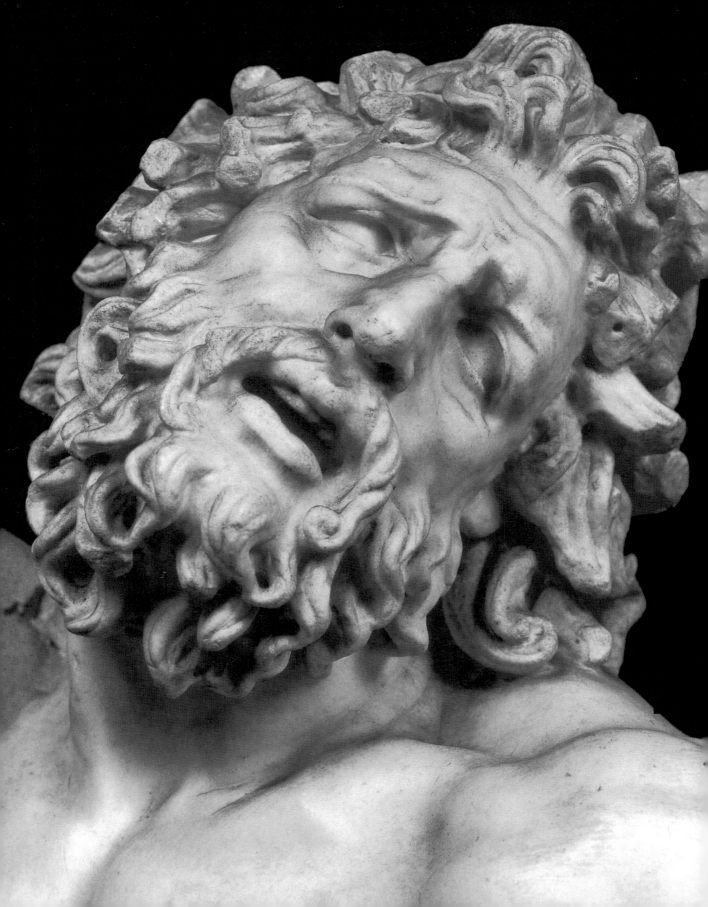

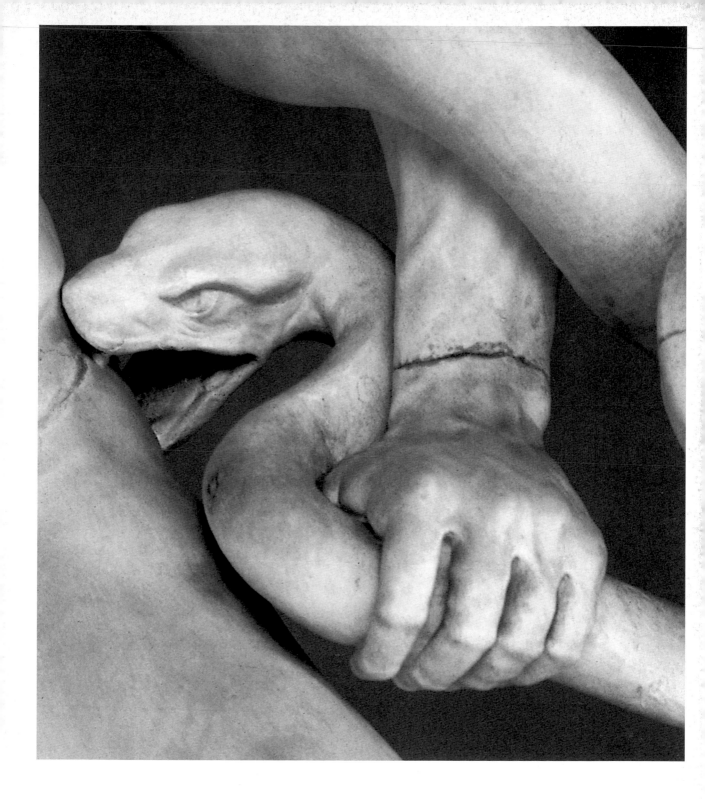

Laocoön and His Sons, details

130 Dome is placed on Pantheon in Rome

101/102 and **105/106** Dacian Wars

79 Pompeii destroyed by Vesuvius

c. 125 Hadrian's Wall in Britain constructed

50 55 60 65 70 75 80 85 90 95 100 105 110 115 120 125 130 135

Trajan's Column, detail: Crossing the Danube

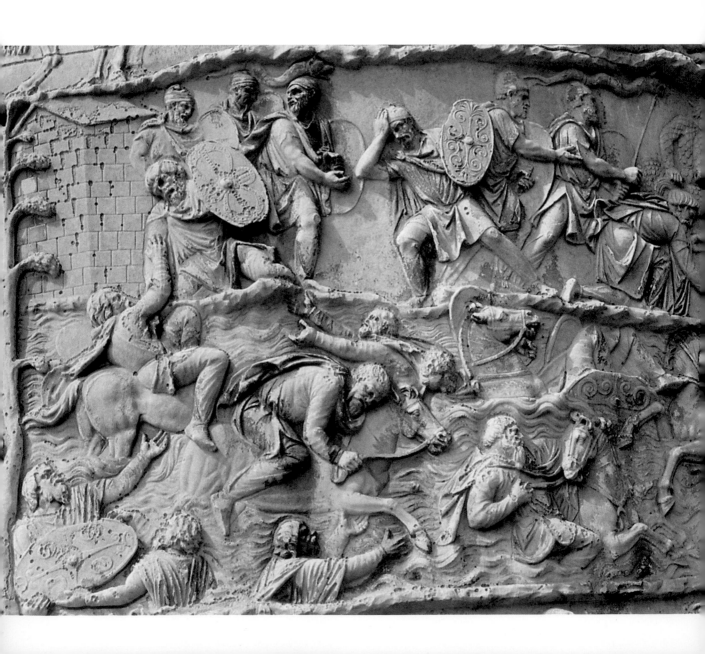

150 Buddha figure from Mathura

161–180 Equestrian statue of
Marcus Aurelius

C. 150 Temple of Bacchus, Baalbec

C. 181 Marcus Aurelius column in
Piazza Colonna, Rome

202 Christianity banned in
the Roman Empire

140 145 150 155 160 165 170 175 180 185 190 195 200 205 210 215 220 225

TRAJAN'S COLUMN

Whole armies climb Trajan's Column in the center of Rome. Between the base and the top there are around 2,500 figures.
They march, set up camps, build fortifications, and fight with shield and sword.

Such triumphal columns with reliefs are a feature of many cities in the Roman Empire, for the Romans used them to tell the story of their successful conquests. In the 2nd century AD, the Roman Empire extended from North Africa to Britain and from the Iberian Peninsula to Asia Minor. Campaigns were thus hardly rare. Trajan's Column, which was completed in AD 113, depicts scenes from Emperor Trajan's two wars against the Dacians.

Tales of Legionaries and Engineers

The frieze on the victory column, which survives almost intact, is a spiral over 650 feet (198 m) long that winds around the column 23 times. It should be read as a pictorial chronicle in which the history of the battles and victories in Dacia (the lower Danube Basin) are gradually unfurled. The military events are shown against a flat relief background. Sometimes there is a suggestion of a town with walls, houses, or bridges, elsewhere a few details of the landscape are shown. Occasionally, military events and the background are combined, as for example in a scene showing Roman soldiers filing to cross the Danube. The legionaries and their opponents are scarcely more sculptural than the scenery, since nowhere is the relief more than an inch or so (2.5 cm) deep. Rich in details, Trajan's Column provides a wealth of useful information about Roman architecture, engineering, and of course military history.

Memorial and History Book

The effect the reliefs have on the viewer is calculated very precisely. The size of the figures, for example, varies: those at the base are about 35 inches (89 cm) high, while those at the top nearly 50 inches (127 cm). This is to offset optical foreshortening, so that all the main figures look the same size from ground level. The perspective owes less to the notion of far and near than to a desire to single out individual elements, with important scenes and figures being larger than others.

The perpetuation of the memory of Trajan's military successes in the Dacian wars was thus assured by the elaborate relief. But the victory column had another purpose. When Trajan died in AD 117, his ashes were placed in the column, which is hollow. Originally, a bronze statue of the emperor 17 feet (5 m) high crowned the column, but it was lost in the Middle Ages. In 1587, Pope Sixtus V replaced it with the statue of St. Peter that currently graces the top of the column. *ik*

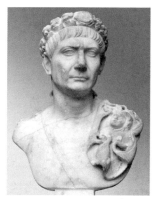

TRAJAN

53 (Trajan) Marcus Ulpius Traianus Crinitus born in Italica (Spain).

97 Becomes Propraetor of Germania Superior during Nerva's reign, and is adopted as a son by the latter on 27 October, thereby becoming co-ruler.

98 Becomes Roman emperor, the first emperor to come from a province and the first "adoptive" emperor.

101–02, 105–06 Subdues Dacia.

113 Trajan's Column is dedicated.

117 Dies in Selinus, Cilicia.

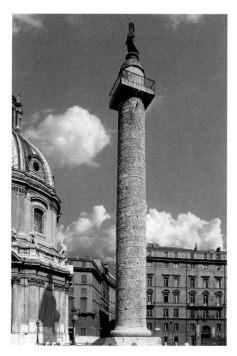

left:
Trajan's Column, AD 113, marble, h. 40 m, Trajan's Forum, Rome

above:
Bust of Trajan, Glyptothek, Munich

150 155 160 165 170 175 180 185 190 195 200 205 210 215 220 225 230 235

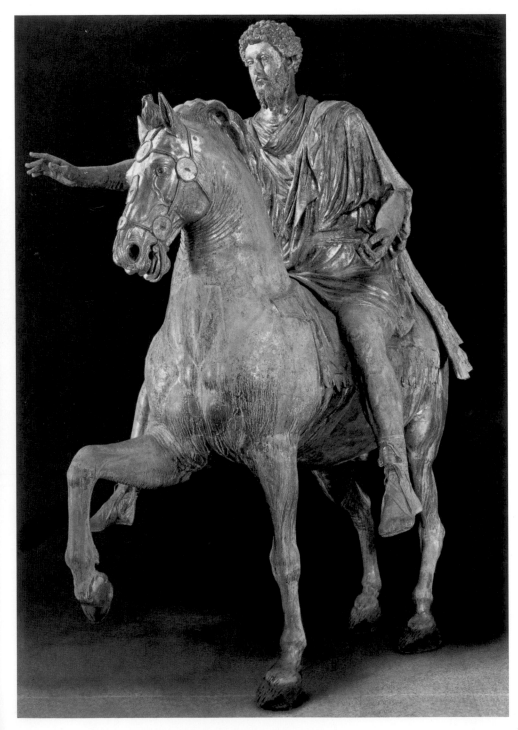

Equestrian Statue of Marcus Aurelius,
AD 161–180, bronze, h. 3.5 m, Palazzo
Nuovo Museum on the Capitoline Hill,
Rome

35 First of the Roman "soldier emperors,"
 Gaius Julius Verus Maximinus

300 Beginning of the
 height of the Maya
 cities such as
 Palenque, Uxmal,
 and Tik'al

313 Christianity recognized
 by Emperor Constantine

| 240 | 245 | 250 | 255 | 260 | 265 | 270 | 275 | 280 | 285 | 290 | 295 | 300 | 305 | 310 | 315 | 320 | 325 |

EQUESTRIAN STATUE OF MARCUS AURELIUS

Probably the most famous equestrian statue from Roman antiquity shows Emperor Marcus Aurelius in a majestic, commanding pose. The statue remained a model for numerous monuments of Western rulers into the modern era.

From antiquity onwards, to be immortalized on horseback has seemed to rulers to be the perfect demonstration of their military and political power. The colossal equestrian statue of Marcus Aurelius, which has a total height of over 14 feet (4.25 m), is considered the oldest surviving work of this kind. It is the only extant Roman monumental bronze, although according to written sources there were more than 20 equestrian statues in the city at the end of the imperial period. Unfortunately, in the Middle Ages they were considered heathen idols and destroyed by Christians. Marcus Aurelius is the exception because he was thought to be the Christian emperor Constantine the Great.

A Statue of Human Kindness and Authority
The figure of Marcus Antonius Aurelius, who went down in history as the "stoic philosopher on the throne of Caesar," radiates benevolence and serene authority, tranquility, and peace. His outstretched right hand has often been interpreted as a gesture of blessing. The dropped left hand once held the reins and some other object, perhaps a scepter or a statuette of Victoria, the goddess of victory, but that has been lost.

Marcus Aurelius is shown with thick, curly hair and a dense beard, such as the post-Hadrian Antonine emperors often wore. Characteristic of portraits of Marcus Aurelius are the drooping eyelids. His clothing always consists of a short tunic with fine drapery folds, and a *paludamentum*, the cloak of a general or soldier. On his feet, he wears the civilian shoes of a senator.

Monument to Victory
He rides a stately charger typical of Roman equestrian statues, and he is depicted as a statesman of great authority. The statue was probably made in the late 170s AD and probably commissioned to celebrate a military victory. At the time, the emperor was campaigning against German tribes in the Danube provinces, and in AD 176 triumphed over the Marcomanni and Sarmatians. A defeated barbarian once crouched beneath the horse's raised right hoof. The equestrian statue was first documented in front of St. John Lateran basilica in Rome in the 10th century. It was not until the 15th century that a Vatican scholar discovered that it portrayed Marcus Aurelius. The statue was by then highly regarded, as people now admired the art of antiquity, but nevertheless in 1538, at the request of Pope Paul III, it was banished to the "secular" piazza on the Capitoline Hill that Michelangelo was then redesigning. The plinth for the horse and rider was also designed by Michelangelo. It bears the arms of the Farnese family (Paul III was a Farnese) and an encomium to Marcus Aurelius.

The statue was damaged during a bomb attack on the City Hall in 1979, and subsequently extensively repaired. Since 1990, it has been in the Palazzo Nuovo Museum on the Capitoline Hill. The figure out in the square in front is a bronze copy. cw

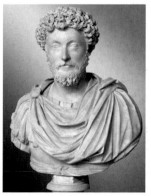

MARCUS AURELIUS
121 Born Marcus Annius Catilius
 Severus in Rome.
138 Adopted by his uncle
 Antoninus Pius as Marcus
 Aelius Aurelius Verus.
145 Marries his cousin Faustina,
 daughter of Antoninus, and takes
 over some public roles.
161 Becomes emperor.
174 Begins his *Meditations* while
 on campaign.
180 Dies in Vindobona (Vienna).
180–193 The Marcus Aurelius Column
 in the Piazza Colonna in Rome is
 constructed, on the model of
 Trajan's Column.

"Let none of your actions be unconsidered, let none happen except in accordance with the rules of perfect living." Marcus Aurelius, *Meditations*

Bust of Marcus Aurelius, Glyptothek, Munich

781–783 Godescalc Gospel, from the scriptorium at Aix-la-Chapelle

767–774 Monastic gateway, Lorsch

c. 810 Lorsch Codex from Charlemagne's scriptorium at Aix-la-Chapelle has ivory cover

c. 800 Palatine chapel, Aix-la-Chapelle

c. 800 Book of Kells

c. 820 Monastic plan of St. Gallen (first surviving architectural drawing in Europe)

745 750 755 760 765 770 775 780 785 790 795 800 805 810 815 820 825 830

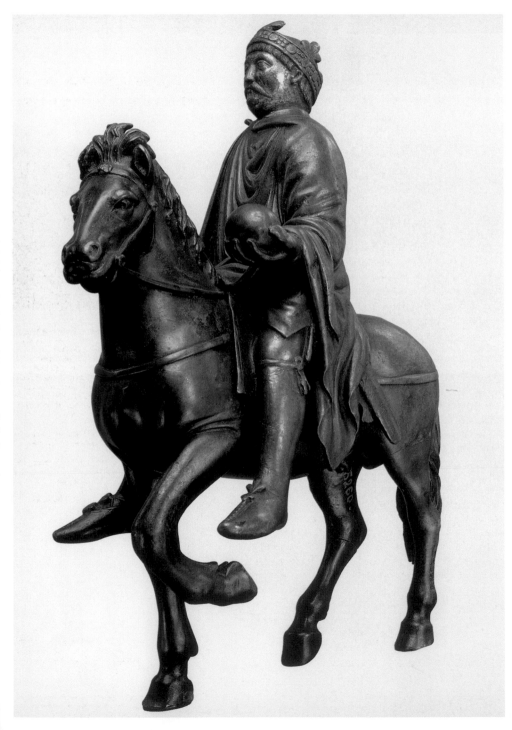

Equestrian Statuette of Charlemagne,
8th or 9th century AD, bronze, height
of rider: 19.5 cm, height of horse: 21 cm,
Musée du Louvre, Paris

LOUIS THE PIOUS (EMPEROR)

OTTO I, FIRST GERMAN EMPEROR
(HOLY ROMAN EMPIRE)

c. 830 Utrecht Psalter, Rheims

c. 875 Gardar Svavarsson discovers Iceland

873–885 Westwork of Corvey Abbey

894 Magyars invade German regions

835 840 845 850 855 860 865 870 875 880 885 890 895 900 905 910 915 920

EQUESTRIAN STATUETTE OF CHARLEMAGNE

Under 10 inches (25 cm) high, the little equestrian statuette that meets the visitor's eye in a display case near the entrance of the medieval crafts section of the Louvre looks downright modest. And yet this is possibly the portrayal of one of the most important Western rulers in history.

King of the Franks from 768 and Emperor from 800, Charlemagne is seen as a cultural reformer. After the fall of the Western Roman Empire and the dark centuries of the so-called Migration Period, Charlemagne was the one who restored the classical legacy and revived written culture, art, and architecture. Borrowing the term used of Italy from the 14th century onwards, the revival of art under Charlemagne and his successors is often called the Carolingian Renaissance today. Masterpieces of manuscript illumination, ivory carving, and gold work have survived, and bronze casting flourished. The results were monumental works such as the doors of the palace chapel in Aix-la-Chapelle and diminutive but no less impressive pieces such as the equestrian statuette in the Louvre.

Material Analysis

The figure comes from the treasury of the cathedral in Metz, a principal Carolingian seat. From the early 16th century, two equestrian statuettes are mentioned in the inventory of the cathedral treasury. One of the two—stated to be made of bronze—was integrated into the liturgy for the annual mass said on the day of Charlemagne's death. And yet French archeologist and art historian Alexandre Lenoir, who bought the statuette in a Metz bookshop in the early 19th century, was anything but certain as to whether the rider should actually be regarded as a portrait of Charlemagne. And when the work reached the Louvre collection in 1934, a number of inconsistencies came to light during restoration. The figure can be taken apart into three pieces: the horse, the body of the rider, and the head of the rider. Material analysis showed different bronze compositions in the three parts. Also, the way the rider sits on the body of the horse is not a perfect fit at all points, and, last but not least, on the back of the horse, covered by the saddle, there were two circular holes which were not there to attach the rider, indicating that originally a different figure sat on the horse.

Given this, it was hypothesized that the horse was made considerably earlier and possibly dates back to ancient Rome. A stylistic comparison with ancient depictions of horses does not rule this out.

Charlemagne or Charles the Bald?

Even if the dating of the horse is uncertain, experts are pretty sure that at least the equestrian figure was produced by a Carolingian master. However, they are not agreed as to who the rider is. Though it resembles other contemporary portraits of Charlemagne, it is equally similar to portraits of Charlemagne's grandson Charles the Bald, who was consecrated King of Lorraine in Metz and so had a closer affinity with the work's presumed place of origin.

Regardless of whether it is Charlemagne or Charles the Bald, just as important as the question of identity is that of what the statuette is intended to show. Equestrian statues are unusual in Carolingian depictions: generally the ruler is shown on his throne. Obviously a clear reference was intended here to one of the most famous equestrian images of antiquity—Marcus Aurelius (see pages 32–33). In the Middle Ages, the figure of Marcus Aurelius was still misinterpreted as a representation of Constantine the Great, who was credited with setting Christianity on its triumphal course. As a warrior for the true faith under Charlemagne and his successors, Constantine was viewed as a radiant guiding figure, someone to be compared with. That would make the little equestrian statuette more than just a portrait of a ruler—it would be a depiction the "new Constantine" and therefore the ideal image of a Carolingian ruler. cs

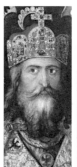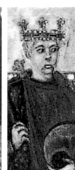

CHARLEMAGNE
c. 742 Born the son of Frankish king Pippin the Short, probably near modern Liège, Belgium.
768 Becomes king of the Franks.
LATE 8TH CENTURY The Palatine Chapel in Aix-la-Chapelle is built.
800 Crowned *imperator augustus* by the pope (Frankish Empire).
814 Dies in Aix-la-Chapelle (Aachen).

CHARLES THE BALD
823 Born in Frankfurt, the son of Charlemagne's son Louis the Pious.
843 Becomes king of the West Franks (modern France).
875 Collects imperial insignia from the pope, as emperor.
877 Dies in Avrieux near Modane, France.

above left:
Albrecht Dürer, *Charlemagne, Charles the Great*, detail, oil on wood, 188 x 87.6 cm, Germanisches Nationalmuseum, Nuremberg

above right:
Charles the Bad from the Charles the Bad Psalter, c. 842–69, Bibliothèque nationale de France, Paris

820–867 Nicholas I (pope)

824–859 Pala d'Oro Sant'Ambrogio, Milan

910 Cluny Abbey founded

928 Córdoba becomes
a caliphate

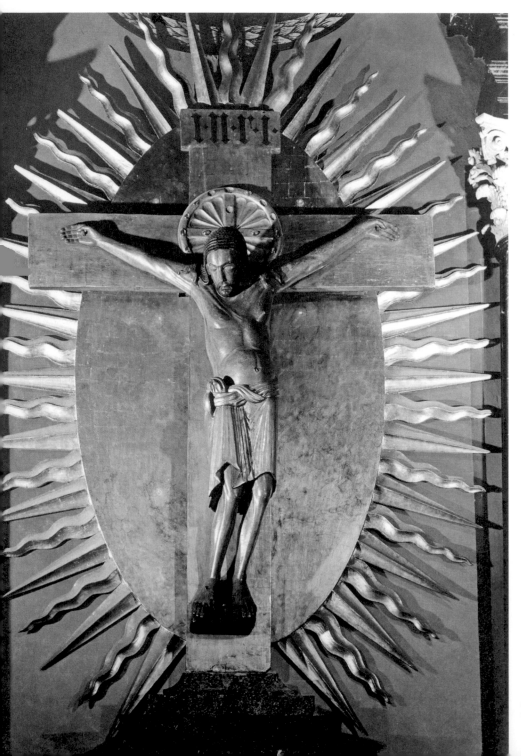

Gero Crucifixion, 969–76, oak, h. 187 cm,
treasury of the high cathedral in Cologne

984–C. 1000 St. Pantaleon, Cologne

1001–1015 St. Michael, Hildesheim

6 Caliphs of Baghdad ousted

LATE 10TH CENTURY Frescoes with miracles of Christ, St. Georg, Reichenau

LATE 10TH CENTURY Otto III's gospels, Reichenau

C. 1020 Bernward Column, Hildesheim

```
940   945   950   955   960   965   970   975   980   985   990   995   1000  1005  1010  1015  1020  1025
```

GERO CRUCIFIXION

The face of death. The thousand-year-old Gero Crucifixion, which is among the earliest monumental figures of the Middle Ages, represents the start of a new chapter in art history. The crucified Christ no longer appears as a triumphal victor over suffering but as a ravaged human being who has been horribly put to death.

Crucifixions were very popular in the ancient world. This method of execution seems to have been "invented" by the Phoenicians, a nation of merchants and seafarers from the eastern Mediterranean. It was soon adopted by Egyptians, Assyrians, Babylonians, Jews, Carthaginians, Persians, and Seleucids as well. Being considered a "dishonorable" form of capital punishment, crucifixion was reserved mainly for agitators and members of socially disadvantaged classes. Its best-known victim was Jesus Christ. If we accept biblical tradition, he was crucified between AD 26 and 29, on a Friday morning at the beginning of April.

A Cruel Form of Execution

Although thousands and thousands of people were put to death in this way, it took a long time before people really understood what happens to the body during a crucifixion. Forensic medical scientists now have a clearer idea. The preceding flogging always caused an immense loss of blood. The victim then had to drag the crosspiece of the cross, which was very heavy, and by the time he reached the place of execution, he was already at the end of his tether. But it was then that the worst of the torture began. When the nails were hammered in, nerve cords were damaged. While hanging on the cross, a major part of body weight wrenched the outstretched arms, and after a few minutes caused severe muscle cramping and searing pains. Then there were symptoms of paralysis in the chest muscles. It was now possible to breathe air in but not out. A death certificate of a crucified victim would presumably say "heart and respiration failure, caused by severe blood loss and trauma."

Gero and the Turin Shroud

However, early representations of the crucified Christ did not show the unspeakable torture. For centuries, the martyred Son of God was shown in an upright position on the cross, dignified and largely uninjured, often even as a heroic, radiant victor over death—and always with open eyes.

That was the tradition with which the *Gero Crucifixion*, one of the most precious treasures of the high cathedral in Cologne, broke. For the first time, the crucified man is shown as dying—with pain-distorted features, sunken chin, crushed chest, protruding tendons, knees to one side, and eyes closed. The astounding realism of the life-size sculpture, which was commissioned by an archbishop of Cologne called Gero, triggered speculation. Did the unknown artist use a parchment copy of the Turin Shroud as a model? That shows the impression of a crucified victim, and is supposed to be the linen that Christ was wrapped in after the Deposition. It is indeed true that the Turin Shroud and the *Gero Crucifixion* manifested numerous similarities, from the almost identical size of the crucified body to an anomaly on the right ear. On the other hand, the Turin Shroud is probably an artifact of the legend-obsessed High Middle Ages, whereas the *Gero Crucifixion* dates from shortly before the first millennium. *kr*

c. 900 Gero born in Thuringia, Germany, the son of the Margrave of Lausitz.
969 Becomes Archbishop of Cologne.
971 During a visit to Constantinople, he possibly sees a shroud venerated as a relic of Christ (which could have been the Turin Shroud).
976 Dies in Cologne 28 June and is interred in the old cathedral.
c. 1000 Chronicler Thietmar of Merseburg reports that Gero "repaired" a crack in the head of the Christ figure of the *Gero Crucifixion* in a miraculous fashion by inserting the host.
1248 After the foundation stone for the new cathedral of Cologne is laid, the *Gero Crucifixion* survives a fire in the old cathedral unharmed.
1683 Canon Heinrich Friedrich von Mering endows a golden sunburst for the *Gero Crucifixion* and a Baroque altar on the Roman model as a frame. The *Gero Crucifixion* still retains these additions.
1880 The construction of Cologne Cathedral is completed after 600 years.

c. 970 Gero Crucifixion

| 925 | 930 | 935 | 940 | 945 | 950 | 955 | 960 | 965 | 970 | 975 | 980 | 985 | 990 | 995 | 1000 | 1005 | 1010 |

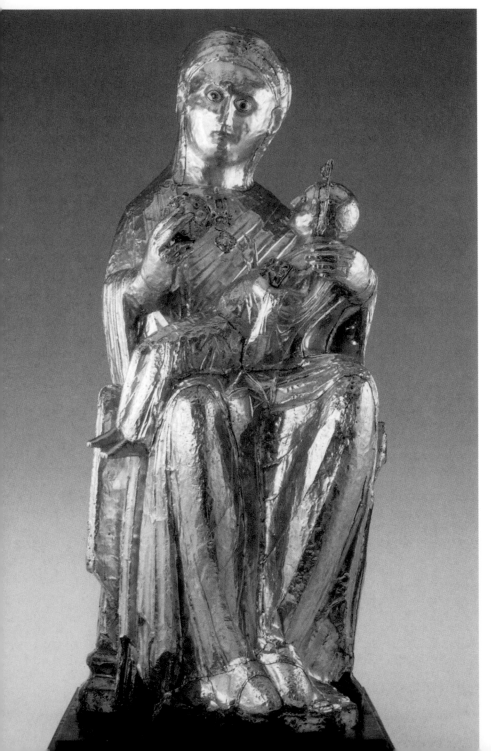

*The Golden Madonna, c. 1000, wood and gold foil,
h. 74 cm, treasury of the Essen Minster*

C. 1015 Bronze doors of Bishop Bernward, Hildesheim

1031 Beginning of the Reconquista (reconquest of Spain from the Arabs)

1066 Norman conquest of England begins

1093 Work begins on Durham Cathedral

BEFORE 1022 *Bernward Crucifix*, Hildesheim

1040/50 Work begins on St. Maria im Kapitol, Cologne

1060 Work begins on the Baptistery, Florence

1099 First Crusade recaptures Jerusalem

1015 1020 1025 1030 1035 1040 1045 1050 1055 1060 1065 1070 1075 1080 1085 1090 1095 1100

THE GOLDEN MADONNA

The Virgin in a golden mantle. Dating from around 980, The Golden Madonna is the oldest surviving fully sculptural image of the Madonna anywhere. The Virgin is now the patron saint of Essen in Germany.

Summer 1925: passengers in a fourth-class compartment of a German train were amazed at the number of cardboard boxes and shabby suitcases that two men were heaving on to the train. No one suspected what the two men were really lugging around—the treasure from Essen Minster. It had been removed from the minster five years earlier because people were afraid of a communist revolution, with riots and attacks on churches. But now the danger seemed to be over. And the precious objects, including *The Golden Madonna*, could at last go back home. It was not her first escapade. The venerable figure of the Virgin spent the worst years of the Thirty Years' War in strongly defended Cologne. She was hidden again in the 1790s, this time in an orphanage, from passing French revolutionary troops. And she only escaped air raids in the Second World War by being hidden successively in a closed mine, the casemates of a bishop's castle, and an airraid shelter.

Supernatural Glow

We don't know who made it. At any rate, he seems to have been more familiar with reliefs than freestanding figures. The front, side, and rear views are all independent, and don't add up to a rounded whole. Comment on the 29-inch (73.6-cm) figure in 1904 was correspondingly harsh, claiming that it did not satisfy the "aesthetic requirements of our time," and displayed "disproportions in individual body parts" and "unpleasant ... rigidities in the posture and the folds of the gown"—quite apart from the "ugly way the belly of the child sticks out." Nonetheless, the figure—which is made of poplar covered with 116 foils of gold leaf—has always attracted not only admiration but also respect and veneration. For example, during her exile in Cologne, she is supposed to have outshone all the other church treasures with her "supernatural glow."

Byzantine Influences and the Windows to the Soul

In the 10th century, Essen Minster (since the 1950s, the bishop's seat of the newly founded diocese of Essen) was the church of a noble lay sisterhood. It was run by Abbess Mathilde, a granddaughter of Emperor Otto the Great. The foundation flourished under her aegis. With her keen interest in art and a considerable legacy from her grandmother, the first wife of Otto the Great, Mathilde steadily collected precious objects for the foundation's treasury. *The Golden Madonna*—represented as the Queen of Heaven holding an orb in her hand—was carried through the city in the great processions at Candlemas and the Monday before Ascension Day. On her head is the still surviving child's crown supposedly placed on the head of Otto III (a cousin of Mathilde) when he was three years old and a cousin of Mathilde, he was elected German king in 983. *The Golden Madonna* may ultimately even have been endowed by Theophanou, the mother of Otto III, who came from Constantinople, because the figure of the Virgin displays Byzantine influences. These include the colored enameled eyes, the "windows to the soul," which reflect the inward spiritual life but reputedly also send out power with her hypnotic gaze. The religious importance of the sculpture was underlined again in the 20th century. Pope John XXIII named the Virgin in the shape of *The Golden Madonna* as the patron saint of the diocese of Essen. However, "Essen's treasure," as the figure of the Virgin is popularly called, is not allowed to travel any more. The restorers have allocated her an airconditioned high-security showcase on the northern side chapel of Essen Minster as a place of retirement. *kr*

845 Bishop Altfrid of Hildesheim founds a lay sisterhood on the Hellweg in North Rhine Westphalia, which later becomes the nucleus of the city of Essen.

973 Mathilde becomes abbess of the foundation. She builds up a notable collection of outstanding works of art for the treasury. She dies 5 November 1011.

993 Otto III visits the foundation at the beginning of the year. Possibly on this occasion, he bequeaths it his legendary child's crown.

1275 Essen Minster is reconstructed as a Gothic hall church.

1370 The "golden image of our Lady" or "ymago aurea beatæ Mariæ Virgine" is mentioned in a history of the city, the Essen *Liber Ordinarius*. This refers to what became known in the 19th century as the Golden Madonna.

1952 The tomb of Abbess Mathilde is discovered in the Minster.

1957 On 23 February, Pope Pius XII set up diocese of Essen. Essen Minster subsequently becomes the bishop's seat and cathedral.

1959 Pope John XXIII designates the Virgin Mary, venerated in the image of the Golden Madonna, as the patron saint of the newly founded diocese of the Ruhr.

976 Work starts on San Marco, Venice

969–976 *Gero Crucifixion*

910 915 920 925 930 935 940 945 950 955 960 965 970 975 980 985 990 995

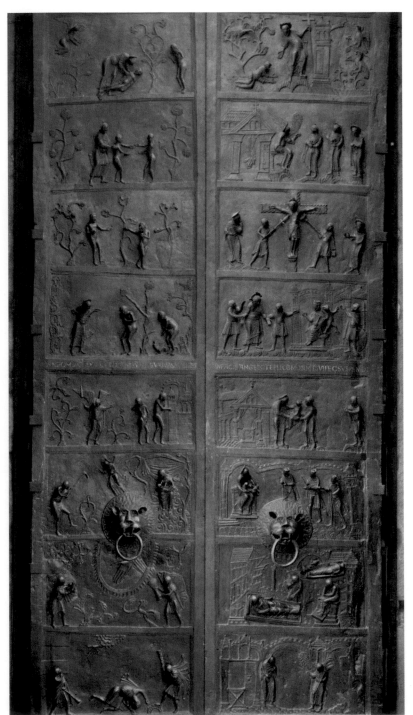

St. Bernward Doors, c. 1015, bronze, h. 472 cm, St. Mary's Cathedral, Hildesheim

Casting Bronze

Monumental works such as the bronze doors in Hildesheim Cathedral constituted a huge technical challenge. To cast bronze, the "lost-wax process" was used in the Middle Ages. In this, a wax model is enclosed in a mould of clay. During the firing process, the wax melts and flows out through escape holes. The next step is to pour molten bronze into the cavity thus produced, via cast-iron pipes. Once this cools down, the clay mould is destroyed. Neither it nor the wax model survives, which is why the technique is also called the "lost mold process."

CANUTE, KING OF ENGLAND, NORWAY, DENMARK, AND SCOTLAND

HENRY III (GERMAN EMPEROR)

c. 1000 Otto III's gospel, Reichenau school

1001–1015 St. Michael, Hildesheim

1030 Work starts on Speyer Cathedral

1036 The restored Cathedral of Mainz dedicated

BEFORE 1065 Wooden reliefs on the doors of St. Maria im Kapitol, Cologne

1066 Norman invasion of England begins

1073 Bayeux tapestry

LATE 11TH CENTURY Founding of the Cistercian order

1095–1099 First Crusade

| 1000 | 1005 | 1010 | 1015 | 1020 | 1025 | 1030 | 1035 | 1040 | 1045 | 1050 | 1055 | 1060 | 1065 | 1070 | 1075 | 1080 | 1085 |

ST. BERNWARD DOORS

Here, depicted with simple drama, Paradise is lost. God the Father points accusingly at the mortified Adam and the significance of his gesture is evident at a glance: the First Man is guilty of sin!

The biblical story of the Fall and the consequent expulsion of Adam and Eve from Paradise is a subject that has been frequently depicted in art. The bronze relief on the door of Hildesheim Cathedral shows the situation very clearly. God knows Adam has disregarded his injunction. Adam visibly crumples, aware of his guilt, and covers his genitals with a fig leaf. But for all his humility, he can't help trying to pass on the blame. It is a small but unmistakable gesture: with his right hand, which passes under his left arm, he points at Eve standing behind him. It was her fault! But Eve too tries to absolve herself of guilt, and points to the dragon-like serpent at her feet.

The Expulsion and its Consequences

We already know the end of the story—Adam and Eve have to leave Paradise. This scene is also depicted with great clarity and simplicity on the left door. The figures and their body language were what mattered to the artist, who stuck closely to the biblical narrative. The Creation of Man, the Forbidden Fruit of the Tree of Knowledge, the Expulsion—all these stories from the Old Testament can be "read" with ease even today by those entering the cathedral.

The right door continues the story with eight scenes from the New Testament, this time in reverse order, from bottom to top. The sequence begins with the Annunciation. Further scenes from the life of Christ take us up from the Nativity to the final scene, the Resurrection. The message is clear, since the Old and New Testament scenes are side by side: Christ died to redeem Man from sin—and the beginning of all sin was to be found in Adam and Eve.

Bravura Piece from a Single Cast

Not only the narrative scheme is memorable on the doors—the dimensions are impressive, too. Each door is nearly 15 feet 6 inches (4.7 m) high and 3 feet 3 inches (1 m) wide. Though there were antecedents

in Italy at the time, the Hildesheim doors were one of the first major series of reliefs since antiquity. Moreover, the doors are "of a piece," each door being cast in a single piece of bronze—the scenes and the frames around them. So who carried out this masterly piece of craftwork? Presumably a whole workshop was involved in modeling the reliefs and subsequently casting them in bronze, but little is known of the craftsmen concerned. Nonetheless, an inscription on the center transom enables us to date the work precisely. The commission for the bronze doors was awarded in 1015 by Bishop Bernward of Hildesheim, after whom the doors were named. *ik*

BERNWARD, BISHOP OF HILDESHEIM

c. 960 Saxon nobleman Bernward's place of birth is unknown. He becomes tutor to (later) German emperor Otto III and later chancellor.

993 Appointed Bishop of Hildesheim. The city becomes an important center of art. Inscriptions on some works of Ottonian art mention Bernward as client.

1007 TO AFTER 1022 Initiator and probably also architect of St. Michael's church.

c. 1015 *Bernward's Column*, a Paschal candlestick in bronze, is made, inspired by the columns of Trajan and Marcus Aurelius in Rome.

1022 Dies.

1193 Canonized.

St. Bernward Doors, head of a lion from the right door

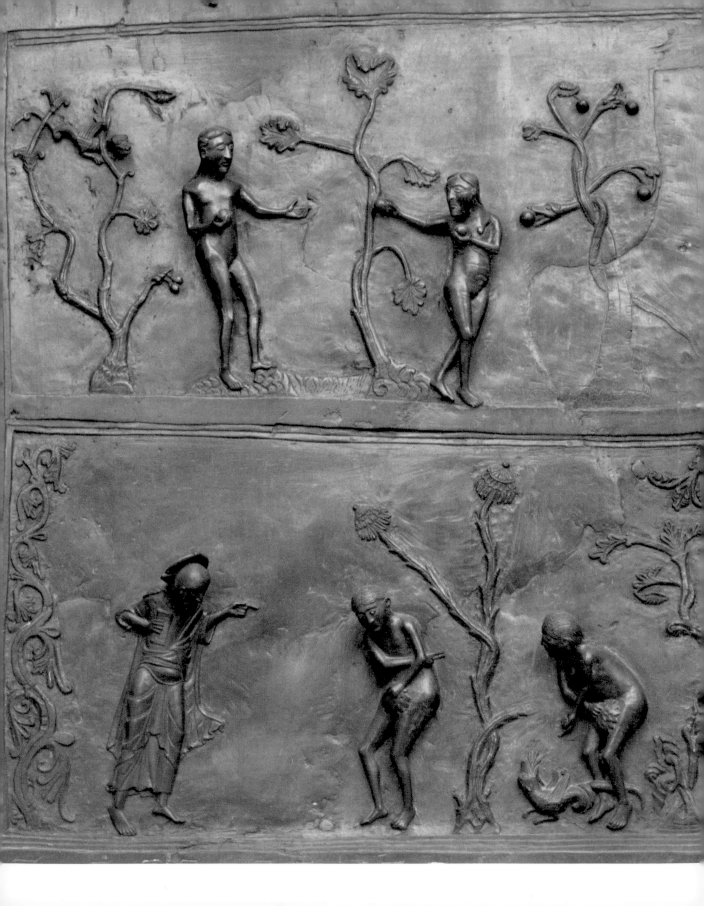

left page:
St. Bernward Doors, left door: the Fall
and the consequent Expulsion

below:
St. Bernward Doors, detail: Pontius
Pilate with a figure of a devil

1050 First documented mention
of Nuremberg

1063 Work starts on San Marco, Venice

1099 Jerusalem recaptured
by the Crusaders

1110 Song China is a progressive
and flourishing state

c. 1130 Doorway sculp-
tures of Autun
Cathedral

1050	1055	1060	1065	1070	1075	1080	1085	1090	1095	1100	1105	1110	1115	1120	1125	1130	1135

Rainer of Huy, Font, 1107–18, bronze,
h. 60cm, St. Barthélemy, Liège, Belgium

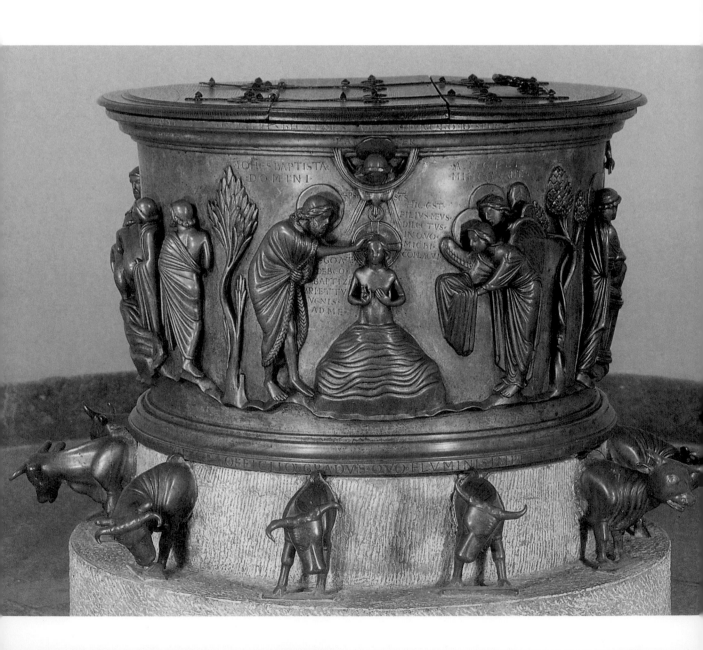

1225–1235 Statues on south door-
way of Strasbourg Minster (e.g.
Ecclesia and Synagogue)

37 Work begins on the choir of St. Denis
near Paris (first Early Gothic)

1166 Monument to Henry
the Lion, Brunswick

1181 Dedication of Nicolas of Verdun's
Klosterneuburg altarpiece

C. 1230 Equestrian
statue, Bamberg

1140 1145 1150 1155 1160 1165 1170 1175 1180 1185 1190 1195 1200 1205 1210 1215 1220 1225

RAINER OF HUY

FONT

The celebrated font in Liège, Belgium, had admirers even at the beginning of the 12th century. To quote one of them, an "almost incomparable cunning [skill]" had gone into the making of it.

Even today, the font has lost nothing of its singularity. Quite the contrary: thanks to its outstanding artistic and technical quality it is considered the acme of Romanesque metalwork. It was made by goldsmith Rainer (or Reiner) of Huy around 1113. We know not only the name of the artist but also the client: it was commissioned by the Abbot of Notre Dame aux Fonts in Liège. It survived the destruction of the church by French revolutionaries, and since 1804 has been at the church of St. Barthélemy.

Stories All Round
Some 26 inches (66 cm) high, the font is encircled top and bottom by a projecting molding. On the smooth walls in between are five scenes linked by a continuous undulating ground level and separated by trees. Thematically, the various scenes revolve around the subject of baptism, with Latin inscriptions providing additional explanations. One scene depicts the baptism of Christ in the River Jordan. Christ is shown in frontal view up to his waist in the Jordan, while over him hover God the Father and the dove of the Holy Spirit. On one side stands John the Baptist clutching his gown at chest height with his left hand while reaching out with the other hand to baptize Christ. On the other side, two angels await the baptized Christ, the one in front holding out a cloth. The figures here and in the other scenes are almost in the round, though still fully attached to the background. The individual figures are distinctive in their postures, physiognomy, and hair styling, and in the different treatment of their clothes.

Biblical Source
The base area of the cylindrical font is formed by ten oxen arranged in four groups. Originally there were twelve oxen, and they provided a link with the account in the Old Testament, which is the basis of the iconographical program. Kings 1:7 gives a precise description of a round basin that King Solomon ordered for his temple in Jerusalem, and in his bronze font, Rainer follows in detail this description of a "sea of cast metal … on twelve oxen." ik

7TH CENTURY Liège founded, later
the seat of a bishopric.
EARLY 11TH CENTURY The construc-
tion of St. Barthélemy's church
starts, one of the principal build-
ings of Mosian Romanesque.
1125 Rainer of Huy mentioned in
episcopal documents as *Reinerus
aurifaber* (Rainer the goldsmith).
C. 1150 Rainer of Huy dies.

1144–1146 Starvation in Europe

C. 1145 West front sculptures, 1163 Work starts on 1181 Works starts on the Imperial 1198 Teutonic Knights founded 1225–1245 West front
 Chartres Cathedral Notre-Dame, Paris Cathedral in Worms in Jerusalem sculptures, Rheims
 Cathedral

1150 1155 1160 1165 1170 1175 1180 1185 1190 1195 1200 1205 1210 1215 1220 1225 1230 1235

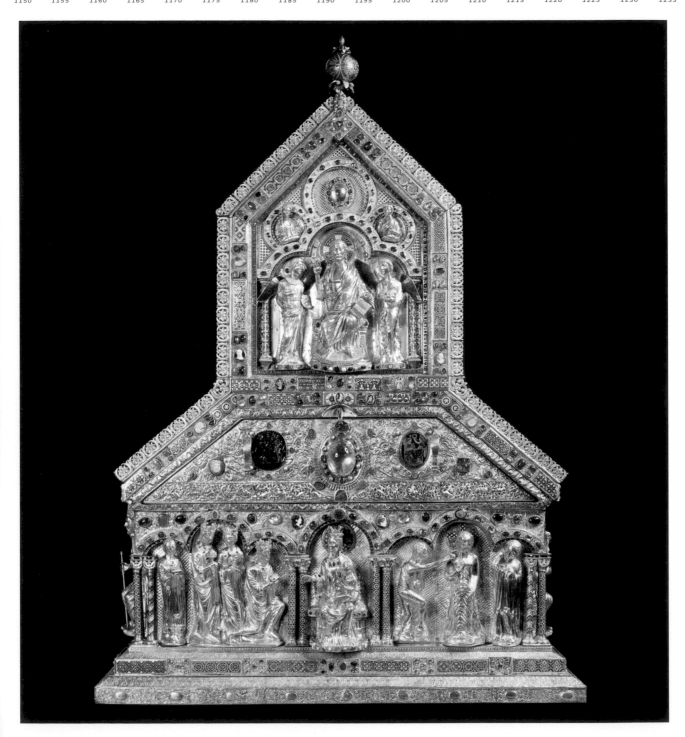

1248 Work starts on Cologne
Cathedral

1268 Amiens Cathedral completed

c. 1267 Giotto di Bondone born

1307 Dante starts work on
the *Divine Comedy*

1240	1245	1250	1255	1260	1265	1270	1275	1280	1285	1290	1295	1300	1305	1310	1315	1320	1325	

NICHOLAS OF VERDUN

SHRINE OF THE THREE KINGS

On 23 July 1164, hardly anyone would have been indoors in Cologne. It was a day to celebrate—the relics of the Three Kings (also known as the Magi, or Wise Men) were arriving in a ceremonial procession.

Their arrival boosted the importance of Cologne as a destination for Christian pilgrims. The city could now boast that even the first kings to have paid homage to Christ could be venerated there. And there were many visitors, as the growing stream of pilgrims proved. And, of course, important relics of that kind needed suitably grand accommodation. The task was undertaken at the end of the 12th century—the result was the largest shrine of the Middle Ages, made in the form of a model basilica with a nave and two aisles. Figures and lavishly adorned panels of gold and silver took shape, with precious stones and enamel glazes adorning all four "walls" of the shrine.

Visitors from the East

The front of the shrine, which is 5 feet (1.55 m) high, is made of pure gold and decorated with numerous precious stones. In the lower area (left) we see the three kings from the East. They have come bearing gifts for the Christ Child, who sits with his mother in the center arch. King Otto IV paid for the precious material for the front of the reliquary, and ensured

Pilgrimages

The cult of relics was of great importance in mediaeval society, especially from the 11th century. Pilgrimages went hand in hand with a belief in the miraculous powers of the mortal remains of saints. Pilgrims traveled to holy places where important relics were kept in order to obtain forgiveness of sins, to have wishes granted, or to find cures for illnesses. The three most important destinations were the Church of the Holy Sepulcher in Jerusalem, the tomb of the Apostle St. Peter in Rome, and the tomb of the Apostle St. James the Greater in Santiago de Compostela in Spain. In the Middle Ages, Cologne was likewise an important destination for pilgrims, its wealth of relics reaping it the title of Sancta Colonia (Holy Cologne).

that he himself was represented—he is the fourth king on the left of the group. With its depiction of the kings, this scene refers to the relics that the shrine contains. The relics could also be seen—the decorated panel above the figures could be removed, and through a grill pilgrims could gaze at the supposed skulls of the Three Kings. Above is another Christ in Majesty, this time accompanied by angels.

No Two the Same

On the sides, which are 7 feet 2 inches (2.20 m) long, there are the 12 prophets of the Old Testament, and above them in a second row the 12 apostles of the New Testament, in each case with an additional king or angel figure. Each of the relief figures is treated differently: whereas some are presented frontally to the viewer, others are in profile or lean slightly forward and appear to be conversing with the next figure to the right or left. In addition, the

NICHOLAS OF VERDUN
c. 1130 Born in Verdun, Lorraine
(now France).
1180s *Shrine of St. Anno* for
St. Michael's Abbey, Siegburg.
The work is attributed to the
workshop of Nicholas of Verdun.
1181 First signed and dated work:
enamel decorative work in the
chancel of Klosterneuburg Abbey,
Austria.
c. 1190 Work starts on the *Shrine of
the Three Kings*.
1205 Shrine of the Virgin at the
Cathedral of Tournai, the second
and last dated work by Nicholas.

left page:
Nicholas of Verdun, *Shrine of the Three Kings*, front view, c. 1181–1230, gold, silver, enamel and precious stones on a wooden base, 153 x 110 x 220 cm, Cologne Cathedral

above:
Nicholas of Verdun, *Shrine of the Three Kings*, detail of the side: the Prophet Jonah

expressive heads of the figures are true to life and show individual traits and expressions.

This most important reliquary of the Middle Ages was designed by Nicholas of Verdun. His workshop and later goldsmiths worked on it from about 1190 to 1220. Meantime, the number of pilgrims to Cologne continued to grow; so much so, in fact, that another project was begun as soon as the Shrine of the Three Kings was finished—about 1248, work began on the construction of the Gothic cathedral of Cologne. *ik*

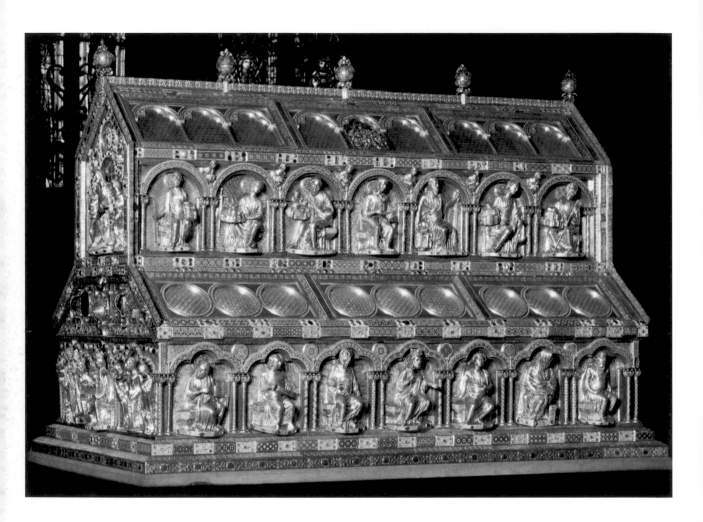

above:
Nicholas of Verdun, *Shrine of the Three Kings*, side view

right page:
Nicholas of Verdun, *Shrine of the Three Kings*, detail: two of the Three Kings, front side

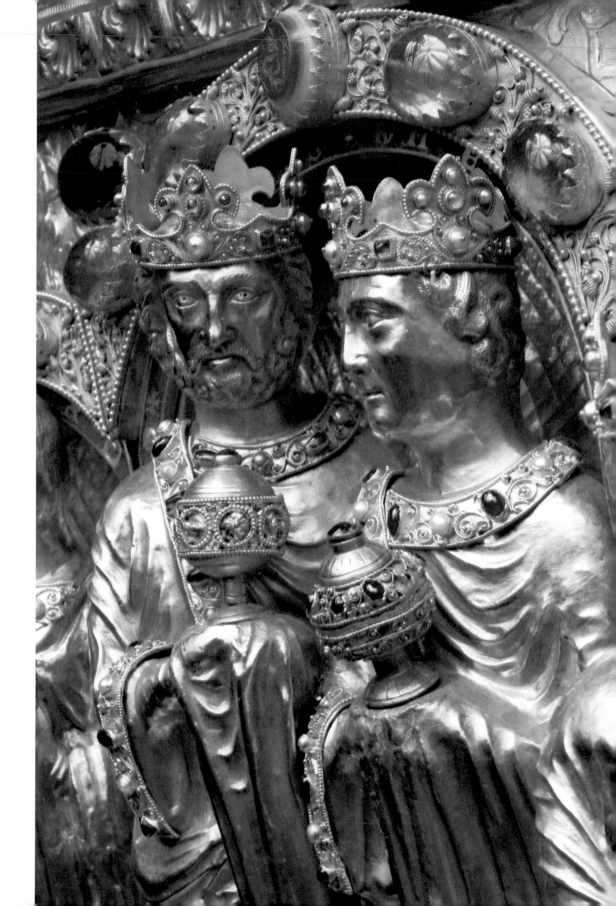

PIERRE DE MONTREUIL, ARCHITECT OF HIGH GOTHIC

GIOVANNI PISANO

c. 1200 Sculptor Benedetto Antelami works on the cathedral and baptistery in Parma

1210 St. Francis of Assisi founds the Franciscan order

1225–1335 Statues on south doorway of Strasbourg Minster (e.g. *Ecclesia* and *Synagogue*)

1225–1245 West front sculptures of Rheims Cathedral

1248 Work begins on the Cathedral of St. Peter and Maria, Cologne

1245 Work begins on the rebuilding of Westminster Abbey in the Gothic style

1260 Niccolò Pisano, pulpit, Baptistery, Pisa

| 1200 | 1205 | 1210 | 1215 | 1220 | 1225 | 1230 | 1235 | 1240 | 1245 | 1250 | 1255 | 1260 | 1265 | 1270 | 1275 | 1280 | 1285 |

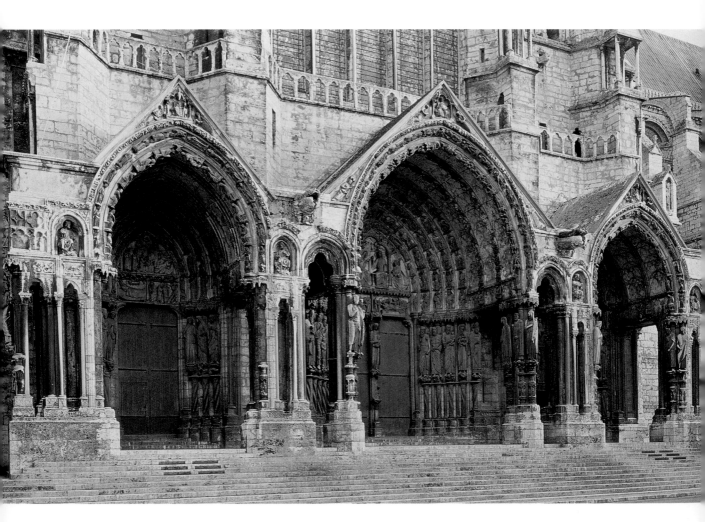

North portal, from 1204/05, Notre-Dame
Cathedral, Chartres

| 1290 | 1295 | 1300 | 1305 | 1310 | 1315 | 1320 | 1325 | 1330 | 1335 | 1340 | 1345 | 1350 | 1355 | 1360 | 1365 | 1370 | 1375 |

PORTAL FIGURES AT CHARTRES CATHEDRAL

The triumph of Gothic. With its soaring architecture, Chartres became the very image of a Gothic cathedral. Its rich array of decorative figures make it a "book in stone" presenting the cosmos of the Christian faith.

It is an overwhelming sight. In the middle of the sparsely populated limestone plains of Beauce, the grain store of France, a huge church suddenly rears into the sky: the Cathedral of Chartres. "It's the seeming pointlessness of it—that here in an empty countryside such an immense building soars out of a low, indifferent town—that creates an impression of unforgettable grandeur," noted the writer Stefan Zweig. In the high Middle Ages, Chartres, which lies 56 miles (90 km) southwest of Paris, had fewer than 10,000 inhabitants. And yet it was here of all places they erected a miracle of architecture, which the sculptor Auguste Rodin would later praise as the "Acropolis of France."

Streams of Pilgrims

Even in the 9th century, Chartres was one of the most important Marian shrines in western Europe, and it still retains its mediaeval fortifications—walls, gateways, and towers. According to legend, the Mother of God is supposed to have been venerated on the bank of the little River Eure even pre-Christian times, in the form of a *virgo paritura*, a virgin who would bear a child. But the cathedral only became really famous when Charles the Bald, king of the West Franks, gave the cathedral treasury an immensely precious relic—the tunic (*sancta camisa*) of the Virgin. It is not clear whether she was believed to have worn it at the Annunciation, when the Archangel Gabriel announced to her that she would be the mother of God, or at the birth of Jesus. At any rate, according to Christian tradition it came from the Virgin's wardrobe, which is why Chartres was always overrun by streams of pilgrims. The money that they left in Chartres—for accommodation, food and drink, as pious donations or for goods bought at the four annual fairs—made the town rich. But on the night of 10/11 June 1194, the old cathedral suddenly went up in flames. The next morning, it was said, even the thickest walls had cracked, though remarkably the west front and its sculptures had

survived. Chartres had lost its spiritual and economic heart. The sancta camisa was also considered lost, but when it emerged undamaged from the smoking ruins they had a new Marian miracle on their hands.

The Bible in Stone

The miracle caused such a flood of donations to pour in for a new building that the present cathedral, which in the words of the French writer Paul Claudel looks like "a kneeling giant … with its arms raised to the sky," was built within only 26 years.
The greatest treasures of this house of God are the lavish figurative sculptures arranged around the three doorways: Adam and Eve, the Old Testament prophets, the 12 Apostles, the 24 Elders of the Apocalypse, St. Martin and St. Nicholas, the signs of the zodiac, the four seasons, the seven liberal arts, the 14 blessings of the human soul—all these "live here in stone … and no one was capable of counting the wealth of figures at the end," wrote Zweig. There are a huge number of biblical, apocryphal, and allegorical figures, originally painted in bright colors. The biblical scenes represented could be understood even by the illiterate. The north transept portal is dedicated to the Virgin, the patron saint of the city. The Annunciation, the Birth of Jesus, the Adoration of the Kings, and the Assumption—the most important stations in the Virgin's life—are presented to the viewer in a sculptural quality that is unique for the Middle Ages in their magic and their pleasure in detail. *kr*

400 Chartres is a Roman city and seat of a bishop.

876 Charles the Bald, king of the West Franks and Holy Roman Emperor, gives the cathedral treasury the sacred tunic of the Virgin Mary. The silk garment was presumably made in the 1st century AD somewhere in Syria. Thanks to this relic, Chartres becomes one of the most important centers of Marian veneration in Europe.

1194–1220 After the old cathedral is greatly damaged by a fire, a largely new building is constructed in its place. In this form, the cathedral of Chartres becomes a model for numerous other European cathedrals.

1793 A courageous general frustrates the planned demolition of the cathedral by the French revolutionaries. It is even today one of the best preserved mediaeval church buildings, conveying largely the same impression as in the 13th century.

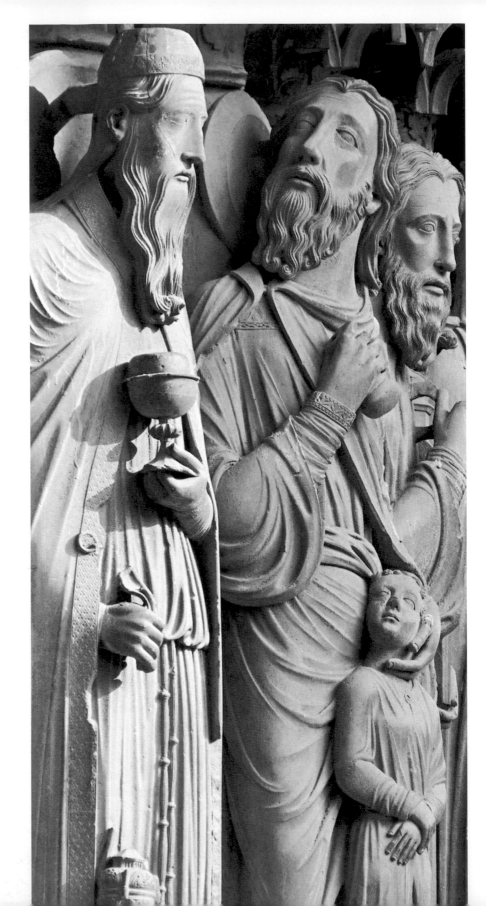

right:
North portal (center), detail:
the Visitation

right page:
North portal (center), left side, detail:
Melchizedek, Abraham, Moses

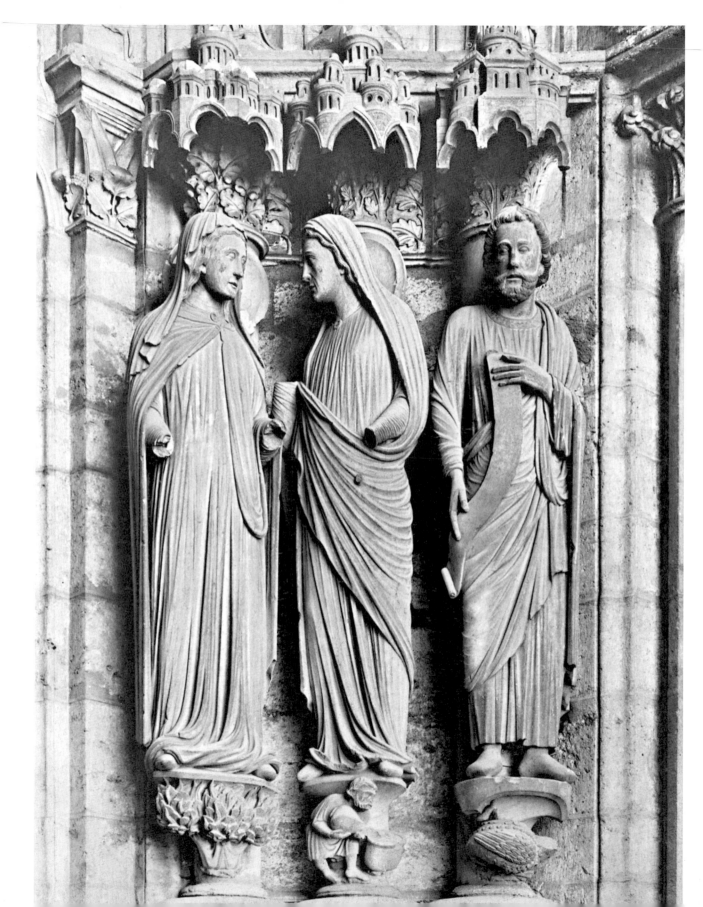

FREDERICK II (GERMAN EMPEROR)

c. 1205 North doorway sculptures, Chartres

1248 Work begins on the Cathedral of
St. Peter and Maria, Cologne

c. 1270–1290 Sculptures in the
narthex of Freiburg Minster

c. 1220 Labors of the Months, Benedetto
Antelami, Baptistery, Parma

c. 1240 Castel del Monte, Andria, Italy

1260 Niccolò Pisano, pulpit,
Baptistery, Pisa

| 1200 | 1205 | 1210 | 1215 | 1220 | 1225 | 1230 | 1235 | 1240 | 1245 | 1250 | 1255 | 1260 | 1265 | 1270 | 1275 | 1280 | 1285 |

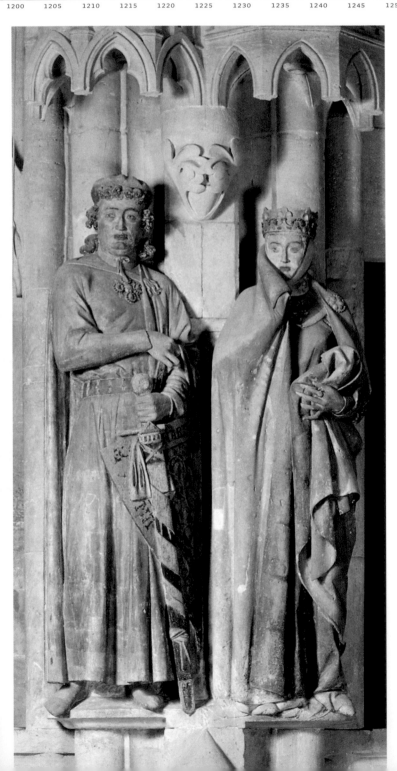

Naumburg Master, benefactor figures
Ekkehard and Uta, c. 1260, sandstone,
Naumburg Cathedral of St. Peter and
St. Paul

1337 The Hundred Years' War between
England and France begins

1344 Work begins on St. Vitus
Cathedral, Prague

1348 Black Death in Europe

C. 1360/70 St. Peter doorway,
Cathedral of St. Peter and
Maria, Cologne

| 1290 | 1295 | 1300 | 1305 | 1310 | 1315 | 1320 | 1325 | 1330 | 1335 | 1340 | 1345 | 1350 | 1355 | 1360 | 1365 | 1370 | 1375 |

NAUMBURG MASTER

EKKEHARD AND UTA

The sculptor who during the 13th century carved the life-sized figures for the choir of Naumburg Cathedral—known as the Naumburg Master for want of a name—is unknown and yet famous worldwide.

In all, he carved 12 stone figures for the Gothic western choir of mediaeval Naumburg Cathedral between 1250 and 1270. The figures represented were the founders of an earlier Romanesque church on the site, perpetuating their names in the Gothic building, which still survives. Thus although we don't know the artist's name, we do have the name of the two founding couples and eight other figures.

Character Chiseled in Stone
In the center, to the side of the high altar and thus in the most prestigious position in the choir, are the two main founders, who are shown together with their wives. In contrast to the other figures, they feature as couples, which further underlines their importance. Alongside Margrave Hermann with his anxious, almost melancholy inclination of the head is his confidently smiling wife Regilindis. But the best-known couple in the church are Margrave Ekkehard and Margravine Uta, the daughter of a family from the Harz. This couple are likewise a contrasting pair. Ekkehard, who has a determined expression, grasps the hilt of his sword with his left hand and the strap of his shield with his right, ready for action. Uta's finely chiseled face meantime registers no emotion. With her left hand she clasps her train, while with her right hand she pulls the collar of her cloak closer to her face, reinforcing the impression of aloofness.

Life-size and Thoroughly Modern
The precise depiction of the characters suggests that these were meant as portraits, even though the people they portray were long dead when the life-size figures were sculpted. This in no way impaired the individual treatment they were given. They have not only distinctive faces and features but also different clothes, and these, like the weapons the men carry, are taken from real 13th-century fashions.

The decorative furnishings and architecture of the western choir form a whole. Each statue has a lavish canopy adorned with small architectural features. Below the plinths on which they stand is further architectural decoration. The sculptures occupy a position about 13 feet (4 m) up in front of a gallery that opens towards the choir. In such a prominent place, statues of saints or biblical figures might have been expected, but far from it. Unusually, indeed uniquely, the Bishop of Naumburg insisted on having 12 secular figures there—though they were of course all nobles. *ik*

C. 1000 Naumburg founded.
AFTER 1028 Construction of the Early Romanesque cathedral begins.
1046 Uta von Ballenstedt and Margrave Ekkehard II of Meissen die.
C. 1170 Cathedral crypt (now the Middle Crypt) built in a rich Late Saxon Romanesque style.
13TH CENTURY The new cruciform basilica with the Gothic west choir is built.
C. 1260 Stained-glass windows in the west choir are some of the most important examples of the zackenstil (jagged style) of the time.

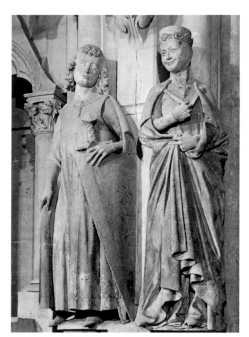

Naumburg Master, benefactor figures *Hermann and Reglindis*, c. 1260, sandstone, Naumburg Cathedral of St. Peter and St. Paul

1200 Aztecs invade Mexican
plateau

1220–1250 Sculptures of main
doorway, San Marco, Venice

1226 St. Francis of Assisi dies

1228–1253 Works starts on the church
of San Francesco, Assisi

1236 Christians recapture Córdoba

1200 1205 1210 1215 1220 1225 1230 1235 1240 1245 1250 1255 1260 1265 1270 1275 1280 1285

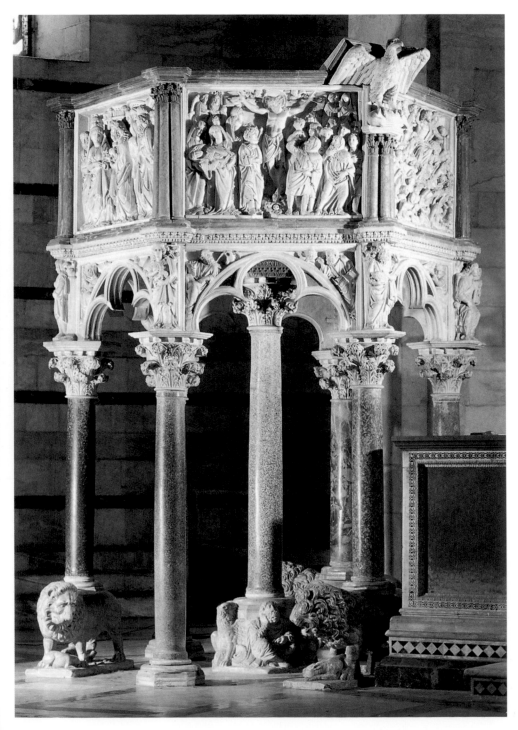

Niccolò Pisano, Pulpit, c. 1260, marble,
h. 465 cm, Baptistery, Pisa

1304–1313 Giotto, frescoes in
the Arena Chapel, Padua

1295 Arnolfo di Cambio begins work
on Florence Cathedral

1308–1311 Duccio, *Maestà*, Siena

1348 Black Death in Europe

1353 Boccaccio, *Decameron*

NICCOLÒ PISANO

PULPIT OF THE BAPTISTERY IN PISA

The 13th-century sculptor Niccolò Pisano proudly recorded the completion of the pulpit in the Baptistery of Pisa Cathedral with an inscription: it was, proudly asserted, an "excellent work."

The inscription also says that the pulpit was completed in 1260. It has a hexagonal ground plan, and stands on one central and six peripheral columns, three of which rest on carved lions. The walls of the pulpit are adorned with five marble reliefs showing scenes from the Life of Christ. Within the architectural framework of the pulpit, the representation of figures is the key element, and there are numerous statues not only in the marble reliefs but also at the angles of the columns and in the spandrels of the arches.

One Panel, Three Scenes
One of the five reliefs decorating the walls of the pulpit shows the Birth of Christ. More precisely, the relief is a sequence of scenes packed together in a single rectangular frame. Top left is the Annunciation, with the Virgin Mary clutching her robe and backing away from the angel who brings her the good tidings that she will bring Christ into the world. In the center of the panel is a much larger figure of Mary, with two maids washing the infant Jesus below her. Bottom right is a herd of goats, part of a third scene this is continued top right, with the Birth of Christ being proclaimed to the shepherds (actually goatherds), as the Christ Child in the crib indicates. Though not much room is available to fit the figures in, there are still lots of fine details, such as the architecture in the Annunciation or the goat raising its head above the herd.

Harbinger of the Renaissance
Pisano's reliefs look as though taken from a careful study of nature. Even the shapes of bodies can be seen beneath the robes. But what looks so naturalistic is in fact based mainly on classical works. In designing his pulpit, the Pisan sculptor was mainly inspired by reliefs on antique sarcophaguses. The robes and heads of his figures show these antecedents so clearly that we can even identify particular sources. In drawing on the art of antiquity, Pisano

Renaissance
Interest in the works of classical antiquity grew throughout the 13th and 14th centuries. Especially in Italy, architecture and written material relating to classical Greece and Rome were studied closely. The culture of antiquity underwent a rebirth (French, *renaissance*), hence the name for the period. In architecture, the grammar of classical antiquity was re-adopted. Sculptors of the Renaissance likewise studied classical antecedents, and made use of features such as classical *contrapposto* (see page 81).

ushered in a new era in sculpture. During the following centuries, works of antiquity would serve as models not only for sculptors—painters and architects, writers and rulers would also take their bearings from antiquity. The achievements of antiquity were reborn in art as the Renaissance. Niccolò Pisano's pulpit in Pisa Cathedral is not only an "excellent work"—it is also a harbinger of Renaissance sculpture. *ik*

NICCOLÒ PISANO
1220–25 Born in Pisa.
1260 Pulpit in the Baptistery in Pisa completed.
1264–67 *Shrine of St. Dominic,* Bologna.
1273 Altar of Pistoia Cathedral (destroyed).
1278 Completes the Fontana Maggiore, Perugia, together with his son Giovanni.
BEFORE 1284 Dies.

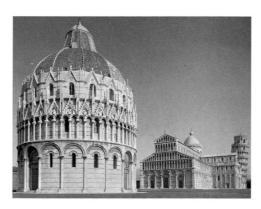

left:
The Baptistery in Pisa, from 1152–c. 1265

above:
Portrait of Niccolò Pisano from Giorgio Vasari's *Lives of the Painters*, first published in 1550

Niccolò Pisano, Pulpit, detail:
The Crucifixion

1340 Work on the Doge's Palace, Venice, begins

1348 Charles University, Prague, founded

1386 Ruprecht-Karl's University, Heidelberg, the third German-speaking university after Vienna and Prague, founded

1419 First Defenestration of Prague	**c. 1450** Hieronymus Bosch born	**c. 1480** Andrea Mantegna, *Lamentation*
1432 Jan van Eyck, Ghent Altarpiece	**c. 1455** Invention of printing (Gutenberg)	**1481** Michael Pacher, winged altarpiece, St. Wolfgang am Wolfgangsee
c. 1430 Donatello, *Annunciation* tabernacle, Santa Croce, Florence	**1453** Fall of Constantinople	

1410	1415	1420	1425	1430	1435	1440	1445	1450	1455	1460	1465	1470	1475	1480	1485	1490	1500

PETER PARLER

SELF-PORTRAIT

Peter Parler was only in his early twenties when he entered the service of Emperor Charles IV, who was also the King of Bohemia. The job he faced was not for the faint-hearted—to take over as architect on the construction of Prague Cathedral.

The young master mason began work at his new workplace, the cathedral of St. Vitus, in 1356. This building for the new see of Prague, an important cultural center in the 14th century, was earmarked as a showpiece burial place for the imperial family. But it was also intended for all those who had contributed to the new structure. Peter Parler constructed a gallery in the choir, where particularly lavish decoration was to contain a whole series of portrait busts. It featured the founders of the cathedral, the emperor and his family, and the Bishops of Prague. It was therefore the first series of sculptural portraits since antiquity, a clear indication of the growing interest in individuality in late 14th-century Prague.

Portrait of a Master Mason
Places of honor went not just to the above exalted personalities. There was also room for portraits of the cathedral masons, so after working for over two decades as architect of the cathedral he carved a self-portrait. He portrayed himself in a plain gown, dispensing with jewelry or other accessories and focusing on the essentials—the face. The head projects slightly above the edge of the niche in which the bust is placed. Parler's sculpturally modeled face radiates calm, and he comes across as a focused, thoughtful man. Just one detail refers to his role at the cathedral—at chest height is a set square, the attribute of his craft.

His Rightful Place
What an honor, for a mason to find himself among members of the royal family and ecclesiastical dignitaries. And not only that—Parler's bust was the first known monumental artist's self-portrait in Late Gothic sculpture. That also attests to his self-confidence as a master mason. As an architect, he had various antecedents to point to. Painters and sculptors long remained artisans, whereas even in the Middle Ages master masons enjoyed a particularly high status among craftsmen. After all, masons put the Bible into stone, they were masters of number and proportion, and they endeavored to make art an exact science. The bust of Peter Parler has a clear message—as an architect, he is a co-author of the building, and so there can be no doubt about his high social standing. *ik*

PETER PARLER
c. 1333 Born in Schwäbisch Gmünd, Germany
c. 1352 Works on the church of Our Lady, Nuremberg.
1356 Appointed master mason of St. Vitus Cathedral, Prague.
FROM 1373 Works as master mason, Charles Bridge, Prague.
1399 Dies 13 July, Prague.

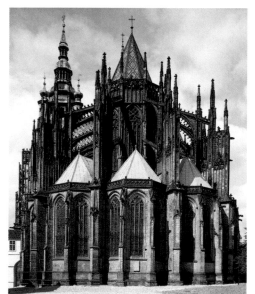

left page:
Peter Parler, *Self-Portrait*, c. 1380, St. Vitus Cathedral, Prague

left:
St. Vitus Cathedral, Prague, Gothic Cathedral founded in 1344

JOHN II THE GOOD (KING OF FRANCE)

PHILIP II THE BOLD (DUKE OF BURGUNDY)

CHARLES VII (KING OF FRANCE)

1340 Work on the Doge's Palace,
Venice, begins

C. 1410 *Les Très Riches Heures* book of
hours by the Limburg brothers

C. 1415 Donatello,
St. George

1340 1345 1350 1355 1360 1365 1370 1375 1380 1385 1390 1395 1400 1405 1410 1415 1420 1425

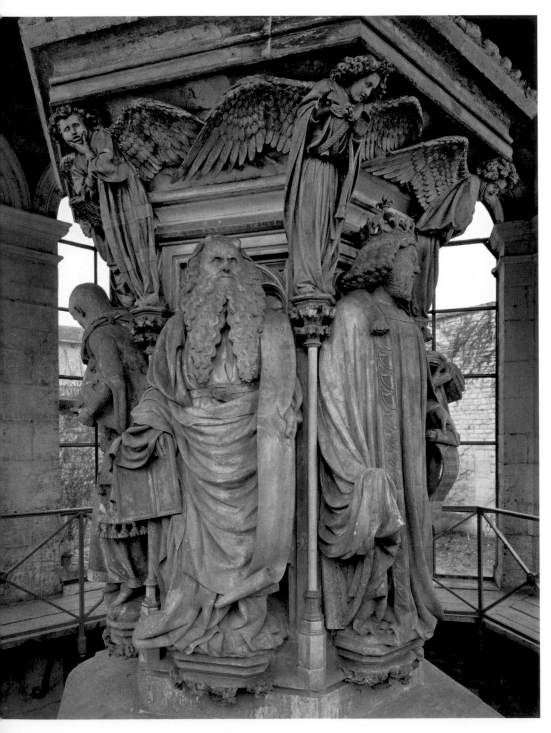

Claus Sluter, *Moses Fountain*,
1395–1403, height of figures:
183 cm, Champmol Charterhouse,
Dijon

24–1452 Lorenzo Ghiberti, *Doors of Paradise*, Florence

1453 Martin Luther born

1480–1482 Sandro Botticelli, *Primavera*

1498 Albrecht Dürer, *Self-Portrait with Landscape*

1431 Execution of Joan of Arc

1469–1492 Lorenzo de' Medici rules Florence

1485 Alberti's treatises *On Painting* and *On Architecture* published

1511 Giorgio Vasari born

1430 1435 1440 1445 1450 1455 1460 1465 1470 1475 1480 1485 1490 1500 1505 1510 1515 1520

CLAUS SLUTER

MOSES FOUNTAIN

Six huge sculptures adorn the base of the Moses Fountain. They were carved by the Dutch sculptor Claus Sluter around 600 years ago. It is still impressive how much life he managed to breathe into each of the stone figures.

Sluter had worked for Philip the Bold of Burgundy since 1385. The Duke had endowed a charterhouse not long before as a burial foundation for the rulers of Burgundy. The sculptural furnishings of this charterhouse near Dijon therefore needed to be suitably ostentatious. It was thus no small task that Sluter faced.

Emotions in Stone
Then in 1395 another project came his way, and that too was on a huge scale—the Duke commissioned him to do a large fountain in the center of the cloisters. Sluter began the job with the hexagonal pier that forms the center of the fountain. Lamenting angels hover at the corners of this pier, their wings tip to tip. They look towards the outsize prophets standing on consoles on the sides of the hexagon. The six monumental sculptures are largely detached from the architecture they grace and appear to be stepping forward. Moses, David, and Jeremiah were the first to be produced, being completed in 1402 and then painted in color. Moses, for example, wore a heavy golden tunic lined in blue material. Subsequently the three prophets Zachariah, Daniel, and Isaiah were done in equally heavy, colorful robes, their busy folds still lending life to the figures today. But what is most astonishing is the powerful modeling of the heads of the prophets. Their faces are impressively lifelike, the facial expressions conveying something of the prophecies they present in their scrolls.

Impressive Even in its Fragments
The prophet figures also bear witness to the monumentality of the work, even though they are just fragments of the total ensemble. Until the 18th century, the work survived in its original form—the Moses Fountain was over 23 feet (7 m) tall and had two stories. The plinth with the six sculptures of the prophets stood in a fountain basin, with a figurative group on the subject of the Crucifixion above it. The

latter scene also involved the sorrowing Virgin Mary, St. John the Evangelist, and Mary Magdalene, but only a fragment of the Christ figure survives. However, the iconographical intention of the fountain was clearly to show the interrelation of Old and New Testaments, so that what the Old Testament prophets foretold—Christ's Passion and death on the Cross—was once visually represented in the upper part of the fountain, in the Crucifixion scene. *ik*

CLAUS SLUTER

C. 1360 Born in Haarlem, the Netherlands.

C. 1379 The register of the Brussels stonemasons' guild records the name of Claes de Slutere van Herlam.

FROM 1385 Works for Philip the Bold.

1389 Head of a workshop in Dijon.

1390 Designs a new sculptural program for the doorway of Champmol Charterhouse.

1390–96 Works on (now lost) sculptures for the ducal chapel at Champmol.

1395 Receives the commission for the Moses Fountain.

1404 Figures for the tomb of Philip the Bold.

BEFORE FEBRUARY 1406 Dies in Dijon.

Claus Sluter, *Moses Fountain*, detail: Christ, 1395–1403, stone with traces of paint, Musée Archéologique, Dijon

1381 Venice gains control in the Mediterranean after defeating Genoa

1425 Masaccio, Trinitá fresco in Santa Maria Novella, Florence

1420 Brunelleschi begins work on the dome of Florence Cathedral

c. 1455 Rogier van der Weyden, *Portrait of a Lady*

1380 1385 1390 1395 1400 1405 1410 1415 1420 1425 1430 1435 1440 1445 1450 1455 1460 1465

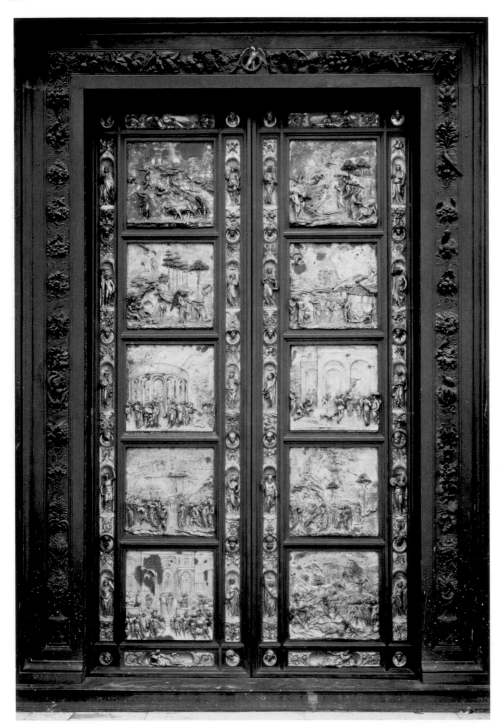

Lorenzo Ghiberti, *Gates of Paradise*, 1425–52, bronze, gilded, 506 x 287 cm, Baptistery, Florence

1473 Nicolaus Copernicus born

1472 First printing of Dante's
Divina Commedia

60–1466 Donatello sculpts pulpits
reliefs for San Lorenzo, Florence

1508–1512 Michelangelo, ceiling frescoes
in Sistine Chapel, Rome

1491–1547 Henry VIII (king of England)

1550 Vasari's *Lives
of the Painters*
published

| 1470 | 1475 | 1480 | 1485 | 1490 | 1500 | 1505 | 1510 | 1515 | 1520 | 1525 | 1530 | 1535 | 1540 | 1545 | 1550 | 1555 | 1560 |

LORENZO GHIBERTI

GATES OF PARADISE

Three sets of bronze doors—north, south, and east—grace the baptistery of Florence Cathedral. No less an artist than Michelangelo later helped to make the east doors of the baptistery famous: he thought them so beautiful that they were "worthy of the gates of paradise," and the name stuck.

The furnishings of the baptistery were a matter for the Merchants' Guild, and in 1424 they decided to award Florentine goldsmith Lorenzo Ghiberti the prestigious commission for the east doors. This was hardly surprising has he had already established a reputation by having, not long before, completed the bronze north doors.

Like a Book

The new doors were to immortalize scenes from the Old Testament. It was originally envisaged that the narrative should be spread over 20 individual panels. Ghiberti had other ideas and finally had his way. He reduced the number of scenes to ten, which meant that the panels were considerably larger than envisaged in the original plan. The *Gates of Paradise* narrative is read like the lines of a book, reading horizontally from top left to bottom right. The story begins with the creation of Adam and Eve and ends with the Queen of Sheba visiting Solomon. Ghiberti had a largely free hand in the design of the doors. But that was a mixed blessing. After all, it meant he had to come up with a completely new kind of representation—he had to pack a complicated Old Testament sequence into only ten panels.

Room for the Proud Artist

So events come thick and fast, as the first of the gilded panels shows. This fits in four separate scenes: left foreground, God the Father creates Adam, the two figures being almost in the round. In the middle ground (and center of the picture) is the creation of Eve, who is supported by angels, from the rib of a sleeping Adam. The next incident (left background) is the Fall—a serpent is winding around a tree trunk between Adam and Eve. After that is the Expulsion from Paradise, which Ghiberti places on the right edge of the picture. God the Father, with a large host of angels behind him, orders Adam and Eve to leave Paradise and an angel energetically hustles the terrified couple out.

Ghiberti became adept at fitting several stories into one panel without the narrative losing clarity. Figures in the foreground appear large and strongly profiled, those in the background smaller and flatter. In this way he conveys the sequence of events clearly even though they are all shown the same panel.

The huge *Gates of Paradise* doors were completed in 1452, after 28 years. Ghiberti was obviously satisfied with his work, for amid the numerous religious figures that adorn the frame of the gilt doors there is also a characterful portrait—of himself. *ik*

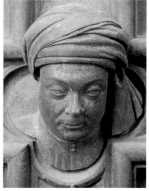

LORENZO GHIBERTI
1378 Born in Florence.
1401 Participates in the competition for the design of the north doors of the baptistery.
1413/14 Bronze statue of John the Baptist for the church of Orsanmichele, Florence.
1419–22 Bronze statue of St. Matthew, Orsanmichele, Florence.
1424 Completion of the north door of the baptistery. Receives the commission for the *Gates of Paradise*.
1452 Completes the *Gates of Paradise*.
1455 Dies 1 December in Florence.

left:
Lorenzo Ghiberti, Baptistery (eastern façade) Florence

above:
Lorenzo Ghiberti, *Self-portrait*, c. 1420, northern portal, Baptistery, Florence

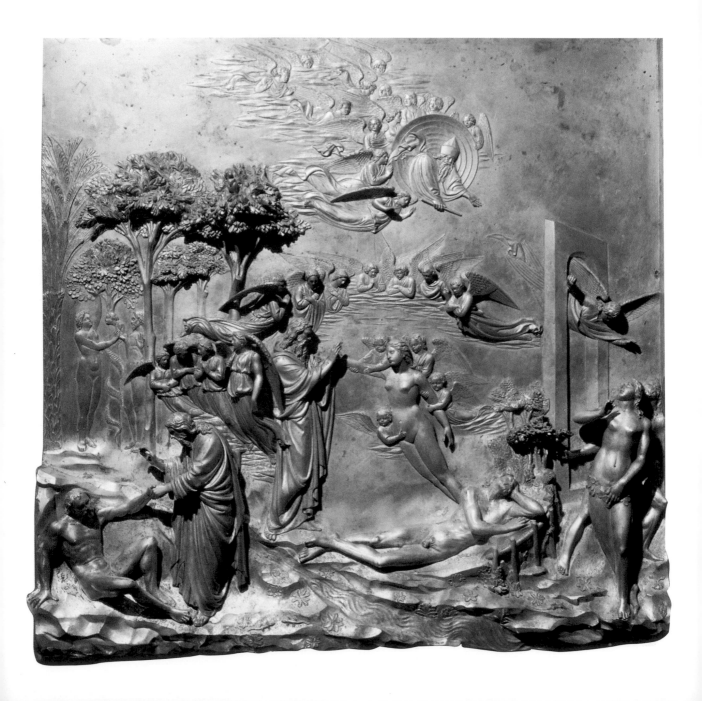

left page:
Lorenzo Ghiberti, *Gates of Paradise*,
detail: the Creation, the Fall, the
Expulsion

below:
Lorenzo Ghiberti, *Gates of Paradise*,
detail: Cain and Abel

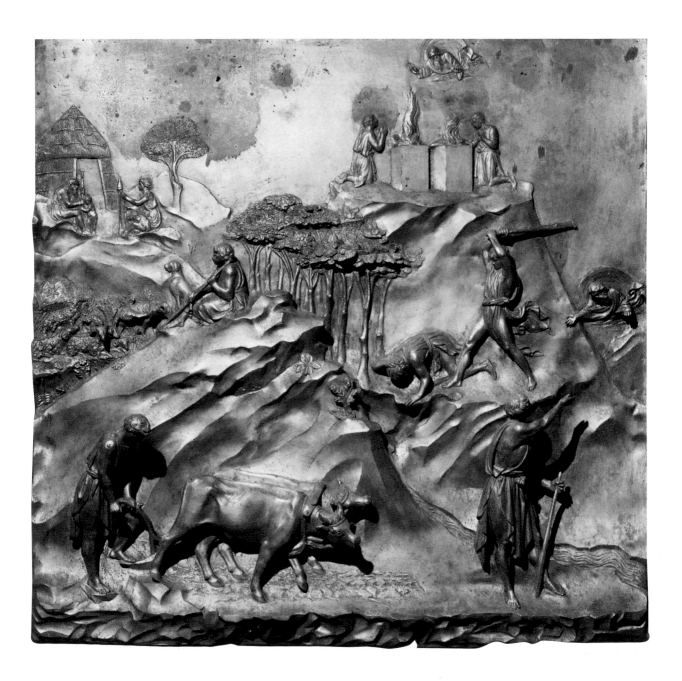

1436 Paolo Uccello, Equestrian portrait, Florence Cathedral

1453 Fall of Constantinople

1390　1395　1400　1405　1410　1415　1420　1425　1430　1435　1440　1445　1450　1455　1460　1465　1470　1475

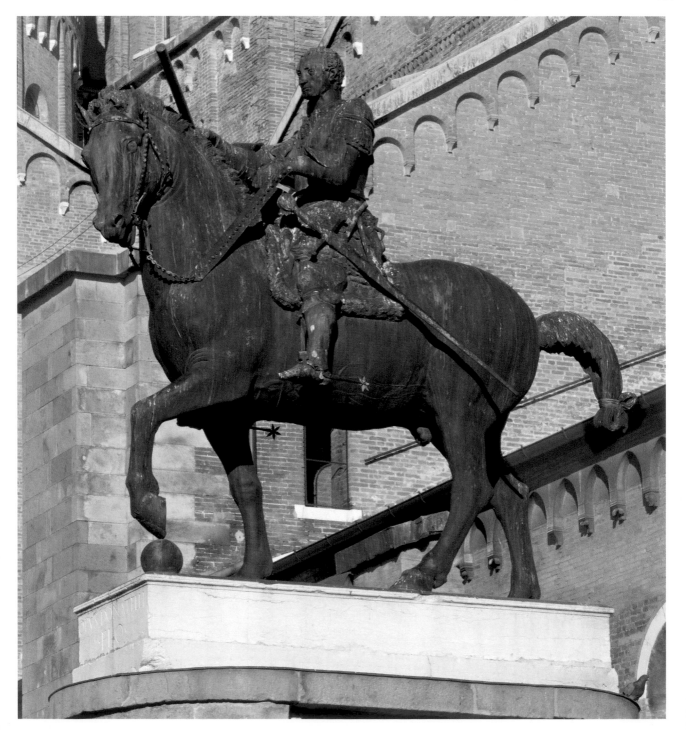

1498 Savonarola executed in Florence

1517 Beginning of the Reformation
1517–1518 Veit Stoss, *Angels' Greeting*, St. Lorenz, Nuremberg

1475 Piero della Francesca, treaty on perspective

1500 Albrecht Dürer, *Self-Portrait in Fur Coat*

1514 Machiavelli's *Il Principe* published
1512–1516 Grünewald, Isenheim Altarpiece

1535 Michelangelo appointed principal Vatican sculptor, painter and architect

| 1480 | 1485 | 1490 | 1495 | 1500 | 1505 | 1510 | 1515 | 1520 | 1525 | 1530 | 1535 | 1540 | 1545 | 1550 | 1555 | 1560 | 1565 | 1570 |

DONATELLO

DAVID

Donatello's bronze David still causes puzzled frowns today, over 500 years after it was made. It is not clear why the artist depicted David naked, when he made it, or who commissioned it.

Such gaps in our knowledge, however, have done no harm to the fame of this celebrated sculpture, which stands 5 feet 2 inches (1.58 m) high. That is hardly surprising: Donatello's *David* can still claim to be the first free-standing nude figure since antiquity (see pages 70–71). The lanky youth stand on a plinth wearing (curiously) only boots and a shepherd's hat, his hair falling in long strands. In his left hand, which rests on his hip, he clutches the stone with which he brought down Goliath. In his right hand he holds the sword he has just used to cut off the giant's head. The victor now poses with his foot on the severed head—the contrast with the bearded head and the delicate youthful physique could not be greater. Though details of the biblical story are consistent with the figure, there is no mention of nakedness in the Bible. Whether the client asked Donatello to depict the biblical giant-slayer and later king this way, or the sculptor himself wanted to do so, is an open question. The fact is, the original commission and precise purpose of the work are not known. All we do know is that this bronze *David* ended up in the possession of the Medici family in Florence after the sculptor's death.

True to Life—Both Horses and Riders

And it is equally certain that Donatello's reputation as an outstanding sculptor was already established before he executed his *David*. Given the exact observation of nature, Donatello probably studied the human body from live models, since his bronze figures look like real flesh-and-blood. His work was therefore much in demand, and not just in Florence. In 1443, for example, Donatello traveled to Padua, where he was asked to set up a memorial to the Venetian general Erasmo da Narni. This celebrated *condottiere* (hired soldier) wanted an equestrian statue commensurate with his military prowess. Every inch the military commander, the Gattamelata (Brindled Cat), as he was nicknamed, wears ornate armor and holds a field marshal's baton in his right hand. One front hoof of his horse is raised as if trotting. On a closer look, it turns out to be resting on a cannonball—the bronze figure is too massive to balance on only three legs. This equestrian statue was not only Donatello's greatest project but also the first life-size bronze equestrian statue since classical antiquity. Horse and rider still stand guard on a lofty plinth overlooking the Piazza di Sant'Antonio in Padua. *ik*

DONATELLO
c. 1386/87 Born Donato di Niccolò di Betto Bardi in Florence.
1404 Works in Lorenzo Ghiberti's workshop.
1406 First securely attributed works: two prophets for Florence Cathedral.
1408 Commissioned to execute the marble David.
1414 St. George for the church of Orsanmichele in Florence.
1426/27 Marble reliefs and other works in Pisa.
c. 1430 Travels to Rome.
1443–53 In Padua, produces among other works the equestrian statue of Gattamelata.
1466 Dies 13 December in Florence.

left page:
Donatello, *Gattamelata*, 1447–53, bronze, h. ca. 340 cm, Piazza di Sant'Antonio, Padua

above:
Portrait of Donatello from Giorgio Vasari's *Lives of the Painters*, first published in 1550

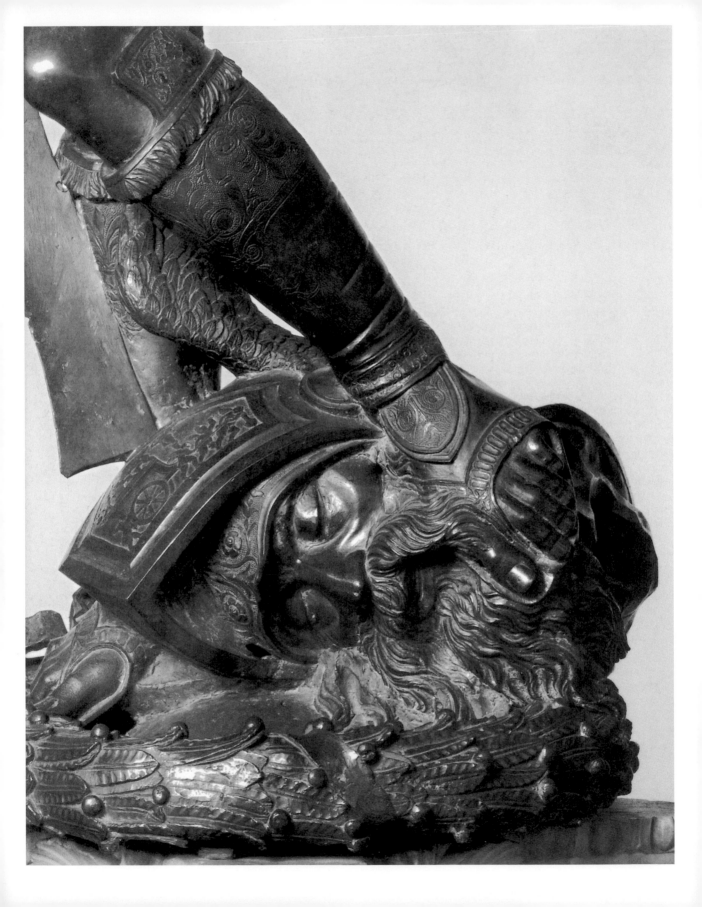

left page:
Donatello, *David*, detail: head of Goliath

right:
Donatello, *David*, c. 1444–46, bronze,
h. 158 cm, Museo Nazionale del Bargello,
Florence

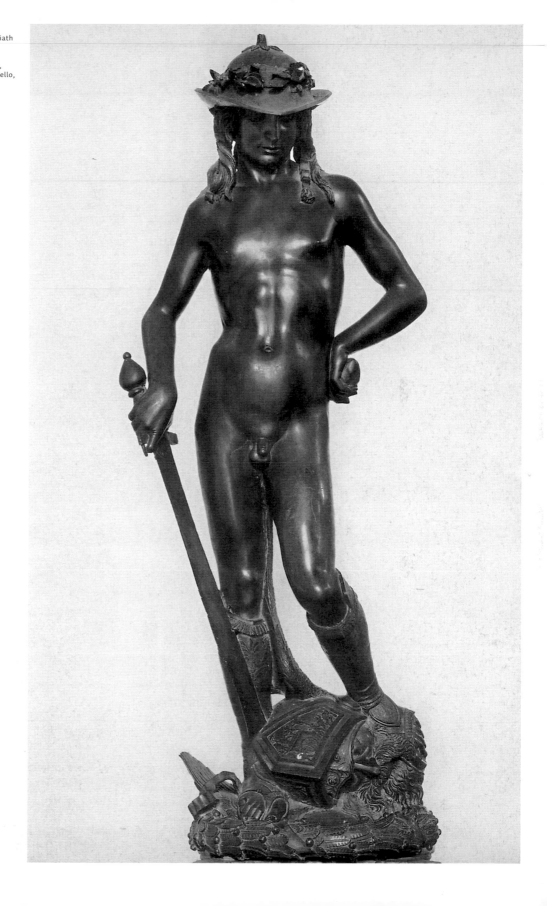

CHARLES V (EMPEROR OF THE HOLY ROMAN EMPIRE)

ALBRECHT DÜRER

1472 First printing of
Dante's *Divina
Commedia*

1491–1494 Nicolaus Copernicus goes to University of Krakow

1453 Fall of Constantinople

1492 Columbus undertakes voyages of
discovery to the Americas

1480–1490 Hieronymus Bosch,
Garden of Earthly Delights

C. 1456 Donatello, *Judith and Holofernes*

1498–1499 Michelangelo,
Pietà, Rome

1506 Work starts on ne
St. Peter's, Rome

| 1430 | 1435 | 1440 | 1445 | 1450 | 1455 | 1460 | 1465 | 1470 | 1475 | 1480 | 1485 | 1490 | 1500 | 1505 | 1510 | 1515 | 1520 |

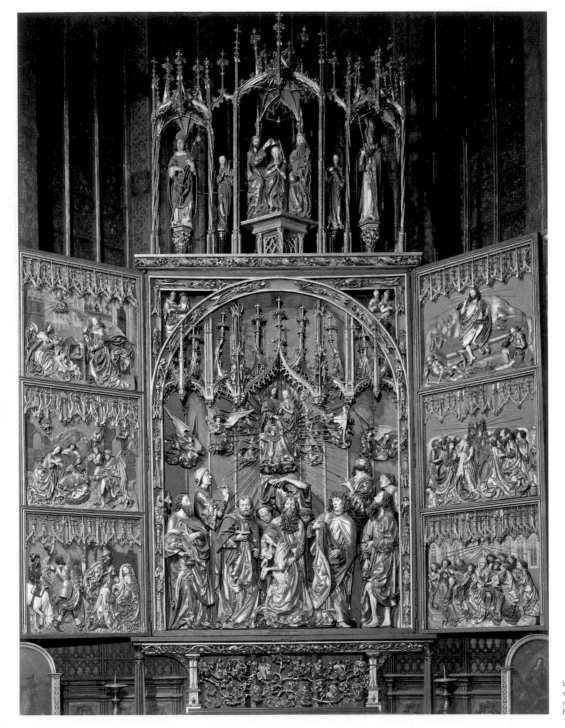

Veit Stoß, *St. Mary* altarpiece,
1477–89, painted limewood,
13.95 x 10.68 cm, St. Mary's
Basilica, Krakow

521 Excommunication of
Martin Luther

1538 Titian, *Venus of Urbino*

c. 1600 El Greco,
Toledo

1525 1530 1535 1540 1545 1550 1555 1560 1565 1570 1575 1580 1585 1590 1595 1600 1605 1610

VEIT STOSS

ST. MARY ALTARPIECE

It must have amazed the citizens of Krakow in 1489—Veit Stoss's carved altarpiece in St. Mary's Basilica measures an impressive 42 feet (13 m) top to bottom and, when the wings are fully open, 36 feet (11 m) wide.

The main figures in the centerpiece of the altar are larger-than-life. Particularly dramatic is the unfolding scene of the Dormition of the Virgin. The Virgin kneels in the center of the shrine, supported by an Apostle. Alarmed, the Apostle behind her clutches his coat and backs away. Another watches the scene aghast, while many others look hopefully to heaven. The story continues above: angels accompany the praying Virgin on her Assumption, set against an aureole. The final phase is the Coronation of the Virgin, which can be seen in the tower-like top panel of the altar, which with its gilt columns and arches is reminiscent of the Gothic architecture of the Lady Chapel.

Pure Narration

Carved altarpieces like this one were popular mainly in churches north of the Alps. They offered room for extensive iconographical programs, particularly if arranged as winged altars. Veit Stoss's altar, for example, can be open or closed. It is only fully open on Sundays and holy days, so that the shrine and three panels on each side can be seen. These show other scenes from the Life of the Virgin, beginning with the Annunciation. Then bottom left we then have the Three Kings bringing gifts for the newborn Christ Child. The scene-stealer is the dark-skinned king doffing his hat in cheerful salutation, his horse grazing peacefully on the left edge of the picture. On weekdays, when the side wings are shut, the scenes from the Life of Christ on the back can be seen. Every panel contains colored figures of lime-wood wearing elegant robes with busy folds, each figure distinguished by individual gestures and facial features.

Solo Mastery

It is scarcely credible that this major altarpiece is an early commission, for when Veit Stoss was summoned to Krakow in 1477 he was about 30, and must already have enjoyed a reputation as a master carver. And he more than lived up to his reputation over the following decade with his work on this monumental *St. Mary* altarpiece, which he made virtually by himself, with little help from assistants. On his return to Nuremberg, art was not the only thing to engage his attention, as he proved an even better merchant. Consequently he left his heirs a substantial fortune. Whether they also inherited his business sense is anyone's guess, but six of his sons did become artists. *ik*

VEIT STOSS
c. 1447 Born probably in Horb-am-Neckar, Germany
1477 Renounces Nuremberg citizenship and moves with his family to Krakow, Poland.
1477–89 Winged altar for St. Mary's, Krakow.
1492 Signed and dated tomb of King Kasimir IV, Krakow Cathedral.
1496 Returns to Nuremberg.
1499 Completes work on a Passion relief for church of St. Sebaldus, Nuremberg.
1517/18 *Great Rosary (Salve Regina)*, choir of St. Sebaldus, Nuremberg.
1520–23 Altarpiece for Bamberg Cathedral.
1533 Dies in Nuremberg.
1547 First biography published.

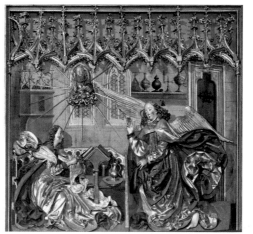

left:
Veit Stoß, *St. Mary* altarpiece, detail: the Annunciation of the Virgin

above:
Portrait of Veit Stoß, c. 1600, copperplate engraving

following double page:
Veit Stoß, *St. Mary* altarpiece, detail: the Dormition of the Virgin

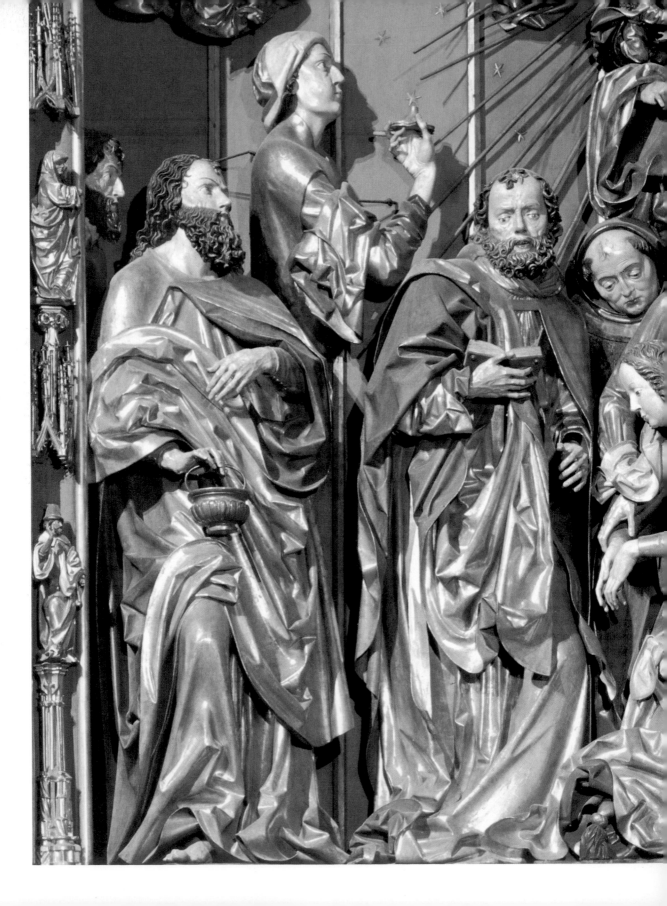

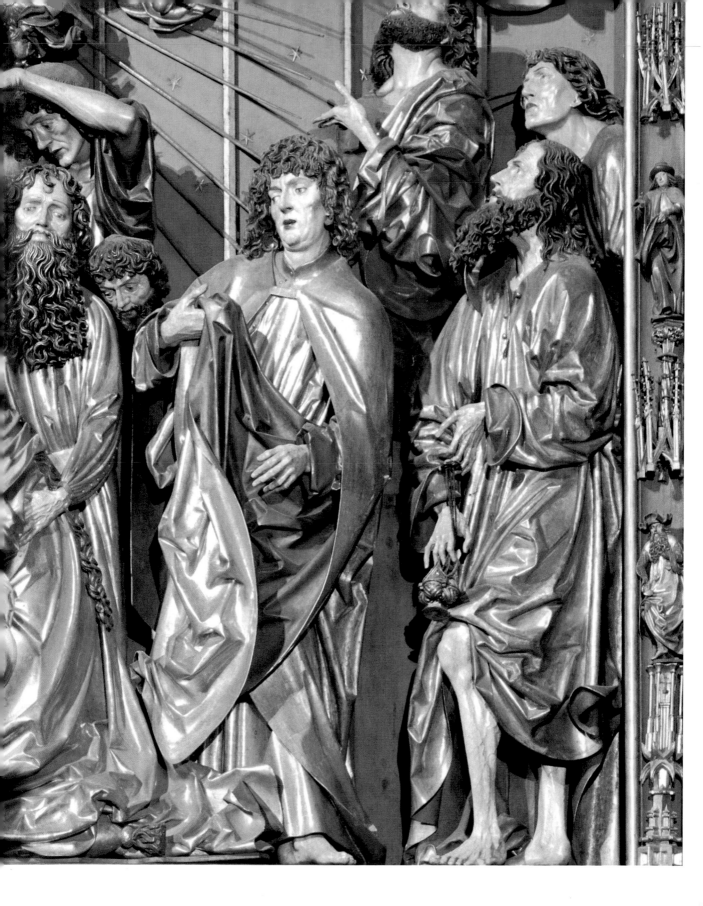

1508–1512 Michelangelo, ceiling frescoes,
Sistine Chapel

1452 Leonardo da Vinci born

C. 1494 Michael and Gregor Erhart, altar-
piece for Blaubeuren Abbey

1517 Luther's *Ninety-five Theses* nailed
to the door of the castle chapel
in Wittenberg

1445 1450 1455 1460 1465 1470 1475 1480 1485 1490 1495 1500 1505 1510 1515 1520 1525 1530

Tilman Riemenschneider, *Holy Blood*
altarpiece, 1501–04, limewood, uncolored,
h. 900 cm, height of figures: up to 100 cm,
Church of St. James, Rothenburg ob der
Tauber

RUDOLPH II (GERMAN EMPEROR)

ELIZABETH I (QUEEN OF
ENGLAND AND IRELAND)

1571 Turkish fleet defeated at
the Battle of Lepanto

1540 Pope approves the founding
of the Jesuit order

1567–1569 Andrea Palladio, Villa Rotonda

1601/02 Caravaggio, *Conversion of St. Paul*

1563 Veronese, *Wedding at Cana*

C. 1595 William Shakespeare,
A Midsummer Night's Dream

1618 Beginning of the
Thirty Years' War

| 1535 | 1540 | 1545 | 1550 | 1555 | 1560 | 1565 | 1570 | 1575 | 1580 | 1585 | 1590 | 1595 | 1600 | 1605 | 1610 | 1615 | 1620 |

TILMAN RIEMENSCHNEIDER

HOLY BLOOD ALTARPIECE

*It's like a vast Gothic monstrance. The Holy Blood altarpiece that Tilman Riemenschneider created for the church of
St. James in Rothenberg is a spectacular expression of late mediaeval pilgrimage mysticism. It promises mercy and salvation.*

A contemporary of Machiavelli, Luther, and Vasco da Gama, Tilman Riemenschneider was a councilor and mayor of Würzburg in Franconia, in the territory of the Bishop of Würzburg. He was considered influential and prosperous, owned houses, land, and vineyards. His public offices, business abilities and talent brought him considerable esteem and lucrative commissions. The "most German of medieval sculptors," he supplied works even to Bohemia. Clients were attracted by the melancholy smiles that played on the lips of his figures, their lively gestures, their delicate movements—in short, his capacity to "awaken beauty from wood and stone," as the novelist Thomas Mann put it. Riemenschneider's craftsmanship was in such demand that his workshop developed into a kind of sculpture factory where at times he had as many as 18 apprentices at work.

Judas at the Center of the Last Supper

Eventually, his reputation reached Rothenburg. Called "the Franconian Jerusalem" because of its Temple Mount-like situation above the River Tauber, Rothenberg was even then a picturesque city with walls, gates, towers, and the massive church dedicated to St. James. The church still contains a precious relic—a rock-crystal capsule containing "three drops of the Holy Blood of Christ," it was said. The first pilgrims started coming in the 13th century. By Riemenschneider's day, a new altarpiece was deemed necessary for the relic, and therefore "master Till Riemenschneider, sculptor at Wirtzburg" was commissioned to make it. To cater for the worshippers of the "holy blood of Christ," he carved an impressive Last Supper scene in limewood for the shrine. As recorded in the Gospel of St. Matthew (26), this was the occasion when Jesus "took the cup, and thanked and gave it to them, saying: drink of it every one. For this is my blood of the new testament, that shall be shed for many, for the remission of sins."

Unusually, Riemenschneider puts not Christ but the traitor Judas center scene. And Judas doesn't come across as an evil villain, but as a man to whom fate leaves no choice. That was a view that was considered unheard of at the time.

Every Face Tells a Story

But Riemenschneider broke with tradition in another way as well. He was among the first sculptors not to paint his sculptures. That does not impair the impact, however. To compensate, he used his chisel and gouge to make the folds of robes finer and to bring out convincing seam and embroidery effects. In addition, he painted the bare wood with a glaze, and separately highlighted pupils, eyebrows, and lips. He made use of natural light as well. Thanks to the stained-glass windows behind the altar, at sunset the shrine looks like a mystically backlit stage.

The faces of the Apostles attract particular attention even today. Every individual face, we are told, tells its own life story. Did Riemenschneider observe his fellow councilors at tumultuous council meetings during his mayoral days, recording the panoply of feelings from anger and despair to resignation on their faces in order to recreate them with the Apostles? We don't know. All we know is that, because of his sympathy for the peasants, in the end he hardly received any commissions. Presumably in that situation, even a pilgrimage to Rothenburg would have been no use. *kr*

TILMAN RIEMENSCHNEIDER
c. 1460 Born in Heiligenstadt, Thuringia, Germany.
c. 1473 Learns the trade of sculptor and carver, presumably in Strasbourg (then a German city) and Ulm.
1483 Settles in Würzburg as a trainee painter. Marries, acquires master status with his own studio, and from 1504 is a councilor and for some years mayor.
1499 The city council of Rothenburg commissions carpenter Erhart Harschner of Rothenburg to build a new *Holy Blood* altarpiece for the church of St. James. The commission is for the shrine, the decorative accessories, and the finials.
1501 In April, the council commissions the carved figures for the *Holy Blood* altarpiece from Riemenschneider.
1525 When the Peasants' War breaks out, Riemenschneider and the rest of the council side with the rebels. When the old order is reestablished, he is locked up in Marienberg fortress and tortured.
1531 Dies 7 July in Würzburg. No work by him is known from after his imprisonment and release.

Tilman Riemenschneider, probably a self-portrait. Detail of the altar platform in the Herrgottkirche in Creglingen, 1505–10

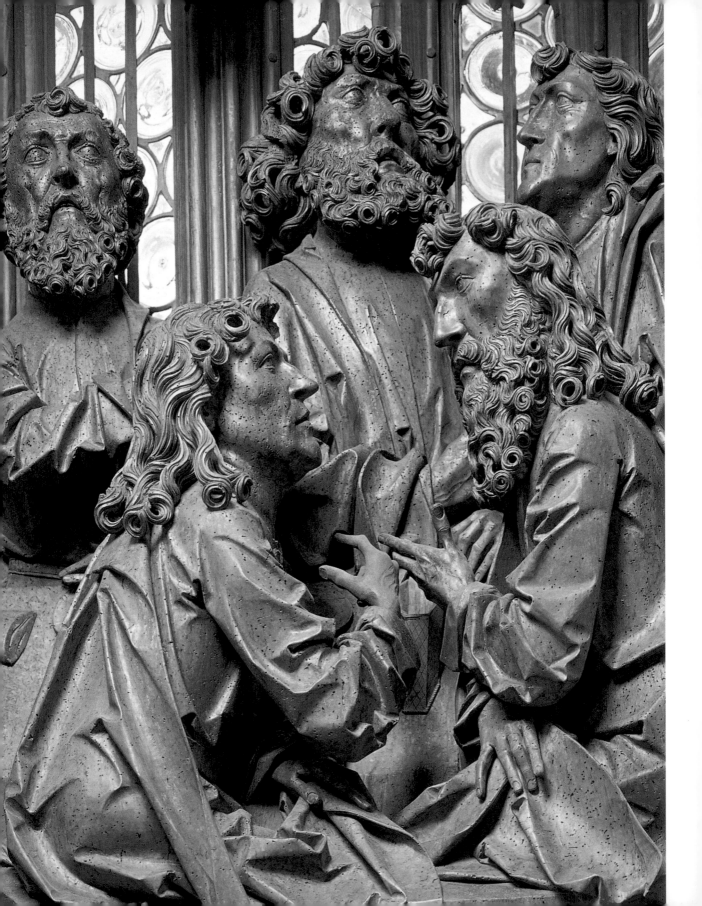

1456 Works begins on Alberti's façade
for Santa Maria Novella, Florence

1491–1493 Tilman Riemen-
schneider, *Adam and Eve*

1492 Beginning of Columbus's voyages
of discovery to the Americas

1506 Work starts on the new St. Peter's, Rome

1529 Turks besiege Vienna

1460 1465 1470 1475 1480 1485 1490 1495 1500 1505 1510 1515 1520 1525 1530 1535 1540 1545

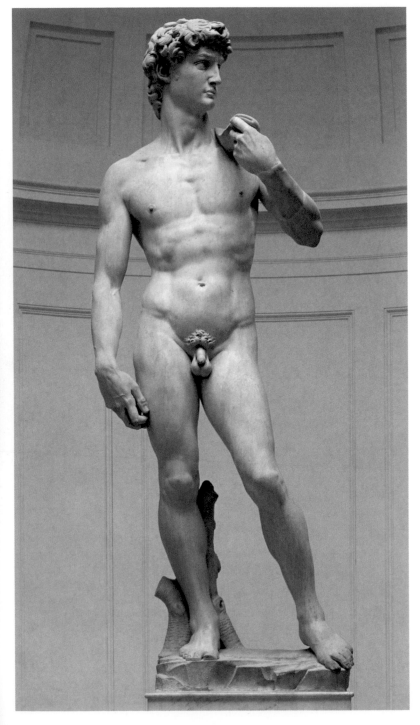

Michelangelo Buonarotti, *David*, 1501–04, marble,
h. approx. 410 cm, Galleria dell' Accademia, Florence

1550 Vasari's *Lives of the Artists* published

1571 Turkish fleet defeated at the Battle of Lepanto

1570 Palladio's *Quattro libri dell'architettura* (book on architecture)

c. 1604 William Shakespeare, *Othello*

1610 Caravaggio dies in Porto d'Ercole

| 1550 | 1555 | 1560 | 1565 | 1570 | 1575 | 1580 | 1585 | 1590 | 1595 | 1600 | 1605 | 1610 | 1615 | 1620 | 1625 | 1630 | 1635 |

MICHELANGELO

DAVID

According to the Old Testament, the shepherd boy David, an unlikely combatant, defeated the giant, Goliath, with a single stone from his catapult.

The Florentines wanted to have David among them, carved in stone and on the cathedral, to represent the struggle of the weak against the strong—for the Florentine Republic was surrounded by more powerful states that threatened its independence. So the Clerk of the Cathedral Works ordered the figure of a David, which was to emerge from a huge piece of marble they owned. The first sculptor failed miserably. Finally, the job was passed to Michelangelo, who made a giant out of it such as Florence had never before seen.

Hewn from a Single Block

Over 13 feet (4 m) tall, *David* took only two years to complete. Michelangelo's treatment was unusual: rather than the victor posing with the head of Goliath, he shows the youthful David before the encounter. The sling is draped over his left shoulder, and he clasps the stone tight in his right hand. Though his left leg is slightly bent (Michelangelo was a master of *contrapposto*), his muscles show a degree of tension. And as with Donatello's *David* made 60 years earlier, Michelangelo's David is also naked. But for the same reason, it was considered unfitting for the statue to be installed on the cathedral as planned. So in 1504 it was set up in front of the Palazzo Vecchio, where it—or more recently, a copy—still stands.

When he completed his giant, the first monumental free-standing statue since late Roman times, Michelangelo was not even 30 and yet already an artist that rulers jostled to employ. In the following decades, not only Florence but also the popes in Rome showered him with commissions, as a sculptor, painter, and architect.

Finished or Unfinished?

While he was still in Florence, the influential Medici claimed his services. In 1520, Michelangelo started work on the family's burial chapel in the church of San Lorenzo, and went in person to the quarries in Carrara to choose the marble. Over the next decade and a half, the wall tombs of Dukes Giuliano and Lorenzo took shape inside the chapel. Four reclining figures adorn the stone sarcophaguses. The allegorical figures of Dawn and Dusk, Day and Night manifest different stages of completion. Compared with the polished figure of Night, the face of Day is noticeably much more rough-hewn. This was not in the least attributable to any lack of time that may have affected the much sought-after sculptor. The figure is more eloquent of Michelangelo's conviction that the work of art is already concealed in the stone, and the sculptor's job was "simply" to expose it. And it was entirely up to him how far he went. Michelangelo's contemporaries praised his works for this degree of unfinishedness, its *non-finito*.

And in any case, he was under pressure. His designs for the Medici chapel were far from finished when he was summoned to Rome. The rewards would prove huge. The following year, Michelangelo found himself appointed the Vatican's principal architect, sculptor, and painter. *ik*

MICHELANGELO
1475 Born 6 March in Caprese, near Florence.
1488 Apprenticed to the painter Ghirlandaio.
1489 Taken on at the court of Lorenzo de' Medici.
1503 Completes *David*.
1595 Pope Julius II commissions him to do his tomb.
1508–12 Works on the ceiling of the Sistine Chapel in the Vatican.
1520–34 New Sacristy, San Lorenzo, Florence.
1529 Appointed military architect of Florence.
1535 Pope Paul III appoints him top sculptor, painter, and architect at the Vatican.
1547 Appointed architect of St. Peter's, Rome.
1564 Dies 18 February in Rome.

Contrapposto

Michelangelo used *contrapposto* in his sculptures—David's straight right leg stands firmly on the ground, while his left leg is slightly bent at the knee and to one side, so that the hips are a little out of the vertical axis. The different distribution of weight between the weight-bearing leg and the free leg gives the figure a livelier look. A favorite design feature of ancient Greek sculpture, *contrapposto* was revived by sculptors of the Renaissance, notably Donatello and Michelangelo.

above:
Daniele da Volterra, *Michelangelo Buonarroti* (detail), c. 1548–53, black chalk, Tylers Museum, Haarlem

following double page left:
Michelangelo Buonarroti, *Tomb of Giuliano de' Medici*, 1524–34, marble, h. (Giuliano) 173 cm, New Sacristy, San Lorenzo, Florence

following double page right:
Michelangelo Buonarroti, *Tomb of Lorenzo de' Medici*, 1521–34, marble, h. (Lorenzo) 178 cm, New Sacristy, San Lorenzo, Florence

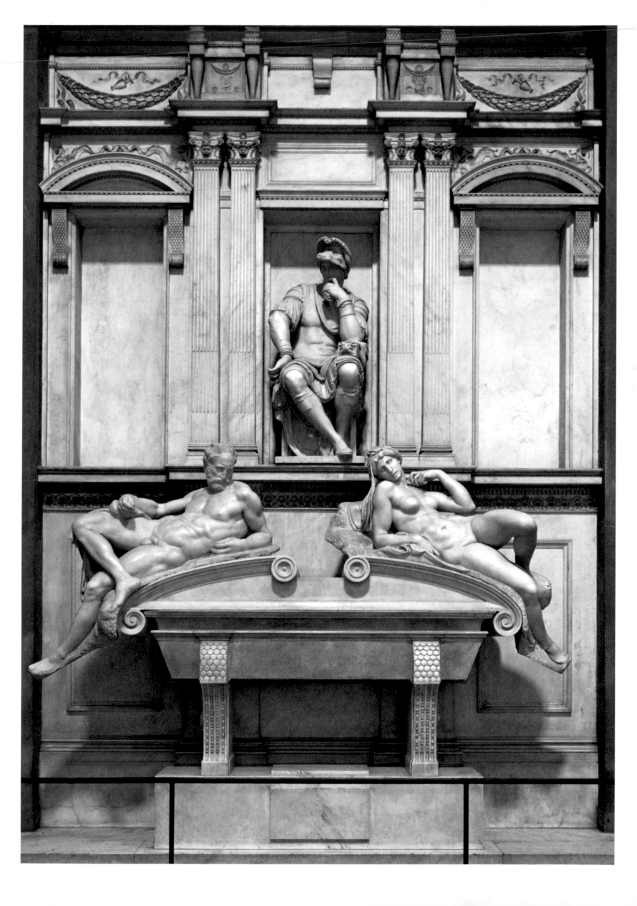

1508 Andrea Palladio born

1523 Veit Stoss, *Lady Altar,*
Bamberg Cathedral

1519 Leonardo da Vinci dies in France

1519 Work begins on the Château of Chambord, Loire Valley

| 1490 | 1495 | 1500 | 1505 | 1510 | 1515 | 1520 | 1525 | 1530 | 1535 | 1540 | 1545 | 1550 | 1555 | 1560 | 1565 | 1570 | 1575 |

Benvenuto Cellini, *Salt Cellar with
Neptune and Ceres*, 1540–43, gold and
enamel, 26 cm x 33.5 cm, Kunsthistor-
isches Museum, Vienna

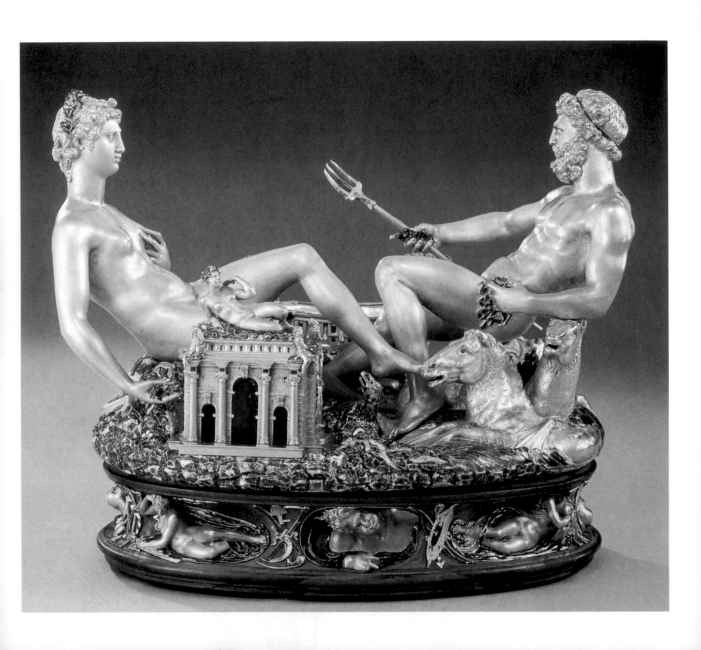

1588 Defeat of the Spanish Armada

c. 1620 Artemisia Gentileschi, *Judith and Holofernes*

1648–1651 Gianlorenzo Bernini, *Four Rivers' Fountain, Piazza Navona, Rome*

c. 1588 Construction of St. Peter's dome completed to plans by Michelangelo

1618–1648 Thirty Years' War

1653–1655 Francesco Borromini, Sant'Agnese, Rome

1580	1585	1590	1595	1600	1605	1610	1615	1620	1625	1630	1635	1640	1645	1650	1655	1660	1665

BENVENUTO CELLINI

SALT CELLAR

One morning in 2003, Vienna awoke to find one of its favorite treasures stolen. On the night of 11 May, a thief managed to remove a famous gold salt cellar by the Renaissance goldsmith Benvenuto Cellini from the Kunsthistorisches Museum.

Later, the thief demanded a ransom for it. Since it was one of the best-known items in the Viennese collection, the art world held its breath. Its estimated value was over $60 million.

The Most Famous Salt Cellar in the World

This richly decorated work is so valuable because it is the only surviving piece of gold work securely attributed to Cellini. The Florentine artist made it during his French period. Much in demand as a goldsmith and bronze founder (and writer—he also left us an important autobiography and other texts), he was in the service of Francis I from 1540. The king commissioned the costly tableware piece from him soon after the artist's arrival in France.

Numerous figures populate the work, which is made of gold and enamel and measures 10 inches by 13 inches (26 by 33.5 cm). Cellini describes it in his autobiography as an allegorical representation of the Earth: "To show how the Sea [Neptune] is linked with the Land [Ceres], I made two figures each a good palm's length sitting opposite each other with intertwined legs, just the way we see the arms of the sea reaching into the Land. The Sea, shaped as a man, contained a richly wrought boat that held plenty of salt, and below it were four seahorses, while the figure held a trident in his right hand. I made Land female, as beautifully figured and appealing as I knew how. I placed beside her a richly adorned temple on the ground to hold the pepper. ... At her side were the finest animals that the Earth can bring forth." Other figures were applied to the base of the salt cellar, the Four Winds alternating with allegories of the times of the day.

Art Thriller with a Happy Ending

Cellini even found an opportunity for a quotation. The four figures of the Times of the Day were inspired by the reclining marble sculptures Michelangelo had carved for the wall tombs of the Medici dukes (see pages 82–83)—Cellini had occasionally been able to witness the creation of that work. The salt cellar was completed in 1543, and it vanished from the museum exactly 460 years later. It was not until 2006 that it was heard of again. In the end, the thief turned himself in and led the police to his hiding place, a chest in the woods. Probably the world's most famous salt cellar finally made it back into the museum unharmed, and can be seen there today. *ik*

BENVENUTO CELLINI
1500 Born in Florence.
1540 Moves to France, where he works for Francis I.
1540–43 *Salt Cellar.*
1545 Returns to Florence.
1545–54 Works on the colossal statue *Perseus.*
1558 Starts work on his autobiography.
1568 His treatises on gold work and sculpture is published in Florence.
1571 Dies 13 February in Florence.

Portrait of Benvenuto Cellini, copperplate engraving, Castello Sforzesco, Milan

1517 Luther's *Ninety-five Theses* nailed to the door of the castle chapel in Wittenberg

1520/21 Magellan circumnavigates the globe

1518 Tintoretto born

1541 Spain conquers the Maya Empire in Central America

1545–1554 Cellini, *Perseus with the Head of Medusa*, bronze, Florence

1560–1580 Giorgio Vasari designs the Uffizi, Florence

1565 Pieter Bruegel the Elder, *Labours of the Months* series

1490 1495 1500 1505 1510 1515 1520 1525 1530 1535 1540 1545 1550 1555 1560 1565 1570 1575

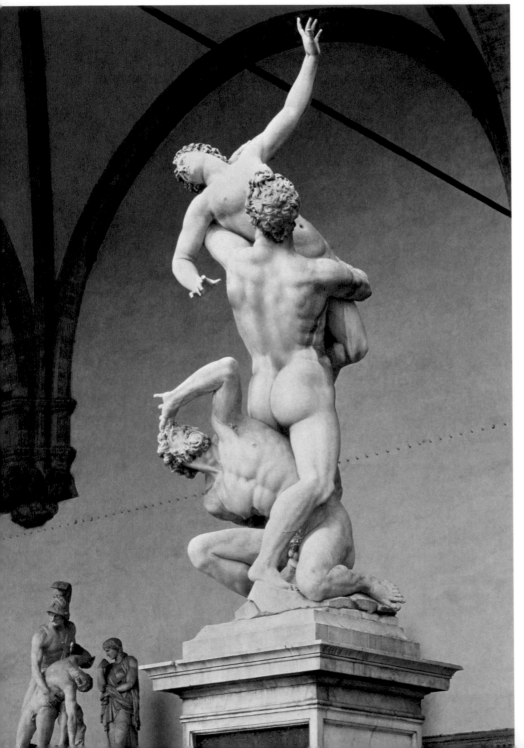

Giambologna, *Rape of the Sabines*, 1583, marble, h. 410 cm, Piazza della Signoria, Loggia dei Lanzi, Florence

77–1592 Il Redentore, Venice, built to Palladio's design

c. 1610 El Greco, *Laocoön*

1624–1633 Gianlorenzo Bernini, baldachin in St. Peter's, Rome

1663–1666 Scala Regia of the Vatican palace, after Gianlorenzo Bernini

1580	1585	1590	1595	1600	1605	1610	1615	1620	1625	1630	1635	1640	1645	1650	1655	1660	1665	

GIAMBOLOGNA

RAPE OF THE SABINES

Among the most famous sculptors in Italy in the second half of the 16th century was Flemish-born Jean de Boulogne, known in Italy as Giambologna. En route from Rome back to his homeland, he stopped off in Florence.

What had originally been intended as a brief visit became a half-century of residence. Soon after his arrival in Florence, the Flemish sculptor established contacts with important collectors and began to work for the influential Medici family. In 1579, they offered him a job involving a huge block of marble—and he boldly accepted. The artist's declared aim was not to create individual figures but an integrated group, regardless of the subject. The most important thing was that the figures should be a virtuoso work of art. The surviving wax models show how he developed a figure group whose three participants form a single complex composition.

Truly Versatile

The work was completed in 1583, and it was agreed it should be installed in the Loggia dei Lanzi in the city center. But it still lacked a subject, so how could it be installed in the loggia? Fortunately, by the time the sculpture, 13 feet 5 inches (4.10 m) high, was finally unveiled at its new location, a subject had finally been found—the Rape of the Sabines. This referred to an episode in the early days of Rome. In order to remedy a shortage of women in the young city, the Romans abducted women from the nearby Sabine tribe. In Giambologna's work, a bearded Sabine kneels on the ground, his left-hand raised in self-defense, while the female Sabine victim struggles in the arms of a young Roman. The three figures fuse into a group, interwoven both through physical contact and through looking at each other intently. The work spirals upwards in a *figura serpentinata* that has no frontal view. In other words this work brought something new to sculpture, since the composition can be fully understood only in the round, the complex arrangement of figures constantly changing as the viewer's position changes.

Clever Marketing

The *Rape of the Sabines* represents the zenith of Giambologna's career, since it made him the uncontested master of large-scale secular sculpture in Italy. And it wasn't only in Italy that his sculptural achievements made a name. Thanks to small bronze statuettes made of his works that could be used in domestic interiors, Giambologna's sculptures became familiar throughout Europe. The Medici, for example, used the small bronzes as diplomatic gifts, and art collectors everywhere scrambled to get copies. The statuettes ended up in collections as diverse as the Emperor Rudolph II's in Prague and those of wealthy burghers in the Netherlands. Soon the masterpieces of the Flemish sculptor were being used in Vienna, Paris, and Madrid for teaching purposes, a use that continued far into the 18th century. *ik*

GIAMBOLOGNA
c. 1529 Born in Douai, Flanders (now France). Trains in Flanders.
1550 Moves to Italy and studies Rome.
c. 1553 Settles in Florence.
1560–62 First major marble sculpture: Samson Slaying a Philistine.
1564 Bronze Mercury.
1563–67 Bronze sculptures for the Neptune Fountain in Bologna.
c. 1580 Statue of the river god Apennine for the Medici garden in Pratolino.
1583 Completes the *Rape of the Sabines.*
1587–93 Equestrian monument for Cosimo I, Grand Duke of Tuscany.
1608 Dies 13 August in Florence.

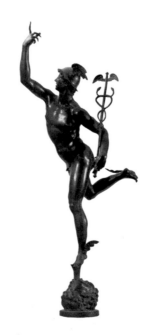

left:
Giambologna, *Mercury*, 1564–65, bronze, h. 180 cm, Museo del Bargello, Florence

above:
Gijsbert van Veen, *Portrait of Giambologna*, 1589, copperplate engraving, Charles Avery Collection

1597–1600 Annibale Carracci, ceiling
fresco, Palazzo Farnese, Rome

C. 1616 Peter Paul Rubens, *Rape of
the Daughters of Leucippus*

1605–1615 Miguel de Cervantes, *Don Quixote*

1616 Copernicus condemned by the Church

1648 Rembrandt, *Christ
at Emmaus*

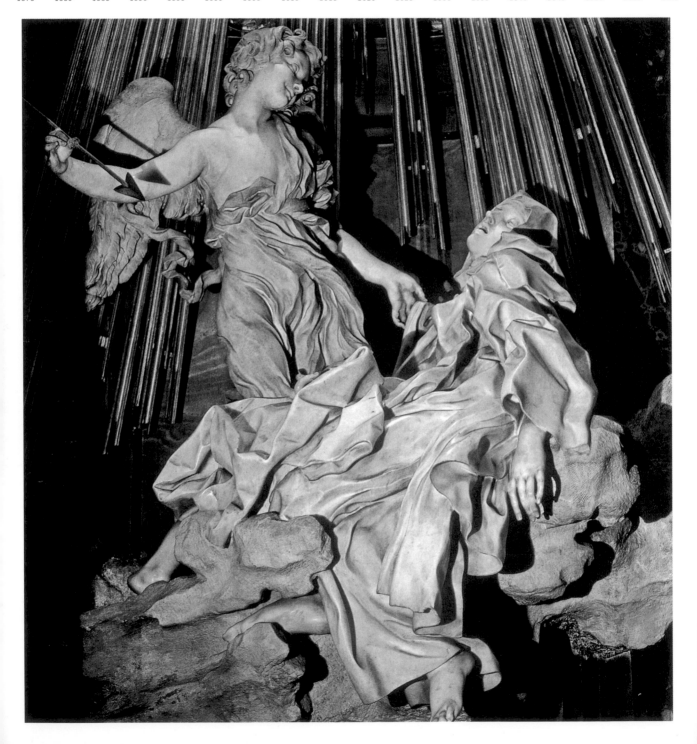

1701–1713/14 War of Spanish Succession

1675–1711 Sir Christopher Wren builds
St. Paul's Cathedral, London

1697–1703 Andreas Schlüter, equestrian
statue of the Great Elector, Berlin

1696 Giovanni Battista Tiepolo born

1720 Work starts on Balthasar Neumann's
design for the Würzburg Palace

1665 1670 1675 1680 1685 1690 1695 1700 1705 1710 1715 1720 1725 1730 1735 1740 1745 1750

GIAN LORENZO BERNINI

THE ECSTASY OF ST. THERESA

Visitors to the small church of Santa Maria della Vittoria in Rome are witnesses to a moment of drama when they are confronted with Bernini's St. Theresa, an enigmatic vision of religious ecstasy.

This is one of the sculptural masterpieces that make Gianlorenzo Bernini the quintessential representative of Roman Baroque. He had already left his mark on the face of Rome as an architect and city planner. The commission to decorate the family chapel in Santa Maria della Vittoria came from Cardinal Federico Cornaro when the multi-talented Bernini was already 50. Accordingly, it was initially members of the Cornaro family that were immortalized there, carved figures sitting in theatrical "boxes" each side of the altar, gazing at Bernini's masterpiece—a monumental figurative group enthroned above the altar. The altar figure—an angel watching St. Theresa in her ecstatic trance—appears to be floating on a cloud.

The Agony and the Ecstasy

The 16th-century Theresa of Avila was a Spanish sister of the Carmelite order, which owned the church of Santa Maria della Vittoria in Rome. Theresa was canonized on the strength of a vision that she recorded in a book. Bathed in an aureole of golden light, the saint reclines on a sea of cloud as she sees the vision and her heart is pierced by a burning arrow delivered by an angel of the Lord. Her face reveals the feelings she described as a mixture of agony and ecstasy. Her head lolls back, her lips part and her eyes are half closed. The strain and rapture are evident even in the tips of her fingers. In a trance, the saint waits for the arrow with which the raptly smiling angel at her side will pierce her body. Emotion takes possession of her face and the dramatic disorder of her gown reflects the agitation of her soul.

Drama Down to the Last Detail

Movement is a major feature of the entire work. Diagonals dominate the composition, conveying a strong sense of upwards motion in the sculptural group. The positioning of the marble figures is wholly theatrical: light falls on the sculpture through an invisible opening above, and combined with the "sun burst" at the back creates an effect of almost supernatural light. Thanks to the radiant white of the marble, the figures clearly stand out from the architectural frame of polychromatic marble. On closer inspection, it is evident that Bernini has considered every detail. The Cornaro Chapel is designed as an integrated scene, with every element from floor to ceiling contributing to the impression it makes on the viewer. It is a masterpiece of Baroque "theater." *ik*

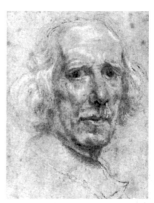

GIAN LORENZO BERNINI
1598 Born 7 December in Naples.
1624–33 Baldachino for St. Peter's, Rome.
1629 Appointed architect for the building works at St. Peter's.
1647–52 Cornaro Chapel, Santa Maria della Vittoria, Rome.
1648–51 *Four Rivers* fountain in Piazza Navona, Rome.
1650 Begins work on the Palazzo Ludovisi, Rome.
1656–67 Designs the piazza in front of St. Peter's.
1658–61 Builds the churches of Sant'Andrea al Quirinale, Rome, and San Tommaso da Villanova, Castel Gandolfo.
1662–64 Santa Maria dell'Assunzione, Ariccia.
1664 Begins work on the Palazzo Chigi, Rome.
1671–78 Tomb of Pope Alexander VII, St. Peter's.
1680 Dies 28 November in Rome.

Baroque

By the mid-16th century, the social importance of the Church and the nobility had waned as the bourgeoisie became increasingly important and Protestantism spread. For the next century or so, the nobility and the Church sought to counter this trend, each in its own way. The Church's response to the rise of Protestantism was the Counter-Reformation, while secular monarchs assumed absolute power. The architectural expression of this increased spiritual and secular authoritarianism was opulence and ostentation in churches, abbeys, and palaces. The clear formal grammar of the Renaissance was swept aside as the artists of the Baroque employed dynamic forms and a wealth of lavish detail, sculpture and painting also being used with architecture to help produce an overpowering total effect on the spectator.

left page:
Gian Lorenzo Bernini, *The Ecstasy of St. Theresa*, 1645–52, marble and gilded bronze, h. 350 cm, Cornaro Chapel, Santa Maria della Vittoria, Rome

above:
Portrait of Gian Lorenzo Bernini

1656 Diego Velázquez, *Las Meninas*

1668 Work starts on the Palace
of Versailles

1713 Johann Dientzenhofer, stairwell,
Schloss Pommersfelden

1715 Work begins on Johann Fischer
von Erlach's façade for the
Karlskirche, Vienna

1720 Lukas von Hildebrandt, Sala Ter-
rena, Upper Belvedere, Vienna

1720 Work begins on Balthasar Neu-
mann's design for the Würzburg
Palace

1650 1655 1660 1665 1670 1675 1680 1685 1690 1695 1700 1705 1710 1715 1720 1725 1730 1735

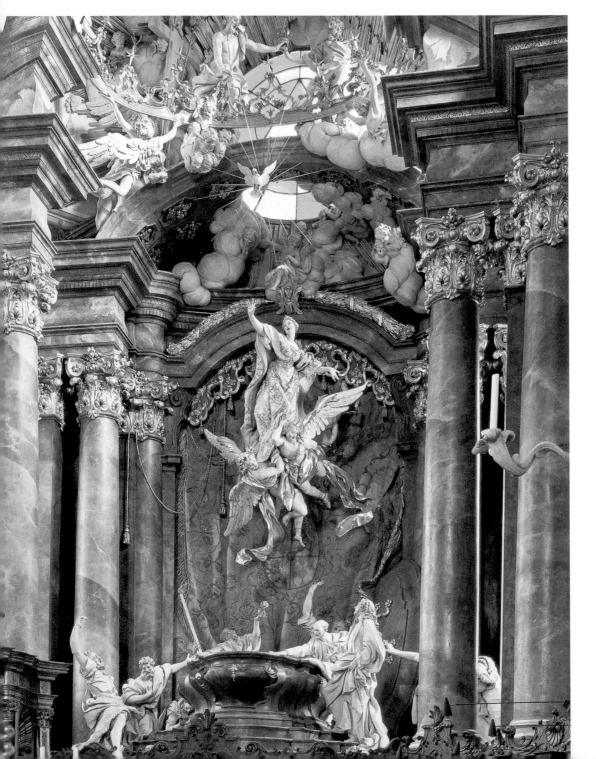

5 Canaletto, *View of the Doge's Palace in Venice*

1774 Ignaz Günther, *Pietà*

1745–1754 Dominikus and Johann Baptist Zimmermann, Wieskirche

1789–1799 French Revolution

| 1740 | 1745 | 1750 | 1755 | 1760 | 1765 | 1770 | 1775 | 1780 | 1785 | 1790 | 1795 | 1800 | 1805 | 1810 | 1815 | 1820 | 1825 |

EGID QUIRIN ASAM

HIGH ALTAR IN ROHR

The altar becomes a stage, the sculptor a theater director. With his bold artistic imagination focusing on broad and dramatic effect, Egid Quirin Asam is considered the creator of the Baroque 'theatrum sanctum'.

The former abbey church of the Austin canons at Rohr on the northern edge of Hallertau in Lower Bavaria contains a masterpiece of international stature: an altarpiece that dramatizes the Assumption of the Virgin as a vast spiritual spectacle. An excited crowd of life-size Apostles react to the tremendous event with melodramatic gestures of amazement, showing all facets of human emotion in the face of the supernatural event.

A Triumphal Drama

The altar shows one of the Disciples just climbing the steps when his gaze is swept upwards to the Assumption of the Virgin. A second Disciple has sunk to his knees in fervent adoration, a third holds a golden rose in his hands with an expression of bliss, while in the background other Apostles hurry up with fluttering robes. High above them soars the figure of the Virgin, borne aloft by angels. The fourth finger of her right hand aims for the ring that the dove of the Holy Spirit carries in its beak to provide the Queen of Heaven with a third symbol of eternal rule alongside the crown and scepter. The huge, elegantly curved sarcophagus in the middle, where the body of the Mother of God had been laid to rest, is empty. The Apostle Thomas reaches into it incredulously, but finds only clothes and "scented roses." The Virgin, whose body according to Jacobus de Voragine's *Golden Legend* had been "innocent of all corruption," was "really assumed body and soul" into heaven.

Technical Wizardry

At the design stage, Egid Quirin Asam, the 31-year-old creator of this triumphal drama, probably had the peasant nativity scenes of his Alpine homeland in mind, as well as the sacred tombs of Easter, and the festivities of the amusement-minded princely houses, with their flying machines and other mechanical devices. Whatever the case, he offers theology you can see and touch, conveying to believers the impression of being directly involved as personal witnesses of a divine miracle.

There is some technical wizardry involved. The Assumption group with its incomparable grace and elegance is not carved of stone but shaped of straw and wire, coated with plaster which is then polished. That is what gives it its sunny lightness, which Asam further intensified by showing Mary not as the careworn wife of a carpenter but as a youthful beauty with delicate grace and regal nobility. The figure is affixed to three iron poles that cannot be seen from any point within the church—not even if you are standing directly below. In this way, the gifted artist achieves a perfect illusion. The church itself, likewise designed by him, is above all an auditorium. The eye is steered forwards towards the *theatrum sacrum*, or holy theater, where the scene is taking place on an altar 10 feet (3 m) high and 23 feet (7 m) wide. The theatrical effect is enhanced by the well-planned indirect lighting and framed by two galleries resembling proscenium boxes. What Asam achieved in Rohr was a sensitive, intoxicating visual world in which architecture, light, and sculpture fuse into a rare, jubilant unity. *kr*

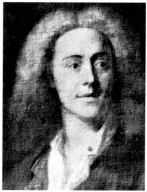

EGID QUIRIN ASAM
1692 Baptized 1 September in the monastic village of Tegernsee in Upper Bavaria, Germany.
1711 Works closely with his gifted elder brother, fresco artist Cosmas Damian Asam (1686–1739). The two of them are much in demand as a team capable of handling spectacular three-dimensional creations involving architecture, light effects, sculpture, and painting. Their work is found in churches, abbeys, and castles in Switzerland, Southern Germany, the Tyrol, and Bohemia.
1717 The Austin canons of Rohr in Lower Bavaria commission 25-year-old Egid Quirin to build them a new abbey church.
1750 Dies 29 April in Mannheim, where he was doing plasterwork on the palace of the Elector of the Palatinate, and painting the Jesuit church.

left page:
Egid Quirin Asam, *High Altar in Rohr*, 1722/23

above:
Cosmas Damian Asam, Portrait of Egid Quirin Asam

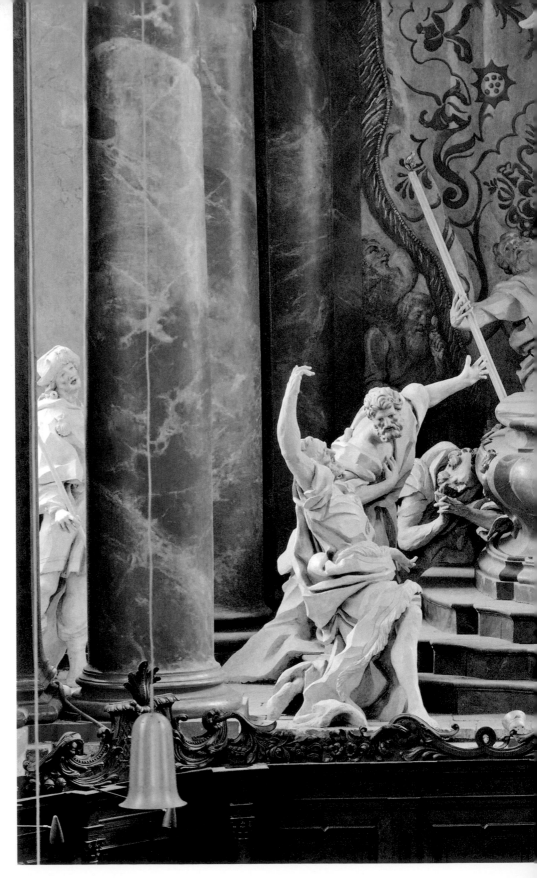

Egid Quirin Asam, *High Altar in Rohr*,
detail: the Apostles at the empty grave

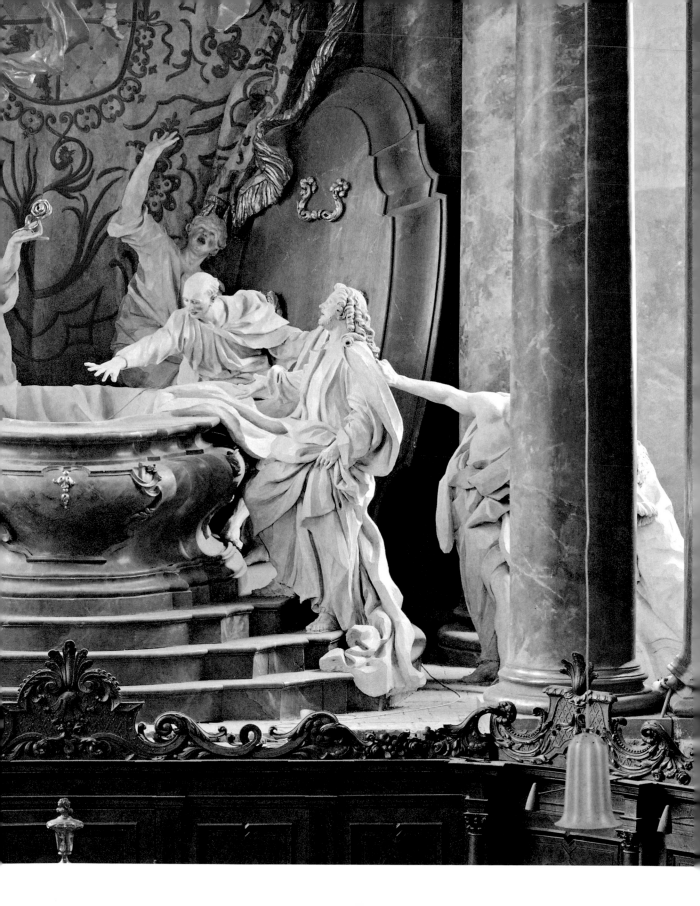

1726–1742 Georg Bähr, Frauenkirche
(Church of Our Lady), Dresden

1733–1746 Asamkirche (St. Johann
Nepomuk), Munich

1690 1695 1700 1705 1710 1715 1720 1725 1730 1735 1740 1745 1750 1755 1760 1765 1770 1775

Franz Anton Bustelli, *Commedia dell'arte,*
Dottore and Donna Martina, 1759/60,
porcelain, h. 19.5 cm and 19.2 cm, Bayer-
isches Nationalmuseum, Munich

1788–1791 Gotthard Langhans, Brandenburg Gate, Berlin

1815 Napoleon defeated at Waterloo

C. 1818 Caspar David Friedrich, *The Wander above the Sea of Mist*

1826 First photographs made by Nicéphore Niépce

1842 China cedes Hong Kong to Britain

1855 Dante Gabriel Rossetti, *Paolo and Francesca da Rimini*

1857 Gustave Flaubert, *Madame Bovary*

1863 Édouard Manet, *Déjeuner sur l'Herbe*

| 1780 | 1785 | 1790 | 1795 | 1800 | 1805 | 1810 | 1815 | 1820 | 1825 | 1830 | 1835 | 1840 | 1845 | 1850 | 1855 | 1860 | 1865 |

FRANZ ANTON BUSTELLI

COMMEDIA DELL'ARTE FIGURES

He emerged from the darkness suddenly like a comet to light up the Bavarian court—only to disappear again shortly after. Yet thanks to Franz Anton Bustelli, Munich was considered the Eldorado of European art in the 18th century.

We know he was born in Locarno in Switzerland in 1723, but we don't know where he grew up, where he went to school, or what he looked like. There was no one who could have even provided more information about his personal life. When he died on 18 April 1763 after a severe illness, he left no dependants. His personal belongings were limited and largely damaged. Even so, Franz Anton Bustelli was one of the most inspired artists of his time. Over a period of eight and a half years he created exquisite works of European status. With their compelling charm, subtle wit, and sophisticated elegance, they are among the most valuable legacies of the 18th century.

The New *à la turque* Fashion

Elector Maximilian III Joseph, who ruled Bavaria at the end of the 18th century, was the quintessential Rococo man-about-town. An opponent of war, a reformer of education, and an aesthete, he ordered a *dramma giocoso* from Mozart (*La Finta Giardiniera*) and commissioned a new opera house from François Cuvilliés. At the same time, this popular ruler was very much concerned with promoting the economy of his country. His capital and official residence-city Munich soon had not only a cloth factory but also a silk manufactory, a hosiery and cotton factory—and from 1747 even an Electoral porcelain manufactory. Ever since Ottoman ambassador Soligman Aga in Paris had introduced to the West the unfamiliar custom of offering his guests an exotic hot drink called coffee that was sipped from fine, fragile porcelain bowls, the ambition had developed at European princely courts of adopting the new fashion *à la turque*—preferably with porcelain from one's own manufactory.

The Commedia dell'arte in Porcelain

Professional porcelain production got under way in Munich in 1754 with the arrival of porcelain-maker Joseph Jakob Riegler—he had learned the secrets of manufacturing porcelain in Vienna, Höchst, and Strasbourg. But it was not until Bustelli arrived that the manufactory achieved a European reputation. The inventory of moulds for 1760 lists "item: 16 pantomime figures." This is the group of figures that made the manufactory world-famous—the acting troupe of the Commedia dell'arte. The eight females and eight males represent stock, larger-than-life characters from 16th-century Italian popular comedy. They include the smug, "excessively larn'd" Dottore from Bologna and the bossy maid Colombina. In Munich, where they had history of a resolutely feisty Electress of Italian origin some decades before, and thanks to the pleasure-loving court's almost daily diet of "comedy, ballet, jousting, and chivalric fare of that kind," Bustelli's creations were treated with a reserve typical of Bavaria. But the art world was delighted with the coquettish female figures, the edgy males, and the facial expressions and gestures of these "birds of paradise," even though they are barely 8 inches (20 cm) high. "Simply unsurpassed" was the general verdict. If you listened carefully, it was said, you could hear the rustling of their colorful enameled costumes. Indeed, the lively couples, born of the *esprit nouveau* of the Rococo, look fresh and vivacious even today. So that that should remain so, the Nymphenburg manufactory recently commissioned contemporary fashion designers such as Vivienne Westwood, Christian Lacroix, and Emanuel Ungaro to "re-dress" Bustelli's figures. *kr*

FRANZ ANTON BUSTELLI

1707/08 Johann Friedrich Böttger and Ehrenfried Walther von Tschirnhaus introduce porcelain-making to Europe in Dresden.

1710 King August the Strong's decree of 23 January establishes the Royal Polish and Electoral Saxon Porcelain Manufactory in Meissen.

1723 Franz Anton Bustelli born 12 April in Locarno, Switzerland.

1747 In Munich, the present-day Nymphenburg Porcelain Manufactory, originally the Churfürstliche Porcelain-Fabrique, is founded on the initiative of Max III Joseph.

1754 Bustelli begins work as figure-maker and master modeler at the manufactory on 3 November.

1759/60 He produces his *chef d'œuvre*, the 16 characters of the Commedia dell'arte. The ensemble, called *Love at the Italian Theater*, is considered the zenith of porcelain manufacture and is still produced from his models.

1761 The manufactory moves to Nymphenburg.

1763 Bustelli dies on 18 April in Munich, leaving behind models for around 150 figurines. The manufactory buildings in Nymphenburg are still used for production today.

INTERNET TIP:
To see more figures of the Commedia dell'arte, you can still visit the Nymphenburg porcelain manufactory, or take a look at their website: www.nymphenburg.com

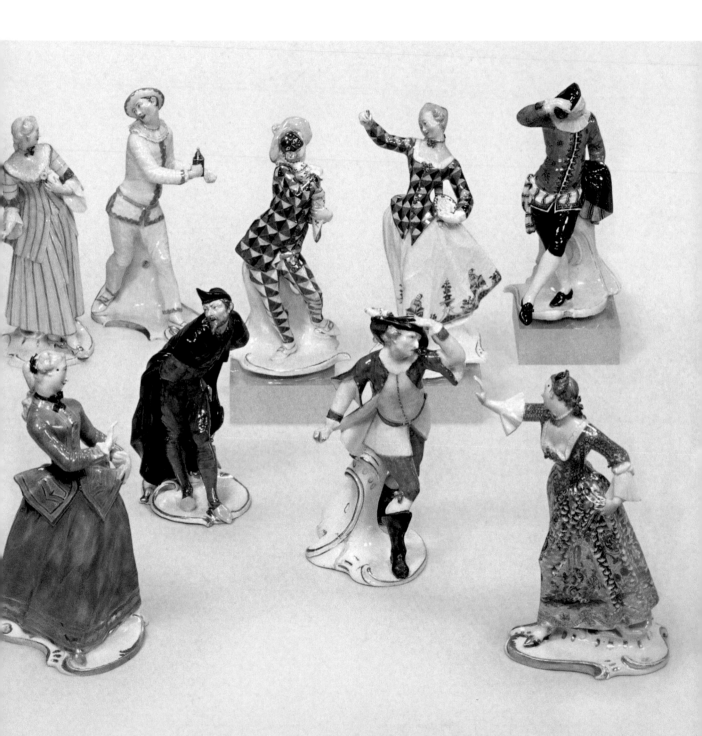

1721 Russia becomes a European great power

1721–1723 Johann Lucas von Hilde-
brandt, Upper Belvedere, Vienna

1745–1747 Schloss Sanssouci, Potsdam

1745–1754 Dominikus and Johann Baptist
Zimmermann, Wieskirche

1782 Henry Fuseli,
The Nightmare

1788–1791 Gotthard
Langhans, Branden-
burg Gate, Berlin

1710 1715 1720 1725 1730 1735 1740 1745 1750 1755 1760 1765 1770 1775 1780 1785 1790 1795

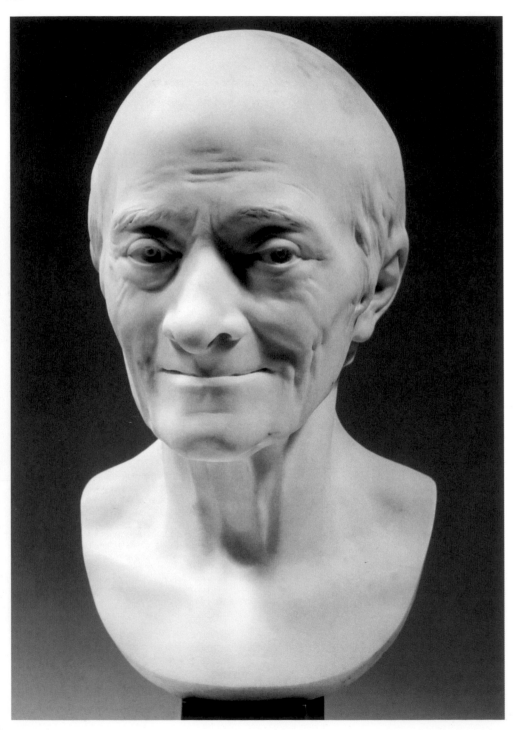

Jean-Antoine Houdon, *Voltaire*, 1778,
marble, 36.8 x 21.4 cm, Musée des
Beaux-Arts, Angers

1789–1799 French Revolution

1804 Napoleon Bonaparte
becomes French emperor

1848 John Everett Millais, William Holman
Hunt, and Dante Gabriel Rossetti found
the Pre-Raphaelite Brotherhood

1880 Edgar Degas,
*Little Dancer,
Aged 14*

|1800|1805|1810|1815|1820|1825|1830|1835|1840|1845|1850|1855|1860|1865|1870|1875|1880|1885|

JEAN-ANTOINE HOUDON

VOLTAIRE

When Voltaire returned to Paris in February 1778 after long years of exile, he was accorded a spectacular reception. It was at this time that sculptor Jean-Antoine Houdon portrayed him, and his Voltaire portraits did much to define the posthumous image of the writer.

The bust of Voltaire, cut off in a semicircle below, shows the elderly philosopher bareheaded and without any indication of clothing. The characteristically astute facial expression and mockery for which Voltaire was famous are visible in the face despite the clear symptoms of age such as baldness, wrinkles, and sunken cheeks. The alert eyes indicate someone with sound judgment and not easily taken in, so that the obvious lack of teeth behind the thin-lipped mischievousness of the mouth appears incidental.

Several Versions

The first version of the portrait is based on the style of classical portraits of philosophers, and is now preserved in the Musée des Beaux-Arts in Angers. Houdon turned out versions of the portrait in a number of different guises. One variant is *à la française*: in this case, the philosopher wears a wig and 18th-century dress. Another variant is the famous full-length marble sculpture now in the Comédie Française. It shows the old man sitting on a kind of throne, dressed in classical robes and with a band in his hair, looking attentively at visitors to the theater.

Instant Success

What Jean-Antoine Houdon produced was in fact a monument to a monument. Voltaire was much in demand as a subject, with numerous sculptors and painters having already produced portraits of the philosopher, mostly during his exile in Ferney on the Swiss-French border. As soon as it was known that the famous author was returning to the French capital in order to put on his last play at the Comédie Française, Houdon expressed great interest in portraying him, and offered to do a portrait of the celebrated author for the prestigious theater. Approval was given, exceptionally, though the honor of a statue in the Comédie Française was actually accorded only posthumously. In Voltaire's case, no such rules could apply. Voltaire gave the sculptor his consent after he had seen Houdon's portrayal of the dramatist Molière.

Holding a crown over him is supposed to have infused new energy in the enfeebled 83-year-old when he was posing. The appearance of the old philosopher is supposed to have prompted Denis Diderot to say he resembled a decaying fairytale castle where the old sorcerer was still in residence. When Voltaire died a little later, Houdon also made a death mask of him. The sculptor could likewise not complain of not being famous enough—he was heavily in demand as a portraitist for celebrities of distinction or rank. No doubt spurred on by the prominence of the two people involved, the portrait was an instant success, and zealously copied even in Houdon's lifetime. Catherine II of Russia had already expressed an interest in a portrait of Voltaire during Houdon's work on his bust of her. The numerous versions turned out by Houdon's workshop testified to the great demand. One critic guessed that Houdon's sculpture was, "of the thousand portraits done of M. de Voltaire, the only one with which he would have been really satisfied." At any rate, it became the portrait of Voltaire best-known to posterity. In combining honesty of physical appearance with respect for the sitter's great intellect, the sculpture pays tribute to the ideals of the Enlightenment, of which Voltaire was undoubtedly the most brilliant representative. *kl*

JEAN-ANTOINE HOUDON
1741 Born 20 March in Versailles, France.
1742 His family moves to Paris.
1758 Becomes a pupil of Michel-Ange Slotz.
1761 Wins the sculptural competition at the Académie Royale.
1764 After completing his studies, goes to the French Academy in Rome.
1768 Returns to Paris and regularly exhibits at the Salon until 1795.
1771 Travels to the court at Gotha, returning there two years later.
1777 Becomes a member of the Académie Royale.
1778 Sculpts his portrait of Voltaire.
1785 Travels to the USA to do a portrait of George Washington.
1828 Dies 15 July in Paris.

Louis-Léopold Boilly, *Jean-Antoine Houdon*, 1790, oil on canvas, Musée des Arts Décoratifs, Paris

LOUIS XV (KING OF FRANCE)

FRANCISCO GOYA

JOHN CONSTABLE

1775 J. M. W. Turner born

1789 George Washington becomes first
president of the USA
1789–1799 French Revolution
1797 Napoleon destroys Repub
lic of Venice and hands
Venice to the Habsburgs

1720 1725 1730 1735 1740 1745 1750 1755 1760 1765 1770 1775 1780 1785 1790 1795 1800 1805

Antonio Canova, *Cupid and Psyche*, 1793,
marble, h. 155 cm, The State Hermitage,
St. Petersburg

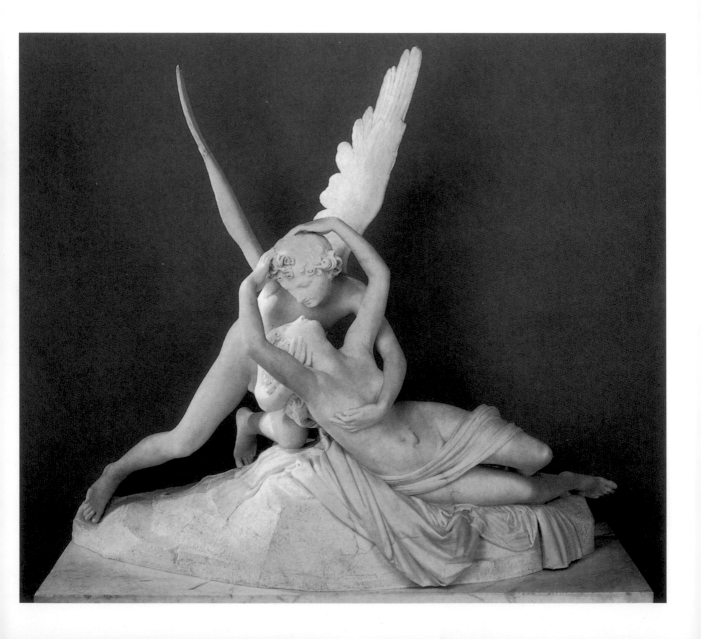

1847 Communist Manifesto by Karl Marx and Friedrich Engels

1862 Gustav Klimt born

1884–1886 Auguste Rodin, Burghers of Calais

1853 Vincent van Gogh born

1889 Eiffel Tower, Paris

| 1810 | 1815 | 1820 | 1825 | 1830 | 1835 | 1840 | 1845 | 1850 | 1855 | 1860 | 1865 | 1870 | 1875 | 1880 | 1885 | 1890 | 1895 |

ANTONIO CANOVA

CUPID AND PSYCHE

The Romeo and Juliet of antiquity. Thanks to Antonio Canova, the Greek ideal of beauty underwent an unexpected revival around 1800. The inspired sculptor from the hinterland of Venice was celebrated worldwide as the Phidias of his day.

Admittedly, Possagno does not pulsate with life. Modern tourists steer well clear of the sleepy village in the Veneto. And yet this quiet town has a special claim to fame. High above the roofs, against the backdrop of snow-covered mountains, a monumental, grandiose structure rises unexpectedly. It is a copy of the Pantheon in Rome and inside there is a huge sarcophagus. This contains the earthly remains of a sculptor who established canons of taste that were accepted from Russia to North America and reaped him a reputation as the most gifted artist of his day. The luminaries of his time, whether Goethe or Keats or Poe, lifted their hats to the sculptures of Antonio Canova. "Michelangelo always has a vision of hell in mind," said Stendhal, "Canova had subtle sensuality."

Convert to the Greek Ideal

Canova worked in Vienna for the Habsburgs, in London for the liberal middle classes, and in Paris for Napoleon, who is supposed to have been "not amused" when he saw his image—apart from the obligatory fig leaf, Canova had depicted him stark naked as a classical hero, though with the distinctive Corsican face. The perfect combination of the classical ideal of beauty and the contemporary need for realism was, after all, Canova's trademark.

Apparently Canova's talent revealed itself very early. Having grown up in his grandfather's sculptural workshop in Possagno, he is said to have modeled a lion in butter for a dinner table when he was 11—and moreover so skillfully that he was thereupon apprenticed to a well-known Venetian master. Later he went to Rome and visited the ruins of Pompeii and Herculaneum, which in those days, just being uncovered from beneath thick layers of volcanic dust and ash, were opening up a unique glimpse into the world of antiquity. Canova became a late convert to Winckelmann's principle that contemporary art achieved its highest form only if it imitated "ancient Greek style" perfectly.

"The Artist's Most Delicate and Yet Most Sensual Creation"

This perfection is just what Canova managed to achieve with *Cupid and Psyche*, a subject that he got from the *Golden Ass* by Lucius Apuleius, the only Latin novel to survive in its entirety. The open wings of Cupid, the god of Love, mark a quantum leap in the handling of marble. The space between them is suddenly as important as the stone itself. Added to that is the bewitching charm of the figures. There are of course critics who talk about the couple as "Canova's normal cemetery plunder." This contrasts with the approving comment by Austrian chancellor Metternich, who ordered a copy in Carrara marble from Canova, and noted in his diary: "It is the artist's most delicate and yet most sensual creation. The marble is transformed here into love and grace. I have just one apprehension about the work—what the innocent and chaste will say. If they visit me, shall I have to cover Cupid with a dressing gown and hide Psyche under a blanket? If these charming creatures did not weigh 23 Zentner [2,535 pounds], I would have wheels put on them. As they are, they are immobile and faithful as a cat. What pleases me is that, despite his wings, Cupid can never leave my house again." *kr*

ANTONIO CANOVA
1757 Born 1 November in Possagno, a village 50 miles (80 km) north west of Venice.
1768 Takes life classes in Venice till 1776.
1775 Sets up his first studio at the monastery of San Stefano in Venice.
1783 His tomb for Pope Clement XIV makes him famous overnight. He is henceforth considered the presiding genius of European sculpture, comparable only with Michelangelo and Bernini.
1802 Pope Pius VII appoints him lifetime director of the Papal art collections.
1815 At the Congress of Vienna, he is the papal legate negotiating the return of works of art stolen from Rome by Napoleon. The rules for dealing with art plunder he formulates are still used today.
1818 The commune of Possagno asks him for a contribution to the renovation of the parish church. Canova designs a new church based on the model of the Pantheon in Rome, shoulders the entire cost of the building, and ordains his future burial there.
1822 Dies 13 October in Venice.

Antonio Canova, *Self-portrait*, 1792, oil on canvas, 68 x 54.5 cm, Uffizi Gallery, Florence

1730　1735　1740　1745　1750　1755　1760　1765　1770　1775　1780　1785　1790　1795　1800　1805　1810　1815

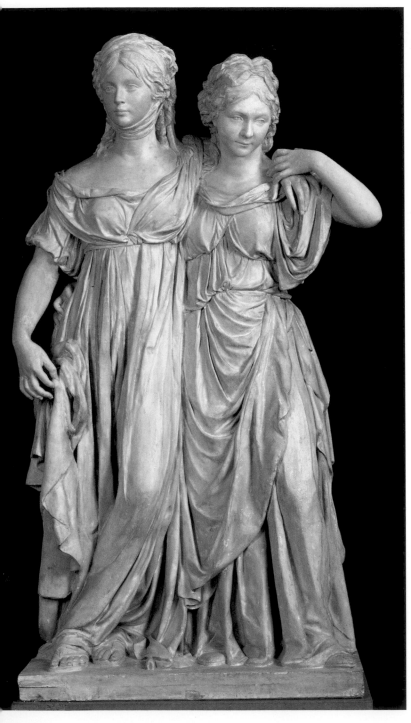

left:
Johann Gottfried Schadow, *The Prussian Princesses*, 1795–97,
marble, 172 x 94 x 59 cm, Nationalgalerie, Berlin

above:
Johann Gottfried Schadow, *Princess Friederike of Prussia*, 1795,
clay, fired, 53 x 34.5 x 23 cm, Nationalgalerie, Berlin

WILLIAM MORRIS

FRIEDRICH NIETZSCHE

VICTOR EMMANUEL II KING OF ITALY

1830 Liverpool-Manchester railway **1852** John Everett Millais, *Ophelia* **1868–1892** Ludwig of Bavaria builds Schloss Neuschwanstein **1893** Edvard Munch, *The Scream*

| 1820 | 1825 | 1830 | 1835 | 1840 | 1845 | 1850 | 1855 | 1860 | 1865 | 1870 | 1875 | 1880 | 1885 | 1890 | 1895 | 1900 | 1905 |

JOHANN GOTTFRIED SCHADOW

THE PRUSSIAN PRINCESSES

The triumph of naturalism. The works of Johann Gottfried Schadow straddle courtly etiquette and bourgeois aspirations. His portrait of two princess sisters helped to set a new fashion.

When Prussian king Frederick William II met the entrancing daughters of the Duke of Mecklenburg-Strelitz, he was astonished by the sensational beauty of the "two angels." He decided that 17-year-old Luise and her 15-year-old sister Friederike should marry his sons. And indeed, nine months later, at Christmas in 1793, a double wedding was celebrated. The older sister married the 23-year-old Crown Prince, later King Frederick William III, while the younger married Prince Frederick Ludwig Karl. Berlin was agog. The enchantment that the sisters radiated captivated all social levels.

Contrary to the Classical Ideal

Painters queued up to depict them. Royal court sculptor Johann Gottfried Schadow received a written order to make busts of the princesses, with the accompanying expectation that he would naturally come up with "something entirely appropriate." Luise and Friederike sat for him in the side wing of the Crown Prince's Palace in stately Unter den Linden. Of course, Schadow knew all about classical ideals of beauty and how one could improve on them as an artist. But what interested him was solely "profiling nature," which is why, like his father, a master tailor in Berlin, he took his tape with him and made measurements of the living models to act as his guide. Though his striving for a lifelike representation was modern, it was still strongly criticized at the time. Weimar archeologist Carl August Böttiger, for example, carped at the strange headgear of Luise, saying it "diminished her beauty." Schadow defended himself, saying that Luise wound a cloth round her head and chin at the sittings to cover a swelling on her neck—which prompted Böttiger in turn to lament poor art "that couldn't even get over a thick neck in its proper business of striving towards an ennobling ideal." The Weimar archeologist's petty remark went unnoticed. In public, the natural, informal expression of the busts was widely applauded. At the same time, Luise's notable head-

dress became not only her identifying feature but also a fashion phenomenon.

In and Out of Fashion

No wonder Schadow soon received a further commission to do a figurative group "of the two high-born ladies" based on the busts. According to his memoirs, he worked "with quiet enthusiasm" on the plaster model, "and the ... ladies provided what he was looking for from their wardrobes, and so the fashion of the time had its influence on their dress." Once again, the result was very successful: "I've hardly ever seen anything more splendid in modern statues," exulted the Berlin correspondent of the fashion periodical *Journal des Luxus und der Moden*. On Frederick William II's fifty-third birthday, the statue of the two princesses was the brilliant focus of the festivities. But when the king died seven weeks later, Schadow's masterpiece was consigned to the shadows with him. Luise's strait-laced husband Frederick William III was, unlike his father, keen on correct court etiquette, and couldn't stand the statue. He might perhaps have tolerated the absence of a majestic pose, but for his wife's navel to be visible between the rich folds of the indecently low-cut dress was quite insufferable. What's more, his sister-in-law Friederike had already strayed from the straight and narrow, and was now a source of embarrassment. In that peculiarly clipped style soon imitated by the Prussian military, he said of the sculpture—praised throughout Europe—"Hate it!" and had it put away, first in a chest and then in a back guest room in Berlin's City Palace. It would be over a hundred years before it was seen again in public. *kr*

JOHANN GOTTFRIED SCHADOW
1764 Born in Berlin. He was later also a writer and for decades the influential director of the Academy.
1793 Double wedding of the sons of King Frederick William II with the daughters of Duke Karl Ludwig Frederick von Mecklenburg-Strelitz.
1795 Designs the Quadriga for the Brandenburg Gate in Berlin.
1795 Models the clay busts of Luise and Friederike at the Crown Prince's Palace in Berlin.
1797 The finished marble statue of the princesses is the marvel of King Frederick William II's fifty-third birthday celebrations.
1801 The statue is installed in the Bolsiertes Room of the Berlin City Palace.
1850 Dies in Berlin.
1949 The statue of the princesses survives World War II undamaged in a vaulted cellar of Berlin Cathedral, but as it is being brought out, Luise's head breaks off.

Julius Hübner, Portrait of Johann Gottfried Schadow

KAISER WILHELM II

LUDWIG II OF BAVARIA

1880 Edgar Degas, *Little Dancer, Aged 14*

1853 Vincent van Gogh born

1876 World Fair in Philadelphia, Alexander Graham Bell invents telephone

1871 Wilhelm I becomes kaiser

1887–1889 Eiffel Tower, Paris

1810 1815 1820 1825 1830 1835 1840 1845 1850 1855 1860 1865 1870 1875 1880 1885 1890 1895

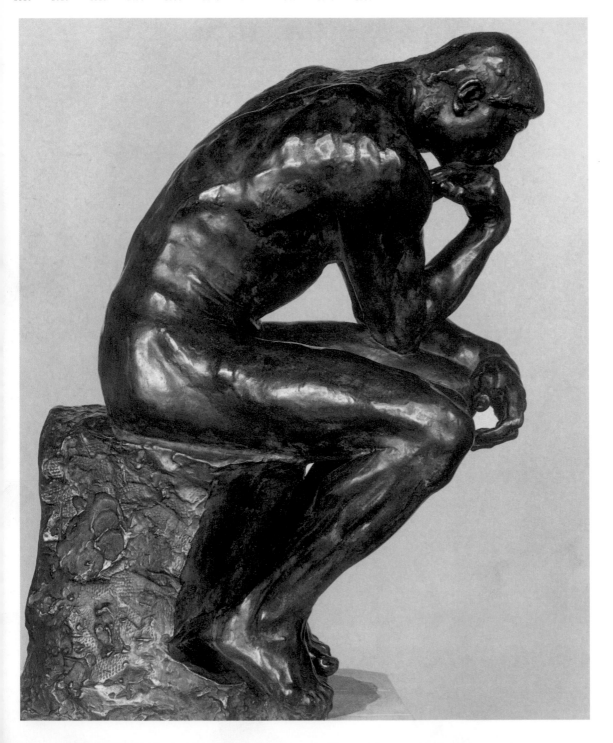

1907 Picasso, *Les Demoiselles d'Avignon*

97–1899 Claude Monet,
The Japanese Bridge

1921 Einstein awarded Nobel Prize

1939–1945 World War II

1914–1918 World War I

1910 Futurist Manifesto,
Italy

| 1900 | 1905 | 1910 | 1915 | 1920 | 1925 | 1930 | 1935 | 1940 | 1945 | 1950 | 1955 | 1960 | 1965 | 1970 | 1975 | 1980 | 1985 |

AUGUSTE RODIN

GATES OF HELL

His first major commission was a door. Not any old door, of course, but a monumental doorway for a new decorative arts museum in Paris. Sculptor Auguste Rodin started on the first designs in 1880, and was still working on the project at the end of his life, 37 years later.

Bizarrely, it was the theme of Hell that he chose as the theme for this "welcoming" entrance. Rodin did his first drawings based on Dante's *Divine Comedy*, with a number of figures that Dante locates in Hell finding a place in his design. Instead of distributing them among separate panels, in the manner familiar from Ghiberti's *Gates of Paradise* in Florence (see pages 64–67), for example, Rodin opted for a unified composition. Countless bodies, some of them almost fully worked out, others less so, stumble and flounder at the Gates of Hell. Some figures seem in free fall, projecting beyond the architectural frames of the door, others clutch at those near them, and still others are beached by the vortex of movement in the background.

No End in Sight

The *Gates of Hell* was planned as a real doorway, something you could go through, but Rodin soon abandoned that idea. The Musée des Arts Décoratifs also had to give up the thought of the work ever being completed, certainly of getting its doors. And in fact it was never built. Major parts of the work were completed by 1896, and in 1900 Rodin even showed the *Gates* unfinished at an exhibition. But instead of completing work on it, he returned to it on and off for the rest of his days. Only after his death was the huge doorway finally cast in bronze, and a cast of the 20 feet 9 inches by 13 feet (6.35 by 4 m) *Gates of Hell* has been in the garden of the Musée Rodin in Paris ever since.

Lost in Thought

Individual figures from the Gates did become famous in the artist's lifetime. Some are even better known than the *Gates* itself. Among these is *The Thinker*, who broods top center over the doors, and was exhibited by Rodin in 1888 (as *The Poet*). The German poet Rainer Maria Rilke, who was Rodin's secretary for a time, described the pensive figure on the lintel as follows: "The figure of *The Thinker* is placed in a calm, closed space, the man who sees the whole greatness and all the horrors of this drama because he is thinking it. He sits lost in thought and silent, heavy with images and thoughts, and thinks with all his might (which is the might of a doer). His whole body has become a skull, and all the blood in his veins has become brain. He is the centerpiece of the door." Not only the door. A cast of *The Thinker* was also the first work by Rodin set up in a public place, for in 1906 the figure was erected outside the Panthéon in Paris. And, at Rodin's express request, a version sits on his tomb in Meudon. *ik*

AUGUSTE RODIN
1840 Born 12 November in Paris.
1857 Applies unsuccessfully to the École des Beaux-Arts (first of three unsuccessful applications).
1875 Travels to Italy to study classical sculpture and the works of Michelangelo.
1877 Exhibits his first bronze: *Age of Iron*.
1880 Receives the commission for the *Gates of Hell*.
1880–82 *The Thinker*.
1886/87 *The Burghers of Calais*.
1900 Rodin exhibition in Paris during the World Fair.
1906 *The Thinker* erected in front of the Panthéon in Paris.
1917 Dies 17 November in Meudon.
1919 Rodin Museum opens in Paris.

left page:
Auguste, Rodin, *The Thinker*, 1881, bronze, 71.9 x 45.1 x 56.2 cm, Musée Rodin, Paris

above:
Pierre Choumoff, Auguste Rodin, 1916/17, photograph

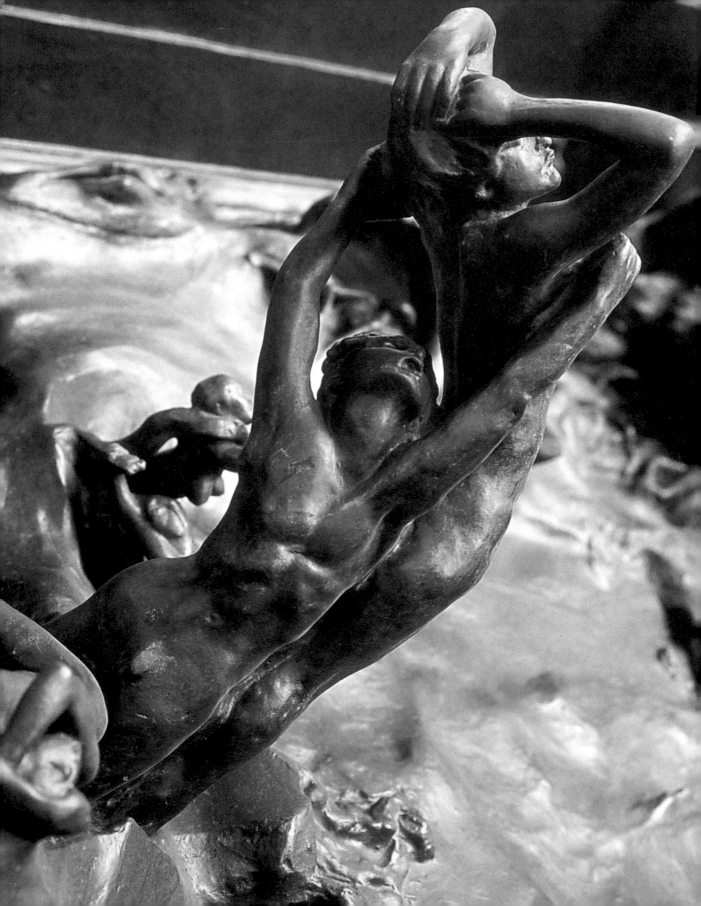

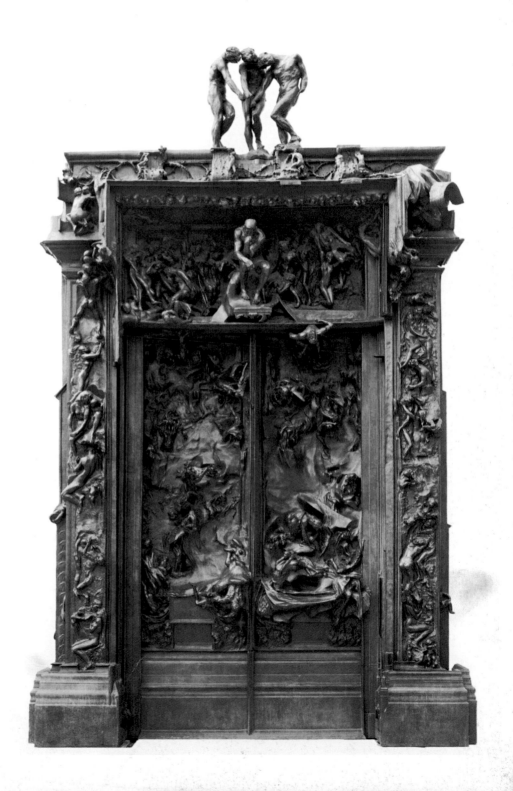

LE CORBUSIER

LUDWIG MIES VAN DER ROHE

1853 Vincent van Gogh born

1884–1886 Auguste Rodin,
Burghers of Calais

1884–1886 Georges Seurat,
La Grande Jatte

1887 Marc Chagall born

1891 Oscar Wilde
*The Picture of
Dorian Gray*

| 1810 | 1815 | 1820 | 1825 | 1830 | 1835 | 1840 | 1845 | 1850 | 1855 | 1860 | 1865 | 1870 | 1875 | 1880 | 1885 | 1890 | 1895 |

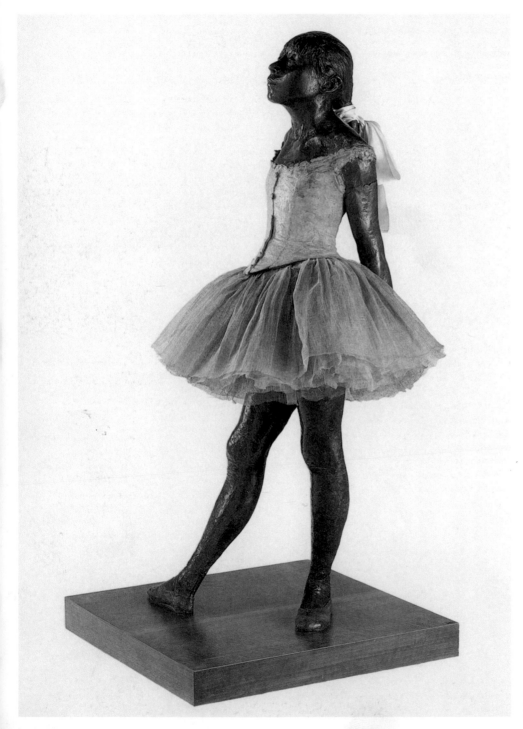

Edgar Degas, *Little Dancer, Aged 14*,
1881, bronze, tulle tutu, satin hairband,
h. 95.2 cm Musée d'Orsay, Paris

1907 Picasso, *Les Demoiselles d'Avignon* **1925/26** Walter Gropius, Bauhaus, Dessau
1905/1907 Founding of Die Brücke and Blauer Reiter groups of artists
1897–1899 Claude Monet, *The Japanese Bridge* **1928–1930** William van Alen, Chrysler Building, New York City
1914–1918 World War I

| 1900 | 1905 | 1910 | 1915 | 1920 | 1925 | 1930 | 1935 | 1940 | 1945 | 1950 | 1955 | 1960 | 1965 | 1970 | 1975 | 1980 | 1985 |

EDGAR DEGAS

LITTLE DANCER, AGED 14

Though the Little Dancer is made of bronze, that does not stop her wearing a real tulle skirt and a hairband made of pink satin. By making a sculpture that is a collage of disparate materials, Degas was venturing into new terrain.

Degas was fascinated by the world of dance. The dancers training, rehearsing, or performing at the Paris Opéra were subjects that perpetually interested him. And not just their movements—the young women had a hard life, and he captured his unromantic glimpses of it on canvas and paper, and occasionally in sculpture, as here. His model for the *Little Dancer* was Marie van Goethem, a dancer from the Opéra.

Behind Glass
Degas exhibited the figure in 1881, but not as a bronze cast—he had modeled it out of colored wax. He showed it with some of his paintings at the 6th Impressionist Exhibition in Paris. Pert and erect, and with her hands clasped behind her back, the young dancer looks self-assuredly at the viewer. Visitors were amazed to see real items from the ballet on a wax figure, a curious mix of reality and art. The *Little Dancer* had real hair, a tutu made of tulle, and real ballet shoes. At the request of its creator, it was shown in a glass showcase, as if it were an exhibit in a natural history museum. But that was not the only thing that caused controversy. Many critics particularly disliked the rather supercilious expression on the girl's face. But for Degas, that was merely the logical outcome of a realistic representation.

Experiments in Wax
That was the first and last time Degas exhibited a sculpture, but by no means the end of his sculptural output. When he died in 1917, around 150 sculptures were found in his studio. At that date, none of the numerous racehorses or the many dancers fashioned in wax, clay, or cork were known. Degas had explicitly decided not to make bronze casts of them: "My sculptures will never convey a sense of being completed, which is the sculptor's *non plus ultra*," he declared, "because no-one will see these experiments. … By the time I die, they'll have fallen apart." However, many of his models were in fact immortalized in bronze in the 1920s, including the *Little Dancer*. In order to convey as realistic a sense of the original as possible, it was attempted to keep to the combination of real and modeled features as much as possible. *ik*

EDGAR DEGAS
1834 Born 19 July in Paris.
1853 Given permission to paint in the Louvre.
1855 Admitted to the École des Beaux-Arts.
1856 Makes a trip to Italy.
1862 Meets Édouard Manet.
FROM 1865 Exhibits at the official Salon in Paris.
1874 Participates in the 1st Impressionist Exhibition.
1881 Takes part in the 6th Impressionist Exhibition, showing among other works the *Little Dancer*.
1892 First solo exhibition.
1917 Dies 27 September in Paris.

MUSEUM TIP
The bronze cast made after the death of the sculptor can be admired at the Musée d'Orsay in Paris. The copy exhibited there is a good reproduction of the wax model. There is also a version in the Tate in London.

left:
Edgar Degas, *Cheval au galop sur le pied droit*, 1917, bronze, h. 30.5 cm, private collection

above:
Edgar Degas, *Self-portrait in a Soft Hat*, 1857–58, oil on paper on canvas, 26 x 19 cm, Sterling and Francine Clark Art Institute, Williamstown MA

QUEEN VICTORIA

1861–1865 American
Civil War

1876 World Fair in Philadel-
phia, Alexander Graham
Bell invents telephone

1887–1889 Eiffel Tower, Paris
1884–1886 Auguste Rodin, *Burghers of Calais*
1891 End of Indian Wars in USA
1897–1899 Claude Monet,
The Japanese Bridge

| 1820 | 1825 | 1830 | 1835 | 1840 | 1845 | 1850 | 1855 | 1860 | 1865 | 1870 | 1875 | 1880 | 1885 | 1890 | 1895 | 1900 | 1905 |

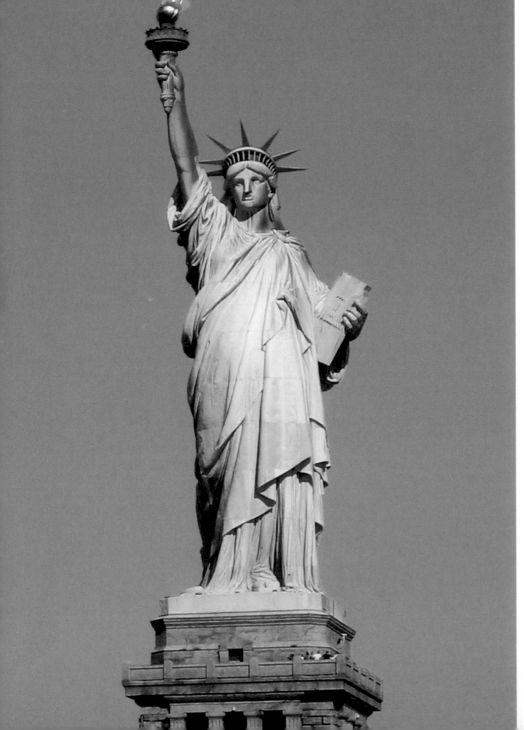

Frédéric-Auguste Bartholdi, *Statue
of Liberty*, 1886, copper, h. 93 m,
New York City

| 1910 | 1915 | 1920 | 1925 | 1930 | 1935 | 1940 | 1945 | 1950 | 1955 | 1960 | 1965 | 1970 | 1975 | 1980 | 1985 | 1990 | 1995 |

FRÉDÉRIC AUGUSTE BARTHOLDI

STATUE OF LIBERTY

Lady Liberty holding aloft the torch of enlightenment—symbol of the American dream and a sign of hope for millions of immigrants seeking a better future in the New World.

Frédéric Auguste Bartholdi was anything but modest. He always thought big. Among his earliest creations was a memorial to French Lieutenant-General Jean Rapp, once an adjutant of Napoleon. The preliminary negotiations with the clients had mentioned only a life-size statue. Bartholdi finally delivered a monumental figure 23 feet (7 m) high. Again, instead of the originally planned memorial column in memory of the siege of the city by German troops in the winter 1870/71, he produced the Lion of Belfort—a sandstone monster 36 feet (11 m) high and 72 feet (22 m) wide representing Belfort's resistance, undoubtedly one of the most fearsome monuments of the 19th century.

The Biggest Sculpture of All Time

All that was still not enough for Bartoldi. After all, on a trip to Egypt, from where he returned with numerous sketches, he had seen the Great Sphinx at Giza. And now he wanted to upstage that with a colossal work of his own. Intoxicated with the idea, he planned the biggest sculpture of all time: a huge, 90-feet (27.4-m) high, lighthouse-shaped, torch-bearing Egyptian woman astride the entry to the Suez Canal, which had just been completed. Undoubtedly, he was influenced by the Colossus of Rhodes, one of the Seven Wonders of the ancient world. Unfortunately, Khedive Ismail Pasha, the Ottoman viceroy of Egypt, had no funds to spare, so no finance was forthcoming. It was therefore an incredible stroke of luck for the disappointed Bartoldi when he happened to make the acquaintance of French journalist and politician Édouard René de Laboulaye about that time. Laboulaye had not only written a three-volume history of the USA, but was also full of a scheme for setting up a huge memorial to the American people in time for the centenary of the Declaration of Independence. It was to be a tribute to the shared belief of the two nations in liberty, equality, and fraternity, and at the same time a thank-you to the Americans for helping

Paris out with food packages during the siege of Paris by German troops in 1870/71. Specifically, members of the Franco-American Society founded by Laboulaye had a colossal statue in mind that would surpass anything that had gone before.

Transported in 350 Pieces

Bartoldi immediately got to work at his drawing table. He revised his unbuilt design for the figure at the entrance to the Suez Canal, gave her the facial features of Isabelle Eugenie Boyer, wife of sewing machine manufacturer Isaac Merritt Singer, and plumped for an island in New York harbor as the future location. However, the lady was actually designed and built out of copper sheet in Paris, and all that took much longer than expected. It was only on 17 June 1885, nine years after the centenary of the American Declaration of Independence, that the Statue of Liberty (also known as *Liberty Enlightening the World*) arrived in New York on board the French frigate Isère—as 350 components packed into 214 chests. Everything was ready by 1886. Amid the deafening booms of foghorns and a 21-cannon salute, the Statue of Liberty, whose torch symbolizes enlightenment, was dedicated by US President Grover Cleveland. At around 305 feet (93 m) from the ground to the tip of the torch, it was indeed the largest sculpture in the world, and certainly one of the best known. *kr*

FRÉDÉRIC AUGUSTE BARTHOLDI

1834 Born 2 August in Colmar, France. After attending the École des Beaux-Arts in Paris, he works as a sculptor.

1870/71 A monumental figure is planned as a gift from the French to the American people. The contract for it is awarded to Bartoldi. The supporting steel frame inside is designed by Maurice Koechlin.

1874 Bartoldi selects an island in New York harbor as a location. This is just a few hundred yards south of Ellis Island, where millions of immigrants from Europe land.

1885 The foundation stone for the huge pedestal is laid, in a masonic ceremony.

1886 Statue of Liberty unveiled on 28 October. Édouard René de Laboulaye, initiator of the gift, does not live to see the day, having been murdered three years earlier in Paris.

1904 Bartoldi dies 4 October in Paris.

1956 Bedloe's Island, on which the Statue of Liberty stands, is renamed Liberty Island.

Frédéric-Auguste Bartholdi, 1880, photograph

AUGUSTE RODIN

PABLO PICASSO

WILHELM LEHMBRUCK

1840 Claude Monet born

1860/61 Charles Dickens,
Great Expectations

1884 Max Beckmann born

1896 *Simplicissimus* magazine, Munich

1894 Reichstag completed in Berlin

1900 Sigmund Freud, *Interpretation
of Dreams*

1830 1835 1840 1845 1850 1855 1860 1865 1870 1875 1880 1885 1890 1895 1900 1905 1910 1915

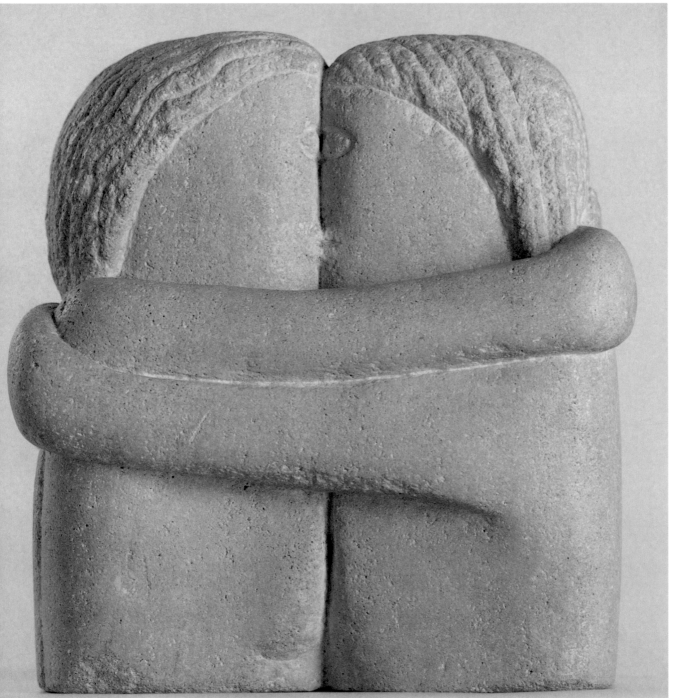

1922 Mussolini seizes power in Italy

1925 Beginning of global economic crisis

1925/26 Marcel Breuer, tubular chair

1937 Picasso, *Guernica*

1966 American Neil Armstrong becomes the first man to walk on the moon

1989 Fall of Berlin wall

1920 1925 1930 1935 1940 1945 1950 1955 1960 1965 1970 1975 1980 1985 1990 1995 2000 2005

CONSTANTIN BRANCUSI

THE KISS

Two lovers barely emerge from a block of stone as though reluctant to leave it. The simple lines of their heads and upper bodies remain within the cube-like outline of the light-colored stone; even the arms cling to it.

The couple are locked in a tight embrace, their lips meeting in a kiss. Their heads and bodies look wholly symmetrical, reinforcing the impression that there are not two figures here but just one, the two having fused. *The Kiss*, one of the earliest works in stone by Romanian sculptor Constantin Brancusi, radically simplifies human shapes in order to attain this block-like sculpture.

The Search for Simplicity

Brancusi was already at home in the heart of the artistic world when he first tackled the subject of the kiss. He had settled in Paris aged 28, after finishing a course at the Bucharest academy of art. In Paris, he met the celebrated sculptor Auguste Rodin (see pages 104–107), who gave him a job as a studio assistant. But after only two months the young artist from provincial Wallachia left: In the end, nothing prospers in the shadow of great trees. And in the following years, what Brancusi produced was in a league of its own, leaving all antecedents behind. *The Kiss* is also the name of a celebrated marble sculpture by Rodin, but Brancusi chose to leave out the stormy passion and sensuality that Rodin's lovers display. Brancusi's approach was to pare down his figures, ultimately fusing them in their extreme simplicity.

But is It Art?

Brancusi frequently returned to the subject of the kiss, once in the form of a tomb stele, and later integrating the motif into a war memorial in his homeland. Other subjects often recur in his work over the decades, in wood, stone and bronze. From 1910, he tackled the subject of birds again and again, making the motif more and more abstract until it finally lost any resemblance to nature. Whether he was working on stone sculptures of people kissing or one of his famous bronze birds, Brancusi always went for formal simplification. His idiosyncratic approach did not always meet with understanding—in 1927, US customs officials refused to classify one of his birds as a work of art, demanding that import tax be paid on the bronze. The affair even reached the courts, where Brancusi was finally vindicated. For Brancusi, form had to do justice to the material, not vice versa. *ik*

CONSTANTIN BRANCUSI
1876 Born in Hobiţa, Romania.
1898–1902 Studies at art school in Bucharest.
1904 Moves to Paris.
1905–07 Studies at the Écoles des Beaux-Arts, Paris.
1906 Meets Auguste Rodin.
1907 Carves *The Kiss*.
1910–12 Creates *Maiastra*, his first bird sculpture.
1913 Takes part in the Armory Show, New York.
1914 First solo exhibition in New York.
1935 Commissioned to create a war memorial in Tîrgu-Jiu, Romania.
1955/56 Retrospective of his work at the Guggenheim Museum, New York.
1957 Dies 16 March in Paris.

left page;
Constantin Brancusi, *The Kiss*,
1907/08, limestone, 28 x 26 x 21.5 cm,
The Philadelphia Museum of Art,
Philadelphia

above:
Portrait of Constantin Brancusi

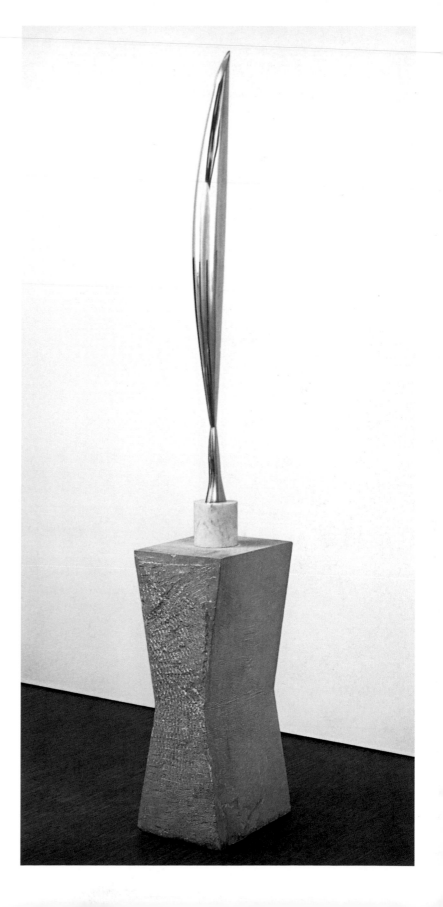

1834 Edgar Degas born

1884 Work starts on Antoni Gaudí's
Sagrada Familia, Barcelona

1900 Sigmund Freud, *Inter-
pretation of Dreams*

1911 Marc Chag
The Village

| | | | | | | | | | | | | | | | | | |
|1830|1835|1840|1845|1850|1855|1860|1865|1870|1875|1880|1885|1890|1895|1900|1905|1910|1915|

Marcel Duchamp, *Bottle Rack*, 1914/1964, galvanized iron,
h. 64.2 cm, Musée National d'Art Moderne, Centre Georges
Pompidou, Paris

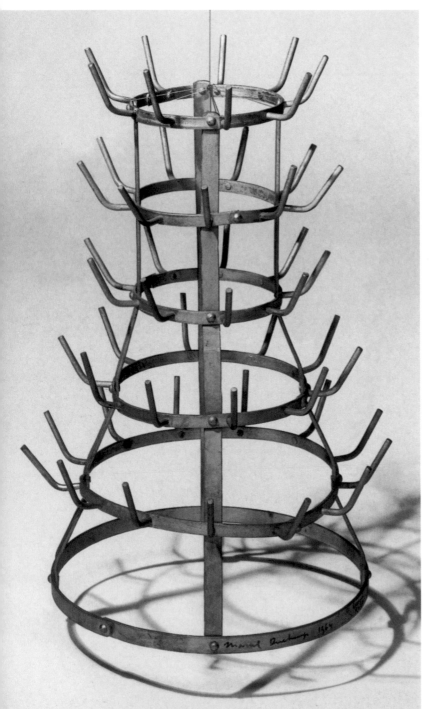

Object Art

The collages artists designed at the beginning of
the 20th century were the beginning of Object Art.
Marcel Duchamp's *Bottle Rack* in 1914 explored
entirely new ways in art by blurring the bounda-
ries between works of art and utilitarian objects.
With his "ready-mades," the artist's ideas were
important, while the work itself and questions of
artistic technique were secondary considerations.
Particularly in the second half of the 20th century,
objects and assemblages of various materials
increasingly replaced sculpture made by tradition-
al methods.

c. 1922 Piet Mondrian,
Composition
1937 Degenerate Art exhibition in Munich

1933 Nazis come to power
in Germany

6 Einstein's Theory
of Relativity

1956–1959 Frank Lloyd Wright,
Guggenheim Museum, New York

1926 Fritz Lang, Metropolis

1942 Edward Hopper, Night Hawks

| 1920 | 1925 | 1930 | 1935 | 1940 | 1945 | 1950 | 1955 | 1960 | 1965 | 1970 | 1975 | 1980 | 1985 | 1990 | 1995 | 2000 | 2005 |

MARCEL DUCHAMP

BOTTLE RACK

In 1914, Marcel Duchamp bought a metal bottle rack in the kitchen department of a Paris store. The 26-year-old artist took the item home with him and signed it as a work of art.

Signed it? Since when has a bottle rack been a work of art? But that was the very paradox that Duchamp was exploring in his works. He was demonstrating that, for him, it was not artistic craftsmanship that counted but the idea behind the work, and the idea alone. Simply by selecting them, Duchamp turned ordinary, everyday things into art. Beginning in 1914, he came up with a whole series of similar utilitarian objects—and they are still controversial. By going for mass products—whether a bicycle wheel, a urinal, or a bottle rack—and signing them, he turned them into art. He later called such works "ready-mades," and also talked about how he went about finding them. In 1968, an interviewer asked how he selected his ready-mades. Duchamp's reply was that it was exactly the other way around—the works chose him. And he went on: "The idea was to find an object that had no attraction from an aesthetic point of view. That was the act of a non-artist ... A crafts-man, if you like."

Ahead of His Time

Duchamp had similar clear ideas about viewers' expectations: "The danger is always of pleasing the immediate public around you, who take you up and lionize you and dose you with successes." At least on that account he needed to have no worries at first—his works were chiefly a source of scandal. After *Bottle Rack*, it was mainly the urinal he tried to exhibit as a drinking fountain in 1917 that caused affront and really pushed back the concept of art. But Duchamp was totally unfazed by its rejection: "Perhaps ... one will have to wait fifty or one hundred years for one's real public, but that's the only public that interests me." As far as *Bottle Rack* is concerned, its popularity scarcely leaves anything to be desired. The former kitchen appliance has long since become one of the best-known art works of the 20th century.

Multiples

Duchamp himself selected his reborn bottle rack several times over. In 1921, he signed a second model, which unlike the first version still survives. The artist first officially presented the work in 1936 during a Surrealist exhibition in Paris, and in the same year showed it at the Museum of Modern Art in New York. Further versions followed in the 1960s, with Duchamp showing himself very open-minded: he signed a small edition of bottle racks, and for *Bottle Rack* fans who had bought a rack of their own in the store, he simply added his signature. Thus copies could likewise be art—as long as you said they were. *ik*

MARCEL DUCHAMP
1887 Born 28 July in Blainville, France.
1904 Moves to Paris, where he attends the Académie Julian.
1913 His painting *Nude Descending a Staircase* scandalizes visitors to the Armory Show in New York.
1914 *Bicycle Wheel* and *Bottle Rack*.
1915 Begins work on the *Large Glass* (*Bride Stripped Bare by Her Bachelors, Even*).
1917 *Fountain*.
1936 Begins work on *Box in a Valise*, which contains reproductions of his works.
1942 Emigrates to the USA.
1951 *Bicycle Wheel* exhibited for the first time.
1968 Dies 2 October in Neuilly-sur-Seine, France.

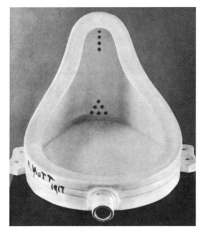

left:
Marcel Duchamp, *Fountain*, 1917/1964, readymade: porcelain urinal, 61 x 48 x 36 cm, Indiana University Art Museum, Bloomington

above:
Ugo Mulas, *Marcel Duchamp*, 1956, photograph

1848 John Everett Millais, William Holman Hunt, and Dante Gabriel Rossetti found the Pre-Raphaelite Brotherhood

1844 J. M. W. Turner, *Rain, Steam and Speed*

1862 Gustav Klimt born

1884 Work begins on Antoni Gaudí's Sagrada Familia, Barcelona

1893 Aubrey Beardsley illustrates Oscar Wilde's *Salomé*

1907 Founding of the Deutscher Werkbun

1830 1835 1840 1845 1850 1855 1860 1865 1870 1875 1880 1885 1890 1895 1900 1905 1910 1915

Naum Gabo, *Kinetic Construction*, 1919/20 (replica 1985), Metal rod with electric engine, h. 61.5 cm, Tate Gallery, London

1950–1954 Le Corbusier, Notre Dame
du Haut, Ronchamp, France

1925/26 Walter Gropius, Bauhaus, Dessau

1955 Beginnings of Pop Art

| 1920 | 1925 | 1930 | 1935 | 1940 | 1945 | 1950 | 1955 | 1960 | 1965 | 1970 | 1975 | 1980 | 1985 | 1990 | 1995 | 2000 | 2005 |

NAUM GABO

KINETIC CONSTRUCTION

A simple vertical metal rod standing on a plinth has been a firm fixture in all art histories for decades. Admittedly it's not just any old piece of metal.

Russian artist Naum Gabo had already spent years abroad, studying natural sciences and architecture in Munich and then making his first sculptures in Norway, before he returned to his homeland in 1917. He settled in Moscow, and got a job as a teacher at the state art-technical workshops. When revolution broke out in Russia that year and social turmoil followed, the young artist wanted to play his own part in the construction of the new society. He therefore turned to modern materials such as glass, steel, and plastic, and soon arrived at a completely new view of sculpture.

Art with an Engine

Over the next three years, Gabo created three sculptures in Moscow that were an expression of his wholly new approach. One of them was the above metal rod called *Kinetic Construction*, which was produced in the winter of 1919/20. It consists of a vertical rod set in motion by an engine. When the structure is moving, the rod vibrates evenly to produce a spindle shape. *Kinetic Construction* consists of the constant repetition of a movement described as "standing oscillation." This gives it "volume," but as soon as the motor is switched off, that vanishes. So the volume is not solid mass but a form created in the emptiness of the surrounding space.

Back to Reality

Works such as *Kinetic Construction* reflect Gabo's enthusiasm for technology. But they also express his conviction as to what subjects sculpture should devote itself. For Gabo, space and time were the two basic elements of life and therefore of art too. To express time, static objects were no use, which is why he had to resort to real movement. His *Kinetic Construction* changed in time and space, manifesting movement, energy, and speed. And that was exactly what was revolutionary—Gabo's works would not simply *represent* all these physical qualities, they would embody them. With his space structures, Gabo did not want to portray reality but to produce real objects. He first exhibited in Berlin in 1922, at the First Russian Art Exhibition. Quite a few visitors were enthusiastic about his works, one of them observing that "this Russian is creating art with a new name, new ideas, and new results." *ik*

NAUM GABO
1890 Born in Bryansk, Russia.
1910 Enrolls as a medical student in Munich, later switching to natural sciences and architecture.
1912 Makes his first trip to Paris.
1919/20 *Kinetic Construction* produced in Moscow.
1922 Participates in the First Russian Art Exhibition in Berlin.
1922–32 Lives and works in Berlin.
1932 Emigrates to Paris.
1936–46 Lives in England.
1946 Moves to the USA.
1977 Dies on 23 August in Waterbury, Connecticut.
1985/86 Major retrospective in North America and Europe.

Michael Carlisle, Naum Gabo on his
80th birthday on 8 August, 1970

1863 Edvard Munch born **1900** Oscar Wilde dies in Paris **1925/26** Walter Gropiu...
 Bauhaus, Dessau

| 1845 | 1850 | 1855 | 1860 | 1865 | 1870 | 1875 | 1880 | 1885 | 1890 | 1895 | 1900 | 1905 | 1910 | 1915 | 1920 | 1925 | 1930 |

1939–1945 World War II

1949/50 Max Beckmann, *The Argonauts*

1954 Federico Fellini, *La Strada*

1933 Nazis comes to power in Germany **1946** First Vespa motorcycle

1956–1959 Frank Lloyd Wright, Guggenheim Museum, New York

1950 Korean War breaks out

2001 9/11 Terrorist attacks in New York

1935 1940 1945 1950 1955 1960 1965 1970 1975 1980 1985 1990 1995 2000 2005 2010 2015 2020

PABLO PICASSO

BULL'S HEAD

"Guess how I made that bull's head?" Picasso asked a visitor. The answer was quite clear: the sculpture in question consisted of just two parts—the handlebar and saddle of a bicycle.

After years of working solely as a painter and graphic artist, in 1943 Picasso returned to sculpture. This time he wanted to work in metal, though it was mainly the things of ordinary life that appealed to him. And the same was true of Marcel Duchamp (see pages 116–117)—Picasso did not look, he found.

What is Left of the Bicycle

And what he found, he put together as a sculpture. By placing them in a new context, the artist "defamiliarized" various everyday objects. A recurrent motif in his work, his *Bull's Head* is radically simplified. Here he created a bull's head from the saddle and handlebar of a bicycle. The work started out as an object he came across—an *objet trouvé* (found object): "One day I found a bicycle saddle underneath some old junk, and alongside it a rusty handlebar. In a flash, the two of them fused in my mind. The idea for this 'bull head' came to me without me thinking about it." Assemblages containing all sorts of found objects would remain Picasso's preferred technique in the coming years.

Working with Nothing

Along with the *Bull's Head*, the *Monument to Apollinaire* is also among Picasso's best-known sculptural works. These two works are further confirmation that his sculptural output is no more to be pigeonholed than his work as a painter and graphic artist. Picasso was invited to submit designs for a monument to the French poet and friend of Picasso's, Guillaume Apollinaire, who had died in 1918. The starting point for Picasso's thoughts on the subject was a remark by Apollinaire about a poet's memorial, where he simply imagined "nothing" to be the material. Picasso took that "nothing" and set about the task energetically, doing countless drawings—simple black lines on white paper. What followed he called "drawing in space," and the most suitable material for it turned out to be wire. So he and his sculptor friend Julio González designed preliminary models of a transparent wire sculpture. Their open shapes and lack of solid volumes came closest to the drawn lines. Picasso's submission for the Apollinaire moment was turned down, but his design was an artistic success. Even the model shows a work that gets by without mass and is almost weightless. *ik*

PABLO PICASSO

1881 Born 25 October in Málaga, Spain.
1895 He and his is family move to Barcelona.
1901 Begins his Blue Period.
1904 Settles in Paris. Begins his Rose Period.
1907 *Les Demoiselles d'Avignon*. He and Braque invent Cubism.
1909 Bronze *Female Head (Fernande)*.
1912 Creates his first wire sculptures and first collages.
1928/29 Works on metal sculptures with Julio González.
1937 Paints *Guernica* for the Spanish pavilion at the Paris World Fair.
1943 *Bull's Head* and other sculptures.
1966 The major retrospective *Hommage à Picasso* held in Paris.
1973 Dies 8 April in Mougins near Cannes, France.

MUSEUM TIP
The French Musée National Picasso is located in a fine town house in the Marais district of Paris. The collection brings together works from every creative period of his life, including a large number of his sculptures.

Pablo Picasso, *Bull's Head*, 1942, leather and metal, 33.5 x 43.5 x 19 cm, Musée Picasso, Paris

Photograph of Pablo Picasso

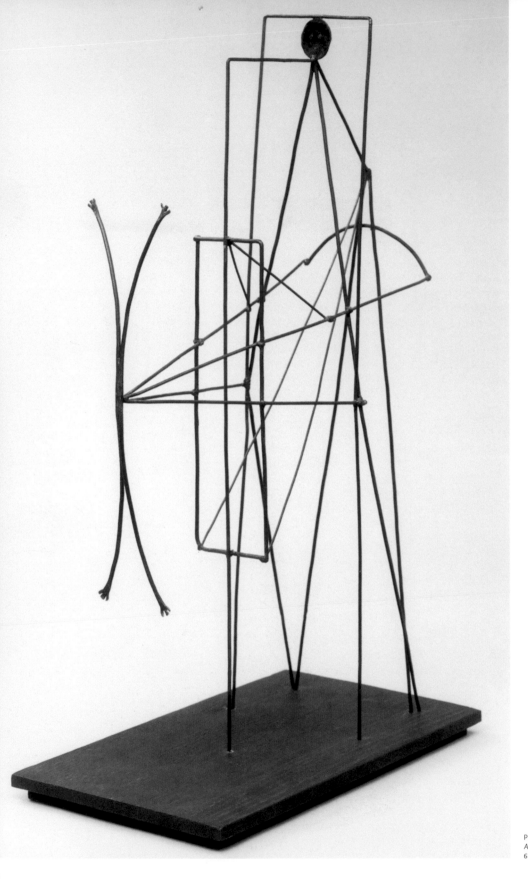

Pablo Picasso, *Monument to Apollinaire*, 1928, iron wire and metal, 60.5 x 15 x 34 cm, Musée Picasso, Paris

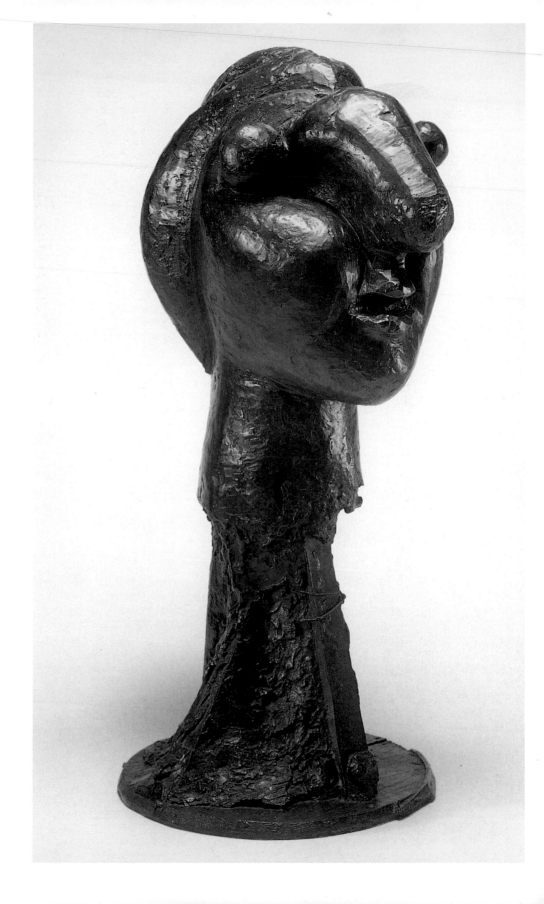

Pablo Picasso, *Woman's Head*, 1931,
bronze, 86.4 x 36.5 x 48.9 cm,
National Sculpture Center, Dallas

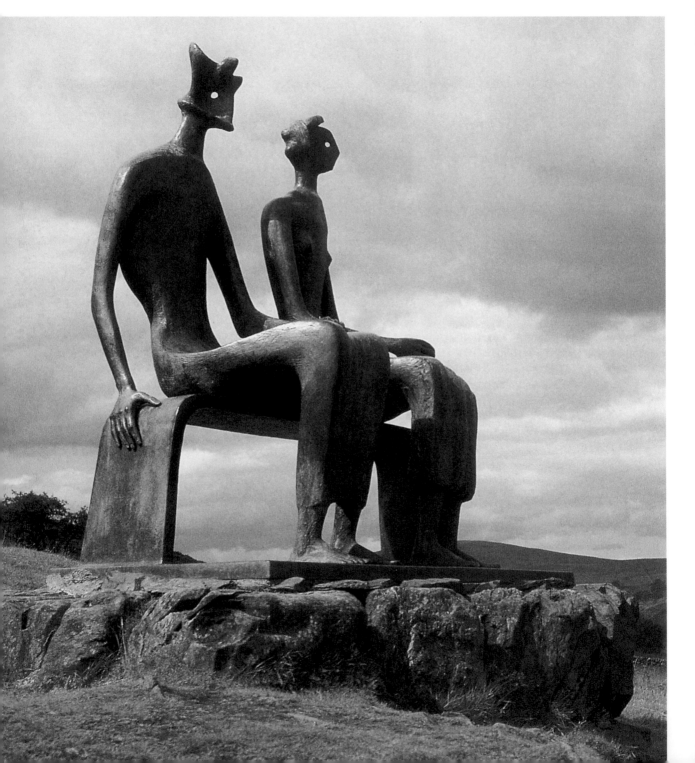

OSKAR KOKOSCHKA

ALVAR AALTO

ALEXANDER CALDER

1969 Woodstock Festival

961 John F. Kennedy becomes US president **1981** First Columbia shuttle

1965 Roy Lichtenstein, M-Maybe **1987** Andy Warhol dies in New York
(A Girl's Picture)

| 1965 | 1970 | 1975 | 1980 | 1985 | 1990 | 1995 | 2000 | 2005 | 2010 | 2015 | 2020 | 2025 | 2030 | 2035 | 2040 | 2045 | 2050 |

HENRY MOORE

KING AND QUEEN

This statue by Henry Moore dates from shortly before the coronation of Queen Elizabeth II in 1953. The British fascination with their just 27-year-old queen undoubtedly helped to make the sculpture well known, but its artistic significance goes well beyond a simple marking of a political event.

Two strange figures sit on a bench on a hilltop in Scotland gazing into the distance. On closer inspection, you recognize that the human-looking bodies have bird-like heads that are too small. The eyes are holes through which you can see the sky. The Queen has her hands in her lap, while the King rests his right hand on the bench and his left hand on his thigh.

Man and Beast

The figures radiate great peace, which is reinforced by the fluid line of their postures. The lithe shapes of the sculpture are due to some extent to Henry Moore's technique of first making a small maquette out of wax while it was soft and warm. Subsequently, he took this view as a model for the larger bronze work. Critics have seen the mixture of man and beast in this sculpture an echo of northern English myths and iconographies. Moore himself said: "The key to the group is perhaps the head of the King, which is a head and crown, face and beard all in one, and to my mind has something slightly Pan-like about it, almost something animal, and yet, I think, something regal." As a god of nature, Pan has much in common with the sculptor's appreciation of the nature-given beauty of his material and the human form.

Nature as the Origin of Sculpture

Henry Moore returned to the theme of reclining figures many times, finding them more interesting than standing or sitting figures, and they form the most extensive group of works by him. He first attempted the subject in the late 1920s, when he revealed his special ability to handle material. Natural materials were of ultimate importance as the origin of the sculpture. He attempted to feel his way into the block of wood or stone, and so worked his sculptures into them. The differing qualities of density, color, and texture in materials were fundamental for him. Often the sculptures are adapted to a landscape, and various angles of viewing give totally different images. Multiple compositions can be constantly recomposed into different viewing angles, and with their different dimensions set up very special relationships with the viewer. Moore always spoke of the "human dimension" of his work. After the Second World War, Moore's patrons were often public institutions. During the war, he did his famous *Shelter Drawings* (people in Underground stations sheltering from air raids) for the government, and subsequently received international commissions for public sculptures. As a result of his long and extensive career, his works can be seen almost everywhere in the world. *kl*

HENRY MOORE
1898 Born 30 July in Castleford, England.
1918 Conscripted into the military.
1917 Student at the Leeds School of Art, and subsequently (from 1921) the Royal College of Art in London.
1925 Scholarship to visit Italy.
1928 First public commission: *West Wind* relief.
1940 Executes his *Shelter Drawings* as an official war artist.
1958 His sculpture is unveiled in front of the UNESCO building in Paris.
1986 Dies 31 August in Much Hadham, now the base of the Henry Moore Foundation.

left page:
Henry Moore, *King and Queen*, 1952/53, bronze, h. 170 cm, W.J. Keswick Collection, Glenkiln, Shawhead, Dumfriesshire, Scotland

above
Henry Moore working on a sculpture in the garden of Burcroft, Kent, photograph from 1937

Henry Moore, *Draped Reclining Figure*, 1952/1953, bronze, l. 157.5 cm, Time-Life Building, Bond Street, London

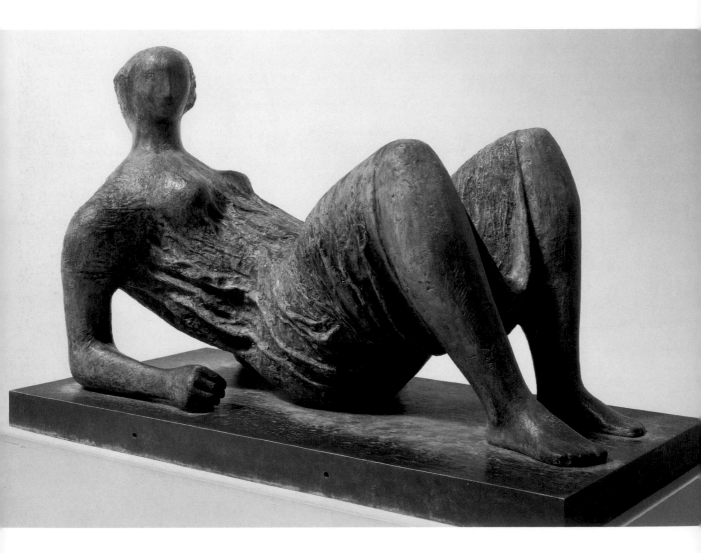

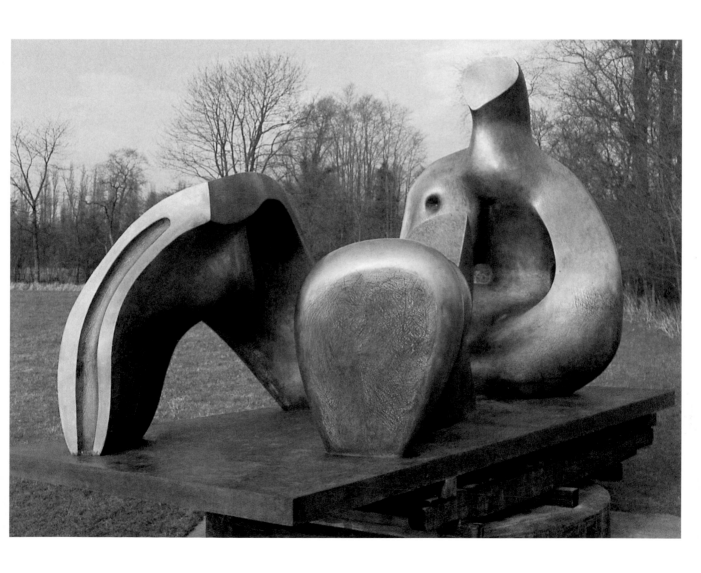

1885 1890 1895 1900 1905 1910 1915 1920 1925 1930 1935 1940 1945 1950 1955 1960 1965 1970

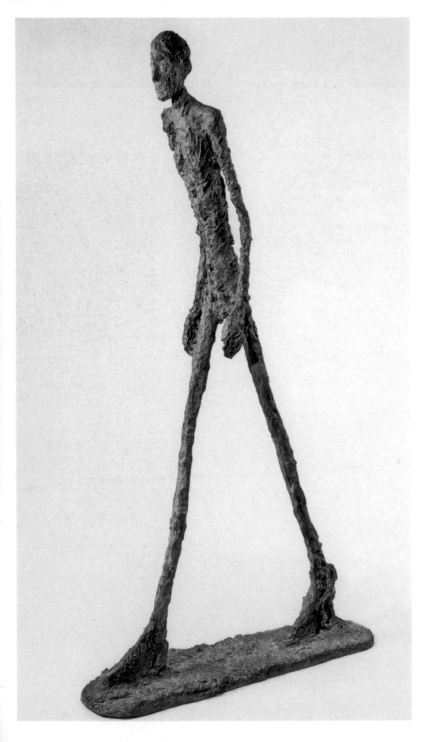

Alberto Giacometti, *Man Striding I,*
c. 1960, bronze, 183 x 26 x 95.5 cm,
Fondation Maeght, Saint-Paul

JOAN MIRÓ

ALEXANDER CALDER

1989 Fall of Berlin wall **2001** 9/11 Terrorist attacks
in New York

| 1975 | 1980 | 1985 | 1990 | 1995 | 2000 | 2005 | 2010 | 2015 | 2020 | 2025 | 2030 | 2035 | 2040 | 2045 | 2050 | 2055 | 2060 |

ALBERTO GIACOMETTI

MAN STRIDING

The figure of a man, thin as a rake and yet life-size, stands on a heavy bronze slab looking keenly ahead. Striding out purposefully, his chin up, he seems to have his destination firmly in his sights.

How do you capture the presence of a person so as to give the impression he is standing right beside you? For the Swiss sculptor Alberto Giacometti, it was essential to answer this question. To do it, he did countless drawings of his favorite models, who posed for him days, sometimes even weeks, on end. In the 1930s, when his early works were already well known and in demand, the artist was still struggling to find a new, individual style. The first sculptures he did in this vein were tiny—so small that they threatened to fall apart. Gradually figures developed with more lively surfaces, small faces, and elongated limbs. The more they shot upwards, the thinner Giacometti's figures became in this period.

Male and Female

These solitary figures or groups of figures look like skeletons, often standing with large feet on heavy bronze plinths. They are among Giacometti's best-known works from the post-war period. The figure of a man striding is a motif that constantly recurs in Giacometti's work over the decades, just like the immobile female figure: "I have established that meantime I can only depict women standing im-mobile, and men always striding. When I design a woman, she is always immobile, the man is always striding." They all show Giacometti's fascination with the surfaces of his works. He used his fingers and the modeling knife to shape his figurative sculp-tures. On their rough surfaces, which are sometimes reminiscent of lava, light and shadow provide an endless variety of effects. Though the striding man is undoubtedly extremely thin and pared down, he retains an extraordinary presence.

No End to the Search

Working from his modest studio in Montparnasse, the arty quarter of Paris, Giacometti came up with figures that grew and grew. He later recalled that he had found the studio much too small at first. But the longer he remained there, the larger it seemed to become. Even his life-size standing figures, such as *Man Striding* of 1960, were created in this Spartan studio. The things he made there in bronze or plas-ter became famous even in the artist's lifetime. His delicate figures traveled to exhibitions in Europe and America and won prizes. Only one person was far from satisfied with his work, and that was Giacometti himself. Even in 1948, the French philo-sopher Jean-Paul Sartre had fears for his friend: "He will never be finished with it; this is simply because a man is always beyond what he has done." *ik*

ALBERTI GIACOMETTI
1901 Born 10 October in Borgonovo
near Stampa (Maloja, Switzer-
land).
1919 Begins art studies in Geneva.
1922 Arriving in Paris, he attends
the Académie de la Grande-
Chaumière.
1926 *Spoon Woman.*
1928/29 *Staring Head.*
1932 First solo exhibition at the Galerie
Pierre Colle, Paris.
1933 First graphic works.
1934/35 First solo exhibition in the
USA (New York).
1939 Meets the philosopher Jean-Paul
Sartre.
1941–45 Lives in Geneva.
1945 Returns to his studio in Paris.
1956 First major retrospective, at the
Kunsthalle, Bern.
1962 Grand prix for sculpture at the
Venice Biennale.
1966 Dies 11 January in Chur, Switzer-
land.

Henri Cartier-Bresson, photograph
of Alberto Giacometti

1914–1918 World War I **1939–1945** World War II **1957–1973** Jørn Utzon, Sydney
Opera House

1907 Pablo Picasso, *Les Demoiselles d'Avignon* **1954** Frida Kahlo **1962** Andy Warhol,
dies *100 Cans*

1885 1890 1895 1900 1905 1910 1915 1920 1925 1930 1935 1940 1945 1950 1955 1960 1965 1970

1981 AIDS deemed an epidemic

1983 SWATCH watches founded

1989 Fall of the Berlin Wall

1986 Chernobyl disaster

1980 John Lennon
murdered

1992–1999 Norman Foster rebuilds
the Reichstag, Berlin

| 1975 | 1980 | 1985 | 1990 | 1995 | 2000 | 2005 | 2010 | 2015 | 2020 | 2025 | 2030 | 2035 | 2040 | 2045 | 2050 | 2055 | 2060 |

JOSEPH BEUYS

FAT CHAIR

If a chair is to be art, we assume it has to be very old, made of precious materials, or by a celebrated designer. The Fat Chair by the German artist Joseph Beuys is none of these, and yet it is a work of great significance in contemporary art.

It consists of a plain wooden kitchen chair of the kind you can get in any furniture store. A large, wedge-shaped lump of fat is placed upon it, covering the entire seat. You can't sit on this chair, so it has lost its original purpose. The sculpture does not correspond with the classical notion of sculptural materials, since it is not made of a durable substance such as stone or metal. Quite the contrary, in fact—it's just an ordinary chair with a slab of fat on it.

The Essence of Fat

Fat is a key material in the work of Joseph Beuys. He particularly valued its malleability and organic qualities. Fat changes with atmospheric conditions: it melts and runs in heat, and becomes hard when cold. It is a source of energy, grease, and many other things. Beuys made whole room-sized installations from blocks of fat, and filled various "Fat Corners" with it. Of his chair sculpture, Beuys said: "The fat on the *Fat Chair* is not geometric like the Fat Corners, but here retains something of its chaotic character. The sides of the wedge are like a cross-section through the essence of the fat. That's what I wanted to emphasize with the fat on the chair, since the chair here represents a kind of human anatomy, the whole business of warming processes to do with digestion and excretion, the sexual organs and interesting chemical changes that relate psychologically to the will."

Art and Society

There is undoubtedly a note of irony in his title due to the double meaning of the German word stuhl ("chair," but also "stool" in both senses). What Beuys is interested in here is very basic physical or bodily processes of transformation. These he always puts in a larger context of existential import.

He derived the organic materials that dominate his work from very personal experiences. He himself put about the myth that after a plane crash in the Crimea—he was a fighter pilot in World War II—Tartar tribesmen saved his life by wrapping him in fat and felt. Starting from this story, he developed a vocabulary of materials that is dominated essentially by everyday materials such as fat, felt, earth, wood, and stone, but also symbolic materials such as gold and blood. Combined with the sober presentation method of his work, his works are sometimes criticized as "detritus-like." But Beuys was less interested in the high craft or material value of his works than in their power to transform people, to make them think and feel differently—his works were all a means to this end. His objective was to use the physical to draw attention to human and political relationships.

He attributed basic importance to talking (about art), with objects to some extent supporting what he was saying. These were relics of his "actions," semi-theatrical works that combined performance and found or made objects. All his life he was keen on dialogue and on changing relationships in society. He used his art in the service of political causes. The plainness of his choice of material corresponds to his democratic understanding of access to art for the masses. *kl*

JOSEPH BEUYS

1921 Born 12 May in Krefeld, Germany.

1940 Takes his *abitur* examination in Cleves; is conscripted for military service.

1944 Survives a plane crash in the Crimea.

1945 Returns from prisoner-of-war camp.

1946–54 Studies at the Art Academy in Düsseldorf under Josef Enseliung and Ewald Mataré.

1961 Becomes professor of sculpture at the Art Academy, Düsseldorf.

1965 Performance work: *How to Explain Pictures to a Dead Hare*, Galerie Schmela, Düsseldorf.

1974 Performance work: *I Like America and America Likes Me*, René Block Gallery, New York.

1985 Palazzo Regale installation in Naples.

1986 Dies 23 January in Düsseldorf.

left page:
Joseph Beuys, *Fat Chair*, 1964, wood, fat, 47 x 42 x 100 cm, Hessisches Landesmuseum, Darmstadt

above:
Photograph of Joseph Beuys

1900 Paris opens its first
underground railway

1923 Roy Lichtenstein born

1937 Salvador Dalí, *Mae West Lips Sofa*

1957–1973 Jørn Utzon, Sydney
Opera House

1964 Andy Warhol,
Marilyn

1885 1890 1895 1900 1905 1910 1915 1920 1925 1930 1935 1940 1945 1950 1955 1960 1965 1970

4–1975 Vietnam War

1989 Killings in Tienanmen
Square, Beijing

1982 Documenta 7, Kassel

1995 Christo and Jeanne-Claude wrap
the Reichstag, Berlin

1974 Joseph Beuys, *I Like America
and America Likes Me*

1975 1980 1985 1990 1995 2000 2005 2010 2015 2020 2025 2030 2035 2040 2045 2050 2055 2060

CLAES OLDENBURG

GIANT TOOTHPASTE TUBE

You don't have to enter the world of Alice in Wonderland in order to see a giant toothpaste tube. It may be exhibited alongside a huge hamburger or a piece of cake 6 feet (1.8 m) wide. The inventor of these surprising objects is American Pop artist Claes Oldenburg, who succeeds in turning our expectations upside down.

On a pedestal in a museum you expect eternal beauty made of marble or bronze, or perhaps abstract constructs or something fine and delicate made of precious materials. A tube of toothpaste you usually find on the edge of a washbasin or in your toothbrush glass. That's where it is regularly seen, its condition and position changing with every use. As a sculpture, it's made of a different material (fabric in this case) and instead of constantly changing like the real object it remains permanent and unchanging. It is, moreover, almost colorless: he called such works "ghost" versions.

Sculpture as Caricature

The cap standing beside the tube indicates that is incompatible with the position of a sculpture on a plinth. This is a caricature of important works of sculptural history. Their original intention was to capture a significant moment. But there is no significant or dramatic moment in the mundane business of using a tube of toothpaste—unless of course you've used it up and the stores are closed. Similarly, the size of the object and the missing colors and simplified shapes presume a close study of the object that the artist places, as it were, under a magnifying glass. Scale confers monumentality on it.

Consumer Goods and Art

This monumentality illustrates the object fetishism of the capitalist world, the fixation on colorful consumer goods, since this was the context in which Pop Art first developed. Making ordinary objects the subject of art was a novelty, as they were now huge and made of cloth or vinyl. Oldenburg filled whole exhibitions with greatly enlarged objects from the supermarket to create his own "store." In this way, products from the supermarket shelves found their way into the museum, where art was now literally pushed off its plinth—Oldenburg's works generally sit on the floor. Oldenburg dramatizes ordinariness with irony, and switches everyday and high culture. In his universe, hard objects became soft sculptures, and small articles became giant sculptures. Since the 1970s, Oldenburg has also been prominently represented in public spaces—gigantic everyday objects can be seen in many places in the world. They allude to our ways of seeing and to our consumer habits with an artistic twinkle in the eye. *kl*

CLAES OLDENBURG
1929 Born 28 January in Stockholm.
1936 Moves to Chicago with his family.
1946–50 Initially studies at Yale, later at the Art Institute of Chicago.
1953 Becomes an American citizen.
1956 Moves to New York.
1961 Organizes *The Store* in New York, a shop where plaster sculptures of everyday items are shown.
1969 First drawings for his giant public projects.
1976 Begins to collaborate with his wife, Cosje van Bruggen.
2009 Cosje van Bruggen dies.

left page:
Claes Oldenburg, *Tube Supported by
Its Contents*, 1979–85, cast bronze
and steel, painted with polyurethane
enamel, 4.57 x 3.66 x 2.9 m, Collection
Utsunomiya Museum of Art, Japan

above:
Angelika Platen, Claes Oldenburg 1972,
photograph, Kassel

Claes Oldenburg, *Giant Toothpaste Tube*, 1964, vinyl, canvas, kapok; wood, metal; painted with enamel, 64.8 x 167.6 x 43.2 cm, Cleveland Museum of Art

1909 Francis Bacon born **1930** Grant Wood, *American Gothic* **1950** Jackson Pollock, **1961** John F. Kennedy becomes
 Number 32 US president
1910 Wassily Kandinsky, *Church in Murnau* **1961** Berlin Wall

1913 Umberto Boccioni, *Unique Form of* **1964–1975** Vietnam War
 Continuity in Space, bronze

1895 1900 1905 1910 1915 1920 1925 1930 1935 1940 1945 1950 1955 1960 1965 1970 1975 1980

Alexander Calder, *Mobile (Untitled)*, 1976,
model

1989 Fall of Berlin wall

1992–1999 Daniel Libeskind,
Jewish Museum, Berlin

2009 Rem Koolhaas, CCTU Head-
quarters, Beijing

1985	1990	1995	2000	2005	2010	2015	2020	2025	2030	2035	2040	2045	2050	2055	2060	2065	2070

ALEXANDER CALDER

MOBILE (UNTITLED)

You wouldn't know from looking at Alexander Calder's mobile in Washington that it's a real heavyweight. But in fact there is nearly half a ton of metal floating around gracefully beneath the roof of the National Gallery of Art.

Made of aluminum and steel, the sculpture is securely attached to the ceiling of the museum. The fragile-looking abstract elements of cut metal drift in space. Painted black, red, or blue, they sway, revolve, swing back and forth, or pause for a moment. Thanks to the way it is suspended, the mobile can move as a whole, but it does also have joints that allow individual parts to move separately—with a playful lightness that denies its weight. It is left to chance what parts of the sculpture move, when, and for how long, depending on air currents, heating, or a breath of wind.

Why Should Art Be Static?

That was what Alexander Calder asked himself as a young artist. Movement was what excited him, and it would soon become a central theme of his sculptural output. His interest also reflects his education, for he was a trained engineer when he took up art. From the 1930s, he produced small mobile works, which were promptly named "mobiles" by Marcel Duchamp. Gradually Calder's mobiles gained monumental dimensions—at roughly 30 feet by 76 feet (9 by 23 m), the example in Washington (see page 138) is one of the biggest. Commissioned by the National Gallery especially for this location, it is one of the artist's last works. Only a few weeks after it was completed in 1976 he died.

Sculptures with a Life of Their Own

With their endlessly surprising movements, Calder's mobiles always provided something to talk about, even during the artist's lifetime. Philosopher Jean-Paul Sartre already confirmed in 1946 that they had a life of their own: "They feed on air, they breathe, they draw life from the free life of the atmosphere. … That hesitation, that starting over, groping, clumsiness and then the sudden resolve and especially that swanlike nobility make Calder's mobiles strange entities, half matter, half life. … The mobiles, which are neither alive nor mechanical, which endlessly surprise us once again and then return to their original position, are like water plants that the current moves back and forth. They are like petals of mimosa or gossamer, borne on the wind." *ik*

ALEXANDER CALDER
1898 Born 22 July in Lawton, Pennsylvania.
1919 Completes his engineer's training.
1924 Works as a press artist.
1926 Moves to Paris. Begins his *Circus*.
1932 Shows his first mobiles in Paris.
1933 Moves to New York.
1937 *Mercury Fountain* in the Spanish pavilion at the Paris World Fair.
1943 A Calder retrospective is held at the Museum of Modern Art, New York.
1957 Mobiles for John F. Kennedy Airport, New York, and the UNESCO headquarters in Paris.
1976 A major retrospective opens at the Whitney Museum of Art, New York. Dies 11 November in New York.

André Kertész, Alexander Calder with his *Circus*, 1929, photograph

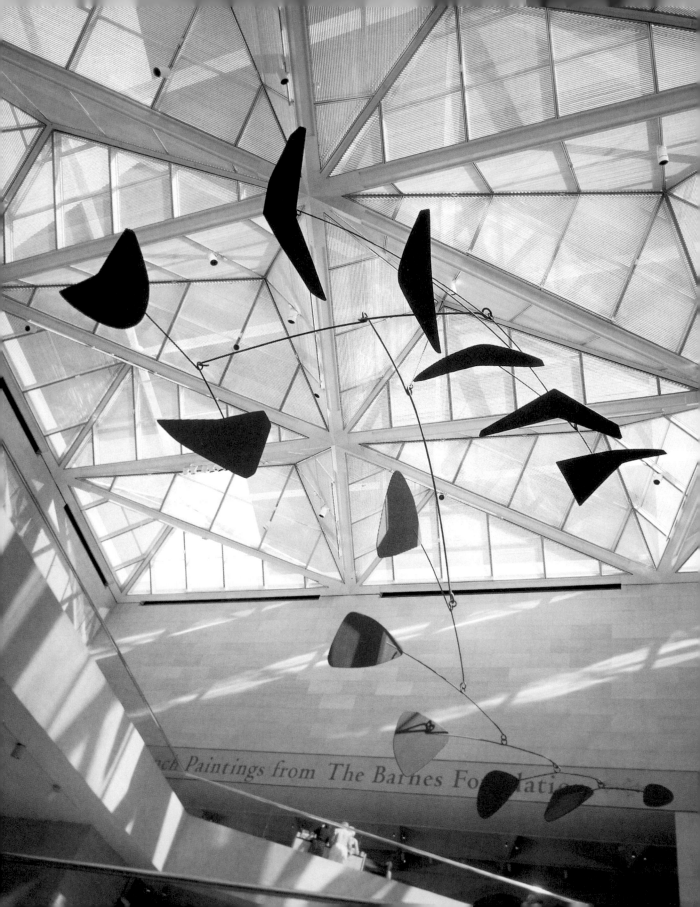

...ch Paintings from The Barnes Fo...datio...

left page:
Alexander Calder, *Mobile (Untitled)*, 1976,
aluminum and steel, 9.10 x 23.15 m,
National Gallery of Art, Washington

below:
Alexander Calder, *Feathers*, 1931,
private collection

ALBERTO GIACOMETTI

MERET OPPENHEIM

HENRY MOORE

1904 Salvador Dali born

1914–1918 World War I

1959 Günter Grass, *Tin Drum*

1962 The Rolling Stones formed

1947 David Bowie born **1958–1960** Oscar Niemeyer, Congress Building, Brasília

| 1885 | 1890 | 1895 | 1900 | 1905 | 1910 | 1915 | 1920 | 1925 | 1930 | 1935 | 1940 | 1945 | 1950 | 1955 | 1960 | 1965 | 1970 |

Niki de Saint Phalle, *Tarot Garden: The Empress (card no. III)*, from 1979, iron reinforced concrete, mosaic, Tuscany

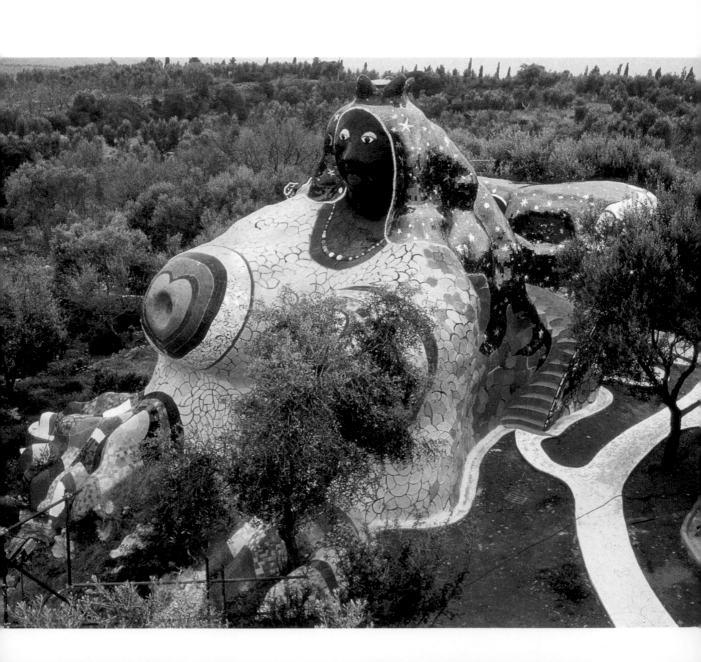

1992 Bill Clinton becomes president of the USA.
The Internet links 5 million computer users

7 David Hockney, *A Bigger Splash* **1990** Reunification of Germany **2006** Zaha Hadid, Phaeno Science
8 Student revolts Center, Wolfsburg

1980 John Lennon shot

1975 1980 1985 1990 1995 2000 2005 2010 2015 2020 2025 2030 2035 2040 2045 2050 2055 2060

NIKI DE SAINT PHALLE

TAROT GARDEN

A monument to 'joie de vivre' and benevolent forces—Niki de Saint Phalle's Tarot Garden in southern Tuscany is a fantastic (in both senses of the word) sculpture garden that has become her artistic legacy.

Actually she wanted to be a saint. But then she found herself on the cover page of *Life* as a photo model, and shot at bags of paint that had been tied to paintings and statues. She finally became famous worldwide as an unconventional—indeed contro-versial—artist. Among her creations is a work called *Hon – en katedral (She, a Cathedral)*. As tall as a building, the female sculpture is accessed by visitors through an oversize vagina. With her unusual ideas, Niki de Saint Phalle caused a stir as an artist early on. But she knew exactly what she was doing. With the Swiss painter and sculptor Jean Tinguely, who would become her second husband, she designed the sets for the celebrated ballet *Eloge de la Folie* (1966), which was described by critics as "one of the greatest creations of post-war ballet."

Art and Pastoral Care
All her life she refused to be pigeonholed. Clever, self-assured, and independent, she championed the equality of male and female as a basic principle of human existence, but would not let feminism appropriate her, defending the individual's religious beliefs as a basic component of every personality. She fought against bigotry and intolerance, and against the demonization of sensuality, emotion, and intuition. But she never questioned the exist-ence of God, and even spoke of her "passionate love relationship" with him. Her art is principally about pastoral care: hardships, fears, contradictions, passions, and ideals. Niki de Saint Phalle, who had never studied art formally and therefore could be considered "unspoiled" in a positive sense, set out on her own quest as to what her work as a sculptor should be about. Seeing herself as a priestess, she wanted to unite death with life, turn fear into exhilaration, and direct vision and imagination to the healing world of legends. However, many viewers find that her artistic idiom, which can assume apparently naïve, folksy, and occasionally even childish forms, takes some getting used to.

Goddess and Whore
Niki de Saint Phalle's beliefs drew on a wide range of sources, including astrology and other "dark" lore, and in particular the esoteric world of tarot. Her Tarot Garden in Garavicchio near Capalbio, around 87 (140 km) miles northwest of Rome, is based on the 22 large "arcana" or symbols of the card game, which in their sequencing can act as tools of self-discovery. With its mixture of pop and esoterica, this sculpture park is the sum of her life's work.

NIKI DE SAINT PHALLE
1930 Born Catherine-Marie-Agnès Fal de Saint Phalle 29 October in Neuilly-sur-Seine, France.
1952 After her exams, she goes to drama school, but then decides to become an artist and establishes close links with the contemporary art scene.
1960 After the failure of her first marriage, she lives with the sculptor Jean Tinguely. They do joint projects for the stage and for Expo 1967. She becomes world-famous with her "Nanas"—brightly-colored, opulent female figures made of polyester foam.
1979 She begins work on her Tarot Garden at Garavicchio, on the very southern edge of Tuscany. She fills it with 22 monumental figures, some truly huge, describ-ing it as her own "Garden of Joy. A little corner of Paradise. A meeting place between man and nature."
2002 Dies 22 May in California of pul-monary emphysema, following years of breathing in toxic fumes from polyester.

left:
Niki de Saint Phalle, *Tarot Garden: The Empress*, interior view

above:
Niki de Saint Phalle, 1980

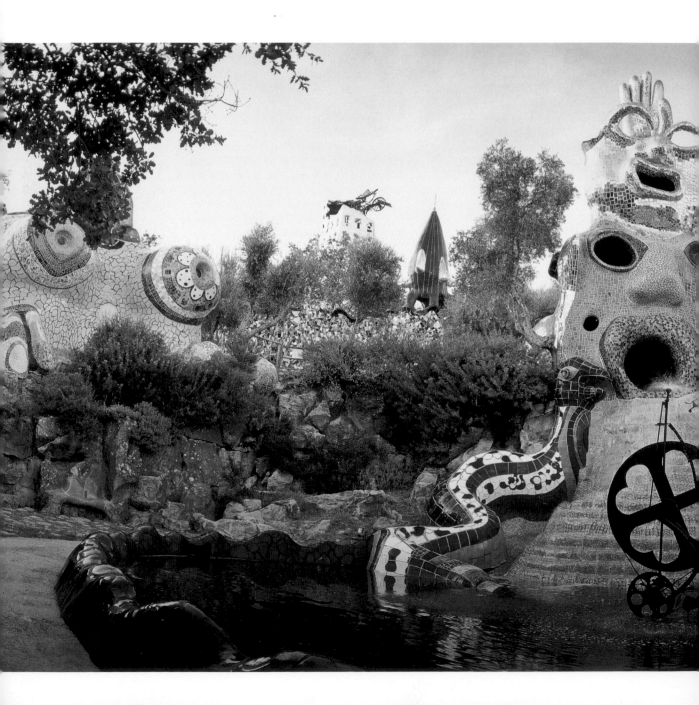

The dominant figure of the part-architectural, part-sculptural landscape is the huge Empress, which in the tradition of tarot is the mother figure, the quintessence of fertility, abundance. In content, the huge iron-based figure draws on the myth of Gaia, while in general shape she resembles the Sphinx. To Niki de Saint Phalle, "the Empress is THE GREAT GODDESS. She is Queen of the Sky. Mother. WHORE. Emotion. Sacred Magic and Civilization. ... I lived for years inside this protective mother. She also served for headquarters for my meetings with the workmen. It was here we all had coffee breaks. On all she exerted a fatal attraction," she wrote, recalling the years when she worked with friends and local craftsmen creating the garden. She did not, incidentally, see herself in the role of Empress. The card she chose for herself was that of the Fool. *kr*

Niki de Saint Phalle, *Tarot Garden: The Magician (card no. I) / The High Priestess (card no. II)*, 1983, iron reinforced concrete, mosaic, Tuscany

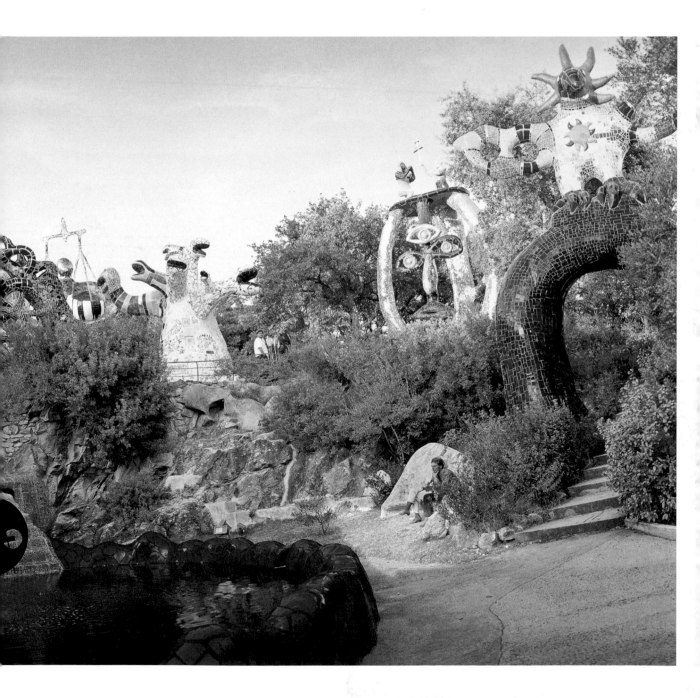

JOSEPH BEUYS ━━━━━━━━━━━━━━━━━━━━━━━━━━━━━━━━━━━

ANDY WARHOL ━━━━━━━━━━━━━━━━━━━━━━━━━

JACKSON POLLOCK ━━

1946 UNESCO founded **1963** President Kenned
 assassinated

1903 Claude Monet's series of Thames **1950** Racial segregation **1967** David Hock
 pictures in London abolished in USA A Bigger Spl

| 1885 | 1890 | 1895 | 1900 | 1905 | 1910 | 1915 | 1920 | 1925 | 1930 | 1935 | 1940 | 1945 | 1950 | 1955 | 1960 | 1965 | 1970 |

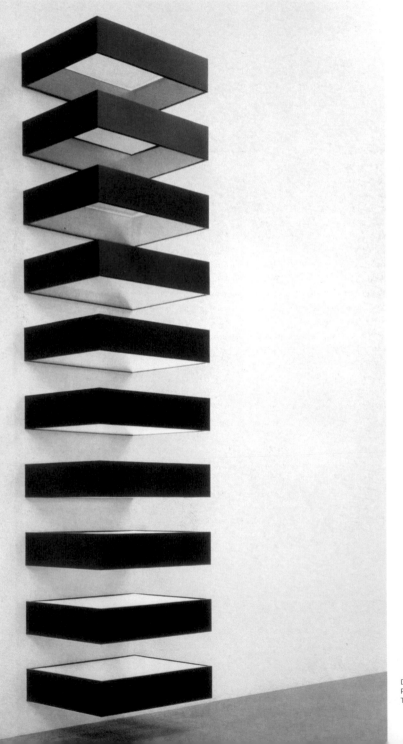

Donald Judd, *Untitled*, 1990, aluminum,
Plexiglas, variable dimensions, London,
Tate Gallery of Modern Art

1980 Ronald Reagan elected US president

969 Neil Armstrong is the
first man on the moon

1991–1992 First
Gulf War

2000 Herzog & De Meuron, Tate Modern,
Bankside, London

1982 First CD players in serial production

| 1975 | 1980 | 1985 | 1990 | 1995 | 2000 | 2005 | 2010 | 2015 | 2020 | 2025 | 2030 | 2035 | 2040 | 2045 | 2050 | 2055 | 2060 |

DONALD JUDD

UNTITLED

Desert inspiration. Judd's "specific objects" mark a deliberate breach with Western tradition. With their reduction to mere material, shape, and color, they take the magic from art and push classical sculpture from its pedestal.

Though Marfa has a splendid Victorian county court, was once a stop on the Southern Pacific railway, and has a cattle-feed factory, it's hardly the place for a major art center. The population barely exceeds 2,000, and it's located in the dusty southwestern corner of Texas once known to the Spaniards as *despoblado* (the desert). But Donald Judd was so taken with the rough charm of the remote former military base that he bought two large artillery sheds and a number of smaller buildings and in time helped to transform the small town into an artist colony. The painter, sculptor, architect, and furniture designer had had enough of the overwrought atmosphere of New York. He particularly loathed museums because in his view most curators were not in a position to present art adequately. Accordingly, he thought that the art exhibited could not be completely understood and therefore fulfill its most important task, which was to inspire subsequent generations of artists by providing points of contact.

Clarity and Order

Donald Judd wanted to change art, and Marfa seemed to him the right place to do it—a rundown settlement, the vast emptiness of the landscape, and the open sky with vultures circling overhead. Wasn't that a sculpture in itself? Simple, plain, and uncomplicated—and, like his works, devoid of any emotion, illusion, or symbolism.

He restored the ruined buildings with purist zeal, designing windows, doors, and partitions, setting up a studio, library, and huge exhibition rooms, where he could finally group large parts of his work the way he had long dreamed of, taking meticulous account of the angle of viewing, light conditions, proportions, and spatial effect. And that's where what he described as his "specific objects" still stand. They represent nothing but themselves, and in their clarity, rigor, and reduction to material, shape, and color are much closer to the laws of mathematics and

logic than to the Western conviction that art is depiction, transformation, and magic.

Materials Not Metaphors

At the start of his career, when he was a painter, Judd's horizons were wholly conventional. However, he soon proved a hot-headed art critic, inveighing against the European tradition, and preaching the depersonalization and objectification of art. His unapologetic aggressiveness aroused outrage—but also some nodding of heads. The fact that he didn't want to hang pictures on the wall, was minded to give color a three-dimensional form by experimenting with free-standing objects made him as interesting to a younger generation of artists as his categorical rejection of any metaphor. Instead of marble, gold leaf and bronze, he gave preference to plywood, Plexiglas and galvanized iron. He denied any higher interpretation, relying solely on the direct effect of the materials used. "Aluminum sheet is aluminum sheet," he was wont to say coolly, if asked what he meant to express with his works. Such reduction to the bare aesthetics of industrial materials is admittedly not for everyone, and can still perplex the public. However, this approach made Judd a key figure of Minimalism, which with its emphasis on geometrical primary structures and its penchant for serial repetition opened a new chapter in the history of art. Marfa is justly considered an experimental laboratory that has influenced the world. *kr*

DONALD JUDD

1928 Born 3 June in Excelsior Springs, Missouri.

1959 While studying art and philosophy, he works as a reviewer for *Art News*, *Arts Magazine*, and *Art International*, writing mainly about European and contemporary American art.

1962 Accepts his first teaching job, in New York.

1972 To be able to present his work adequately and to work undisturbed, he moves to Marfa in Texas, though he retains his New York apartment.

1990 Opens a studio in Cologne and writes for the German art periodical *Art Forum*.

1994 Dies 12 February in New York. His assets are invested in a foundation, the purpose of which is to maintain his artistically designed working and living spaces, his libraries and archives in New York and Marfa, and to make them available for research and to the public.

Donald Judd in his architectural office in the former Marfa National Bank, 1961, photograph

1914–1918 World War I

1948 Mahatma Ghandi born

1939-1945 World War II

1969 Woodstock festival

1885 1890 1895 1900 1905 1910 1915 1920 1925 1930 1935 1940 1945 1950 1955 1960 1965 1970

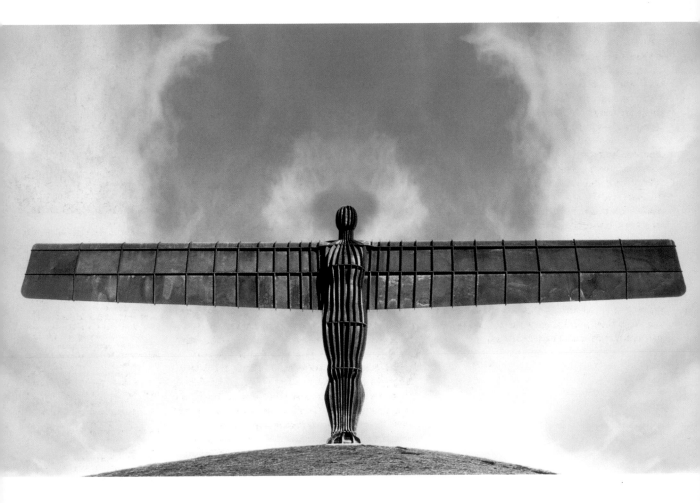

Antony Gormley, *Angel of the North*, 1995/98,
Steel, 22 x 54 x 2,20 m, Gateshead

1990 Reunification
of Germany

2001 9/11 terrorist attacks in New York

2003 Iraq War

1973 Picasso dies

1986 Jeff Koons,
Rabbit

1996 First cloned mammal: Dolly the Sheep

2008 Herzog & De Meuron, Bird's Nest Stadium, Beijing

1991 Damien Hirst, *The Physical Impossibility of
Death in the Mind of Someone Living*

| 1975 | 1980 | 1985 | 1990 | 1995 | 2000 | 2005 | 2010 | 2015 | 2020 | 2025 | 2030 | 2035 | 2040 | 2045 | 2050 | 2055 | 2060 |

ANTONY GORMLEY

ANGEL OF THE NORTH

"My body is the seat of my being. I try to find a language in the body that overcomes the limitations of race, faith and language but is always about the roots of identity. ... I wanted to re-invent the body from inside out. From the perspective of existence." Antony Gormley

Antony Gormley's sculpture *Angel of the North* was created between 1994 and 1998 in collaboration with engineers and shipyard workers. The huge figure of an angel stands on a hill beside the M1 motorway near Gateshead in the north of England, a landmark visible far and wide. It is 66 feet (20 m) high and its outspread wings measure an extraordinary 177 feet (54 m). No less impressive is the 200-ton weight.

Guardian Angel

With regard to the steel figure, Gormley himself talks of the materialization of the imaginary guardian angel of his childhood, a divine helper now made visible. At the same time, he emphasizes the ironic aspect of the sculpture, whose outsize wings represent at once a blessing and a burden: it will never be able to fly with them.

Gormley is fully committed to creating contemporary art, works that are fully of their time. Thus the *Angel of the North* embodies ideas about technology and progress—in particular how man has changed as a result of technical progress, and to what extent man's body is dependent on technology.

Human Figure and Space

The *Angel of the North* is not the first work by the English sculptor to be based on his own body, in this case magnified 11 times over. The human body has formed the starting point of his œuvre since the 1980s. In the case of *Another Place* (1997), for example, he created one hundred life-size cast-iron standing figures that are spread across a beach near Liverpool. He is considered to have rescued the human figure—a central theme of sculpture since prehistoric times—from its long period in the shadows, when leading British sculptors worked primarily with abstract forms or inanimate objects. Gormley draws emphatic attention to the relationship between inside and outside—the space inside and outside the body. In recent works he has made figures from wire so as to make the inner space visible. He emphasizes the imaginative potential and openness of his sculptures to associations and emotions, granting the level of reality arising from the viewer's perception the same importance as the physical presence of the works themselves, including the *Angel of the North*. Often the sculpture is seen by passers-by in relation to the people who have climbed the hill on which it stands, and who seem tiny in comparison with the figure. And if you get closer to it, it's capable of offering much scope for the imagination. Gormley expressed his concern thus: "I should like to create something that becomes an assembly point of feelings—feelings perhaps we were not aware of before this thing was there—or feelings that did not arise before it was there." *cw*

ANTONY GORMLEY
1950 Born in London, the youngest of seven children.
1968–71 Studies archeology, anthropology, and art history at Trinity College in Cambridge.
1971–74 Travels to India, and under the guidance of S.N. Goenka learns the techniques of Vipassana meditation.
1974–79 Studies art at the Central School of Art and Design, Goldsmiths' College, and the Slade School of Art in London.
FROM 1981 Numerous solo exhibitions: at the Tate Britain, the Irish Museum of Modern Art in Dublin, the Kunstverein in Cologne, etc.
1994, 1999, 2007 Awarded the Turner Prize, the South Bank Prize for visual art, and the Bernhard Heiliger prize for sculpture.
Gormley lives and works in London.

INTERNET TIP
Detailed information on the artist and his work can be found on his website: www.antonygormley.com

Bruno Vincent, Antony Gormley at the Hayward Gallery in London, 2007.

1900 First recordings of Caruso **1919** Pierre-Auguste Renoir dies

1958 Truman Capote,
Breakfast at Tiffany's
1961 John F. Kennedy
becomes US president
1962 Cuban Missile Crisis

1885 1890 1895 1900 1905 1910 1915 1920 1925 1930 1935 1940 1945 1950 1955 1960 1965 1970

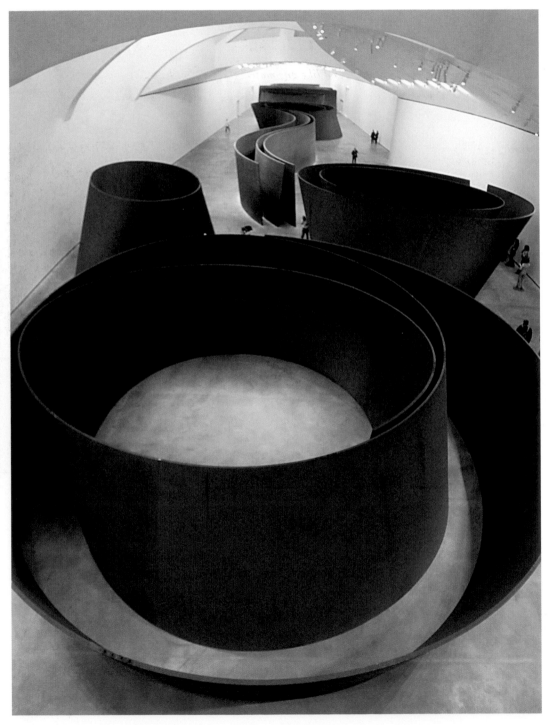

Richard Serra, *The Matter
of Time*, 1994–2005, steel,
Guggenheim Museum, Bilbao

ALVAR AALTO

1993–1997 Frank O. Gehry, Guggenheim Museum, Bilbao

1964 Beginning of the Vietnam War **1987–1989** Tadao Ando, Church of Light, Ibariki

1982 Michael Jackson, *Thriller* **2004** Norman Foster, Swiss Re Tower, London

| 1975 | 1980 | 1985 | 1990 | 1995 | 2000 | 2005 | 2010 | 2015 | 2020 | 2025 | 2030 | 2035 | 2040 | 2045 | 2050 | 2055 | 2060 |

RICHARD SERRA

THE MATTER OF TIME

According to Richard Serra, space is just another material, and like any material it can be shaped. Serra gets to grips with his material with a special technique—sculptural form.

There was plenty of this "material" available at the Guggenheim Museum in Bilbao, since Richard Serra devised his *The Matter of Time* installation for the largest exhibition area in the museum. The room on the ground floor is 426 feet (130 m) long and nearly 100 feet (30 m) wide. Surely dimensions of this sort would swallow up any work of art, wouldn't they?

Entering the Labyrinth

In fact, with the eight steel objects that make up the *Matter of Time* there is no danger of that. Each piece is over 13 feet (4 m) high. The installation follows the architectural contours of the exhibition area, since the huge room gets narrower towards one end, the ceiling lower. At the wider end of the room there are three works, *Torqued Spirals* and *Ellipses*, which, as with all the pieces, visitors can enter. As they curve, the steel plates tilt towards each other and then drift apart, the spaces between changing with every step until all of a sudden you reach an open space. The next object is called *Snake* and undulates three times through the room. Three curved walls made of steel plate 2 inches (5 cm) thick form two corridors around 100 feet (30 m) long. The alternation between wide and narrow, compressed and opened-out spaces is continued in the following works. Two further *Torqued Spirals* come next, followed by *Between the Torus and the Spheres*, which straddles the room and thus almost looks like a barricade. The blockish-looking work at the narrow end of the room, *Blind Spot Reversed*, looks closed from outside. But its pointed ovals surprise the visitor with a corridor that gets narrower and narrower at each turn. Shapes, spaces and surfaces vary as much as the colors of the steel, which range from rust red to dark gray.

Absolutely Useless

"If you rob art of its uselessness, what you're doing is not art," says Serra, adding: "I'm interested in sculpture, which is neither useful nor functional." Visitors to *The Matter of Time* are accordingly free to move around, or rather have to move around—to enter the labyrinthine spirals and experience the changing space between high steel walls. Though all visitors enter the installation at the wider end of the room (the huge room has only one entrance), the order in which they explore the works before finally making their way back to the entrance is up to them. Serra's sculptures not only do without plinths. What gives them life is that they can be perceived from ever-changing perspectives. *ik*

RICHARD SERRA
1939 Born 2 November in San Francisco.
1957–61 Studies literature at the University of California, Berkeley.
1961–64 Studies art at Yale, New Haven.
1966 First solo exhibition at the La Salita gallery in Rome.
1967 First works with rubber and neon strip-lights.
1968/69 Uses lead in the *Splashing* and *Casting* series. First major steel works for interiors.
1981 *Titled Arc* installed in Federal Plaza, New York.
1986 A retrospective is held at the Museum of Modern Art, New York.
1989 After fierce debate, *Tilted Arc* is removed and destroyed.
1995 *Snake*, Guggenheim Museum, Bilbao.
2005 *The Matter of Time*, Guggenheim Museum, Bilbao.
Serra lives and works in New York and Inverness, Canada.

Dieter Schwerdtle, photograph of Richard Serra in Kassel, 1982, private collection, Turin

Richard Serrra, *The Matter of Time*,
detail: *Snake*, 1994–97, 4 x 31.7 x 7.84 m

Richard Serrra, *The Matter of Time*,
detail: *Torqued Spiral (Closed Open Closed
Open Closed)*, 2003, 4 x 13.1 x 14.1 m

NIKI DE SAINT PHALLE ━━━━━━━━━━━━━━━━━━━━━━━━━━━━━━━━━━━━━━━

ALBERTO GIACOMETTI ━━━

HENRY MOORE ━━━━━━━━━━━

1900 Sigmund Freud *The Interprtation of Dreams*

1939–1945 World War II

1952 Samuel Beckett, *Waiting for Godot*

1962–1968 Ludwig Mies van der Rohe, Neue Nationalgalerie, Berlin

1958/59 Mark Rothko, *Black on Maroon*

| 1885 | 1890 | 1895 | 1900 | 1905 | 1910 | 1915 | 1920 | 1925 | 1930 | 1935 | 1940 | 1945 | 1950 | 1955 | 1960 | 1965 | 1970 |

Louise Bourgeois, *Maman*, 1999, steel, marble, 9.27 x 8.91 x 10.23 m

1991 Soviet coup d'etat attempt

1990 Reunification of **2001** 9/11 terrorist attacks in New York
Germany **2004** Tsunami catastrophe in Asia

1991–1992 First Gulf War **2008** Rem Koolhaas, China Central Television Headquarters, Beijing

1997 Deng Xiaoping dies, Hong Kong returned to China

| 1975 | 1980 | 1985 | 1990 | 1995 | 2000 | 2005 | 2010 | 2015 | 2020 | 2025 | 2030 | 2035 | 2040 | 2045 | 2050 | 2055 | 2060 |

LOUISE BOURGEOIS

MAMAN

Exorcism is healthy. Louise Bourgeois produces disturbing sculptures and installations from the traumatic images of her childhood and youth. Born in 1911 and discovered late, she is still considered the 'enfant terrible' of the New York art scene.

Now in her nineties, Louise Bourgeois could easily put her hands on her lap and twiddle her fingers. But the petite old lady wouldn't dream of it. She still works as if possessed, going to her studio every morning at the same time. Her self-discipline is exemplary, her tongue legendary. She hurls buzz saws around if asked the wrong question. She owes her impulsive creativity to having, in her own words, "too much identity." She vents it in art. For someone who followed the Freudian debate, art is a kind of psychotherapy that allows her to express all the rage that simmers in her "sick heart." This "sick heart" is the result of her childhood, which has "never lost its magic power, its mysterious darkness or its drama." Even now, Louise Bourgeois draws on her personal experiences in the first half of the 20th century, recorded in copious diary entries.

Father Figure

The focal point is nearly always her father—a patriarch and Don Juan who openly had an affair with the English nanny in front of his wife and children, and who had a taste for cruel personal remarks. One day, for example, during a family meal, Burgeois explained: "he cut out the shape of a girl's body from mandarin peel, held it up in front of everybody and exclaimed: 'Look, everyone, this is Louise. She has nothing between her legs except a pair of thin white threads.' Everyone laughed at me." It seemed a belated revenge when in 1968 she made a huge erect phallus of Latex and hung it from the ceiling on a butcher's hook. Another work shows her parents' house, a little fairytale castle near Paris, with a gigantic guillotine over the roof. To spite her frivolous, authoritarian father, she deliberately married an avowed puritan, American art historian Robert Goldwater, whom she described as a feminist, and moved to the USA with him.

Mother Figure

Even before she left, she had studied painting, with Fernand Léger among others. But it was only after she had severed her links with her past and fled to the New World that her artistic energy exploded. She now not only painted pictures but also experimented with all sorts of materials, regardless of fashions, conventions, and genre boundaries. Since then her work has been about her own personality. Even her most abstract works are self-portraits or codes for her relationships with other people. Her oeuvre illustrates the story of her life and tells of her mental state at the time. According to the German philosopher Peter Sloterdijk, her whole artistic output revolves exclusively, obsessively, around her personally. Yet Louise Bourgeois has also established a reputation as a "coolly probing architect of the inner self laid bare." The "gray domina" aroused a stir worldwide with *Maman* in 1999, a sculpture 33-feet (10-m) high that weighs half a ton and would do credit to any ghost train. The steel monster symbolizes her mother, who ran a restoration workshop for old tapestries and who died in 1932. She "was my best friend," confessed her daughter, "clever, patient, comforting, sensitive, hard-working, and indispensable. Above all, she was a weaver—like a spider." We may rightly suspect that *Maman* is not just flattering. After all, there are female spiders which after copulation eat the male—and Louis Bourgeois and her siblings occasionally indulged in the fantasy that they were eating their father for supper. *kr*

LOUISE BOURGEOIS
1911 Born 25 December in Paris, the second of three children.
1936–38 Gives up the study of mathematics and geometry and takes up art.
1938 She and her husband, art historian Robert Goldwater, emigrate to the USA, settling in New York.
1945 First solo exhibition of paintings at the Bertha Schäfer Gallery in New York.
1951 Her father dies, and she becomes a US citizen. As an artist, she largely works for herself, and is among the first women to produce installations.
1988/89 An exhibition that tours a number of US cities makes her belatedly known to a larger public.
2007 Shortly after her 95th birthday, the Tate Modern in London puts on a spectacular solo exhibition of her work.
Bourgeois lives and works in New York.

Photograph of Louise Bourgeois, New York 1939